Living Happily Ever After

COUPLES TALK ABOUT LASTING LOVE

By Laurie Wagner, Stephanie Rausser, and David Collier

INSPIRED BY THE FILM *FOR BETTER OR FOR WORSE*, PRODUCED BY DAVID COLLIER

CHRONICLE BOOKS

SAN FRANCISCO

Printed in Hong Kong.

Library of Congress Cataloging-in-Publication Data:
Wagner, Laurie, 1960–
 Living happily ever after : couples talk about lasting love /
 by Laurie Wagner, Stephanie Rausser, and David Collier.
 160 p. 25.5 x 24.5 cm.
 ISBN 0-8118-0889-0 (PB) 0-8118-0865-3 (HC)
 1. Marriage—Case studies. 2. Communications in
marriage—Case studies. 3. Man-woman relationships—
Case studies. 4. Love—Case studies. I. Rausser, Stephanie,
1966– . II. Collier, David, 1961– . III. Title.
HQ734.W184 1996
646.7'8—dc20 95-44530
 CIP

Book and cover design: Julia Hilgard Ritter

Distributed in Canada by Raincoast Books
8680 Cambie Street
Vancouver, B.C. V6P 6M9

10 9 8 7 6 5 4 3

Chronicle Books
85 Second Street
San Francisco, CA 94105

www.chroniclebooks.com

Contents

Acknowledgments

This has been an incredible project to work on. The stories I've heard have inspired my marriage and my life. I'd like to thank all of the couples who so graciously let me into their home and into their lives. I wasn't able to use every couple who I met along this journey, though I'm grateful to all of them. I'd especially like to thank my interns, Steve Mockus, Kelly Ramsey, Bruna Darini, Alan Montelibano, and Rachel Kimball, who helped me transcribe, interview, and edit in exchange for Thai food and coffee. I couldn't have done it without them and appreciate all the insight and feedback that they gave me. There would be no book if not for David Collier, my longtime friend and associate. Thank you. And to my sweet husband, Mark Wagner, my partner on the high road of marriage. —L.W.

I want to thank all the couples for being so cooperative; Custom Process for the discount; David Collier for having the faith in my work to involve me in his project; Laurie Wagner for her encouragement and great polaroids; Pat Sanborn, whose uncanny spirit has helped to guide and inspire me; Gordon Rausser, whose diligence and determination have left an indelible mark; Laura Craft, for always being there; and, of course, Eva and Lawrence, who make my home the greatest place to wake up in and the greatest place to come home to.
 —S.R.

It has been a lot of fun working on this book and watching it come together. I would like to thank Laurie Wagner for her tireless energy, resourcefulness, and quick wit. Laurie worked with me for the first year on the *For Better or For Worse* documentary film, which explores the lives of five couples married fifty years and longer. It was a real pleasure to work with Laurie again, picking up where we left off six years ago. I would also like to thank Stephanie Rausser for her imaginative and whimsical eye; the couples for sharing their stories with us; our managing editor, Annie Barrows; my faithful cat, Wally; and finally my parents for giving me life.
 —D.C.

Foreword

Laurie Wagner and I met one winter morning at a cafe in Berkeley to discuss a documentary film idea I had. I wanted to call it *For Better or For Worse*. The concept was an hour-long documentary for PBS that would explore the lives and relationships of five couples married fifty years or longer. It was 1987. Laurie, then a sassy freelance journalist, was interested in getting into filmmaking; though we had never met, we hit it off instantly. I was just a year out of film school, excited about launching my first feature-length documentary, and completely naive about the many challenges ahead.

The film was inspired by my grandparents, now in their nineties and married over 67 years, and by my own parents' marriage, which ended when I was five. I saw the film as a way to explore relationship issues and to confront my fears about commitment.

Laurie and I spent the next year driving around in my Volkswagen Bug with our tape recorder, interviewing couples. Our goal was to find five culturally diverse couples who were good storytellers, had some insights into what made their marriage work, and could express the bittersweetness of their shared history.

The interview process was a real eye-opener. We walked into the lives of 70-, 80- and 90-year-olds and asked them intimate questions about how they met, what they fought about, where sex fit into their lives, how they managed to live together for over fifty years, and the inevitability that one would probably die before the other.

One of the most memorable experiences Laurie and I had was when we were interviewing Bob and Arthur, a gay couple together 38 years. Even though they didn't meet the 50-year requirement, we decided to interview them anyway. About an hour into the interview, Arthur had a massive heart attack, and within minutes he was dead. We did everything we could to resuscitate him, to no avail. It was a deeply moving experience for us, one that brought us closer to understanding the reality that all of these couples would have to face: the loneliness that comes from losing a lifelong partner.

When we weren't interviewing couples, Laurie and I wrote grant proposals to raise money for the film. The process was trying and tedious, and often caused us to argue. I kept saying that making a film is a long process, and it would be at least a year before the movie could be finished. But I said that for five years. After a year of interviewing and proposal writing, Laurie informed me that she was moving on. She needed to return to her writing.

Over the next four years, I worked with two other co-producers, Marcia Jarmel and Elizabeth Thompson (with whom I became romantically involved). Altogether we interviewed over 200 couples in the pursuit of five couples for the film. Interviewing older couples about their love for one another was a great backdrop for the beginning of our relationship.

In 1993, the film was finally completed. PBS had given us a completion grant in exchange for broadcasting the film. The happiest day of my life was the day we premiered the film in a small theater in San Francisco. I couldn't believe that the film was finished. We had a big

party and all of our friends and family showed up to help us celebrate.

That year, *For Better or For Worse* was nominated for an Academy Award. The film had surpassed all of our wildest dreams. Elizabeth and I flew down to Los Angeles for the awards. I borrowed a tuxedo that didn't fit quite right from a friend. But it didn't matter; we were just amazed and excited to be there. That day we practiced our acceptance speech a couple hundred times in the hotel room. We ran from one end of the hotel room to the other to simulate the experience of running up to the podium. That night, when they announced the winner for best feature documentary of the year, they didn't call out our names. I admit, we were a little disappointed, but mostly we felt honored to have been nominated.

Shortly after the nomination, I got a call from Chronicle Books to produce *Living Happily Ever After.* I immediately called Laurie to tell her I had a writing gig for her, one for which she was well-qualified. We all agreed that it would be better to profile couples married 30 years and longer, rather than limiting it to over 50 years, in order to broaden the generational perspective.

Elizabeth and I split up in 1994. Needless to say, I don't have all the answers about relationships. I can say that producing the film—and more recently this book—has taught me a great deal about what it means to be a good partner, and what it takes to be in a long-term relationship.

—David Collier

Living Happily Ever After

Helma and Benno Schneider escaped from a German concentration camp together in 1944 and came to the United States in 1961. They have two sons and four grandchildren and have been married for fifty-three years. He is seventy-two, and she is seventy. They first owned a deli and a liquor store, and now they own and manage an apartment building. Benno was a champion tennis player in Latvia; he still plays, as well as ice skates. Helma volunteers at a local medical center.

Helma and Benno Schneider

"How did we meet?" smiles Benno.

"You tell the story, Papa," says Helma.

"This was in 1942," he begins, "I was working in a…"

"We were in a ghetto camp," she says, "the Riga ghetto in Latvia."

"My family went to the ghetto in 1941," says Benno. "I think there were sixty thousand Jews in the ghetto at that time. At the end of that year the Nazis killed the first group of us. They killed our parents, our children, and our brothers and sisters; but they left five thousand young men alive to work. I lost my whole family except for my brother, who is still alive today. I was eighteen at the time. After they killed so many, they brought in Jews from Germany to take their places."

"Thousands of people," Helma adds, "from every city. My mummy, my father, my youngest brother, and I were the first to come from Cologne."

"After Helma came to our ghetto," continues Benno, "I would see her every morning as we got in line to walk to work. I was always the last one in my group. I had in mind, in case something happened, that I might have a chance to save myself and run away. Helma and her family were always in the first row of their line; she was right behind me, and that's how I saw her."

"My first present from him was a little piece of soap," she smiles.

"The first time I saw her I said, 'Hello,'" he remembers. "The next morning I knew she would be there, so I said, 'Hello,' again. The third time I decided I would give her a present, so I gave her the little piece of soap."

"And a note," Helma recalls, "saying he wanted to meet me. I was sixteen."

"What else could I say?" he asks. "Helma was a young girl…"

"I was pretty," she adds.

"Yes," he agrees, "a pretty, young girl, and I was a

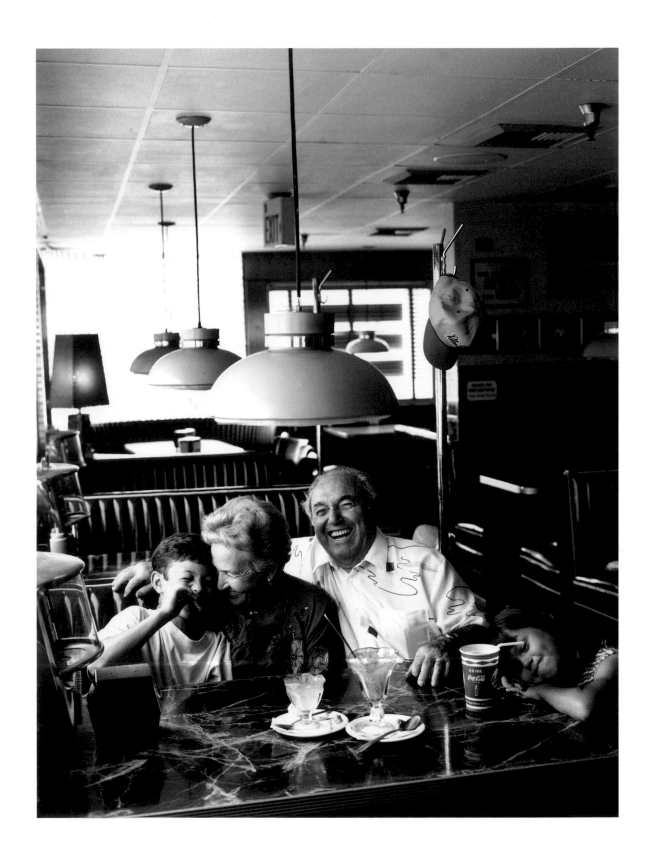

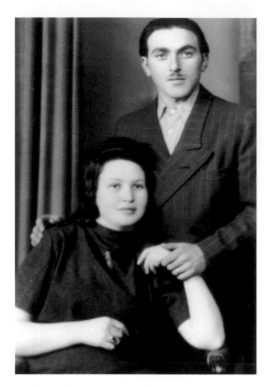

Helma and Benno Schneider, 1946.

nice boy; so I thought, 'Let's see what happens.' You understand, in a place like that any minute you can get killed, so it was fun to meet somebody, a young, pretty girl."

"He met my parents," says Helma. "It's not like you meet somebody and you go out, no darling. Thank God he helped me feed my parents."

"You couldn't think of marriage or anything in such a place," he adds. "I saw that her parents needed food, and because I was Latvian, I knew everybody. I could get a piece of chocolate, a piece of bread, some butter, and I brought this over to them. Her mother, by the way, was a number-one cook. She could cook from nothing, so whatever I brought in was fantastic, we had something to eat and were not hungry. They came to like me as a son. When they started liquidating the ghetto, her parents told her to go with me to the concentration camp. She had a chance to stay with them in the ghetto, but her parents said 'Go with him,' many times."

"They thought," Helma explains, "there might be a chance we could stay alive, and he promised my parents that if we stayed alive he would take care of me."

"We were not married," Benno explains, "but we were blessed by her parents. I took my uncle to her house, we had a glass of wine, and…"

"He asked for my hand," says Helma.

"Yes," he says, "if I want to take her with me, it is

better that they bless us. We call this day of blessing our marriage, that is the day we count."

"We couldn't make it official," explains Helma, "it was impossible, we were prisoners."

"We could never get married in the ghetto," explains Benno. "We could never have babies. You have a baby, you are killed, finished. So we went, and very soon after that, her parents were killed in the ghetto."

"You want to know our other life? Besides this?" Helma asks.

"No," says Benno, "they want to know this life."

"It is not easy to tell," says Helma, "but we were together and we're still together, thank God."

"We went to a place called Kaiserwald," he continues. "They separated the boys from the girls with barbed wire, but we spoke."

"Through the barbed wire," Helma explains. "A year later, we go to another camp."

"Yes," says Benno, "I was sent to another camp, and Helma asked her capo to please send her there because her fiance was going. And the capo says, 'Fiancé shmeeancé, what difference?' But she took out another girl who was going and put Helma in her place; this was very lucky. We promised each other that if we stayed alive, if we could get free someday, that we would be together. You always knew you would get killed, but you had a hope that maybe you would stay alive. You have to have this hope, otherwise you are nothing, you will kill yourself. And on July 31, 1944, we escaped," he says.

"They liquidated the camp," explains Helma, "because the Russians were coming. They were scared, so they took us out."

"They walked us in rows through the forest to the harbor," explains Benno. "We wore the stripes, we didn't have hair because…"

"They needed our hair," says Helma. "They were going to put us on the freighters, and we heard that two

ships of prisoners had already sunk. So in the forest Benno said to me, 'I'm running.'"

"I said, 'I'm running as fast as I can,'" he continues, "and she said, 'I am running after you,' and that's what we did. Everybody ran, all three hundred Jews at once; it wasn't organized. The guards were shooting people from all sides. Only eighteen people got away."

"He got shot in the foot," remembers Helma.

"But if you get shot at a moment like this," explains Benno, "and blood is coming out, it is nothing, you understand? You run. Till you fall down dead, you run."

"You should never know this suffering," says Helma, shaking her head.

"There were three of us who escaped that day," says Benno. "Then we found a girl named Mira stuck on the barbed wire, so we took her off and she went with us."

"We were almost a year in the forest," says Helma. "But everything is destiny. Mira was a nurse and this helped us."

"It was a living hell," says Benno. "We ate whatever we could steal. But we were in love, we were caring for each other. One time I got lost in the forest for three days, and so Helma went three days without food and water. When I found my way back, she was already…"

"He saved me with his saliva," says Helma.

"So you understand," says Benno, "if a person is so close to you… On May 15, 1945, we were free. The Russians found us; we didn't even know the war was over."

"We went back to Riga," says Helma, "because Benno knew the language and he thought he might find some family."

"One hundred and twenty-six people in my family," he says, "and we only found two uncles and a cousin."

"And now our other life begins," says Helma. "A normal life. A legal life. In 1946, when I was twenty-one, our son Sasha was born. We were living in Riga, which was now Russia; and because we were free, we did get a marriage certificate. Our other son, Ira, was also

born in Riga, but life in Russia was not easy for us. Papa didn't have shoes."

"But we wanted to live," Benno says, "we wanted to build a life. We were there for thirteen years, and then in Germany for two years before we came to Los Angeles in 1961. We love America more than anything else," he insists.

"America was so good to us," Helma says, "so I go twice a week and do something for my community."

"She's volunteered in hospitals for eighteen years," he adds, "and doesn't get anything for it."

"I remember when we bought our first deli," says Helma. "We had it for four and a half years, and they had to carry me out because I didn't know that America has *cans of soup*, so I cooked everything from scratch. We worked hard, we worked twenty-four hours a day together. But we never fought;

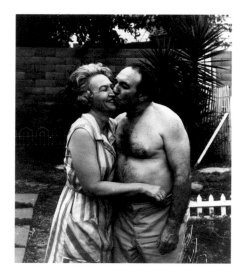

Helma and Benno Schneider, 1960s.

disagreements okay, but we don't fight. Little things, like I tell him, 'Don't make the sandwich like that.'"

"Oh, sure," Benno smiles, "everything I did was wrong, and she always did it right. But I don't get upset at her."

"He tells me to mind my own business," says Helma.

"When I get mad at her," he adds, "I say, 'I love you, Mom,' and everything is okay."

"But right now I am very depressed," Helma confesses. "I have moods, you have no idea; but he understands this."

"You understand that if a person smokes for forty years," he says…

"I did," she says, "now I have only one lung."

"And in forty years how many times did I tell her about it?"

"No," she concedes, "never did he tell me, 'Don't smoke.'"

"And I never wake her up when she snores," he adds proudly.

"Oh!" she laughs, "you snore!"

"Yes, I do," he says, "but so do you. Every time a person lays back, his mouth is open and he snores. But I never wake her, I let her sleep."

"Don't you dare wake me up," she smiles.

"Helma," he says, "likes everything to be clean."

"Yes, the husband must have a clean shirt," she says, "otherwise I am ashamed of being his wife. I put everything out that he's going to wear; for my sons I did the same."

"And when I need a pair of socks…" says Benno.

"Socks," she laughs, "he didn't know where his stuff was, only I knew where his clothes were."

"Now I know," he says, "but I don't know how many socks I have. Not that I care; why should I know? I have different things to do."

"This is the European upbringing," she explains. "My mummy showed me these things."

"And for Helma," he says, "manners are very important."

"Yes," she agrees, "I am very fussy about table manners."

"Not me," he says, "but I have learned what I have to do. I have to sit straight. I have to eat over the table. I have to have my fork on my left and my knife on the right, and I cannot eat with my fingers; I must use my fork. Yes, these are her rules. I know if I don't do these things, she will get nervous, and then she will get headache, and I don't want this. I tell you something very important for every husband: if he loves his wife, he should please her. Now if she asks me to go to the second floor and jump, I would not jump. I would break my head and get killed. If she would tell me to go steal something, I would not steal. But my wife is number one. The children get mad at her sometimes, and I say, 'Don't even try. Mommy is number one, Mommy is head of our house.'"

"Every day," she says, "he tells me, 'Panz, I love you.' We can look at each other and know what the other person wants to say. We are very loving, but sex was more when we were young. It's still important, but once in a while I have a headache."

"No," he disagrees, "very often you have headaches."

"No, Papa," she corrects, "I didn't mean *real* headaches."

"Oh," he says.

"Life teaches you a lot, if you want to learn," says Helma. "Because, you see, we don't live for each other, we live with each other."

"You ask us how we survived our life before America?" says Benno. "I can only answer one thing. We are strong people. We live because we have a beautiful family, and when you have children and your children have children, this is what holds you and makes you stronger. You forget these other things."

"But I tell you," Helma adds, "there is not a day that we don't say, 'Remember when we went into the forest?'"

"I tell you," he says, "if I could have a wish, I wish my family would all be together the way I brought them up. My second wish is that my daughters-in-law not fight and disturb the brothers who should love each other. And my third wish is if I win a million dollars tomorrow, it would be okay, if it was meant to be."

"One quick-pick," says Helma, "that's all you need."

"No, today I played three quick-picks," he tells her.

"And you didn't tell me," she smiles.

Fredda and Harris Meisel have been married for thirty-eight years. They live on a hilltop in a home overflowing with strange and wonderful objets d'art, each with its own unique story of creation or acquisition. Harris, sixty-three, is a physician-painter-poet-sculptor. Fredda, sixty, has designed prize-winning recipes that have taken her and Harris all over the world. She is active in her community and devoted to her family. The couple has three children and two grandchildren.

Fredda and Harris Meisel

"I remember the first kiss Harris ever gave me," Fredda begins. "I didn't know it, but a piece of spinach was stuck between my teeth. Anyway, he said, 'May I kiss you good night?' I guess I smiled, and he noticed the spinach and said, 'Just a minute,' as he plucked it out."

"Well, we've always been able to be very real with one another," says Harris, "which is important because nobody feels deeply in love all the time. And nobody feels committed all the time. It seems more helpful to decide instead whether you're devoted to the well-being of that other person. And this has been a consistent theme in our marriage, both in our passionate love and in simply being glad that the other exists; that's probably our greatest treasure."

"I think it's the taproot to our marriage," says Fredda. "There's a definite respect."

"That's just it," he agrees. "I can be me and feel totally safe with Fredda. She encourages me to do things

that make me happy, because that's what's important to her. It's not unusual for her to sacrifice her own needs for mine, and that means we may unintentionally hurt each other sometimes."

"Just recently," adds Fredda, "we were in the cocktail lounge of this hotel, and this lovely pianist began playing a medley of Irish songs. Well, we got to talking to her, and Harris ended up sitting next to her at the piano and singing while I nursed my drink."

"No, this is how it went," Harris laughs. "Fredda knows I love to sing, so she said to me, 'Why don't you sing with her?' So I ended up singing."

"All evening," she grins, "but it's true that I encouraged him. After a while, I looked over at the two of them singing song after song, and I realized that I was really envious. I was wishing that it was me sitting next to my husband singing songs at the piano, and I berated myself for giving up piano lessons."

"But you know," Harris explains, "knowing Fredda,

17

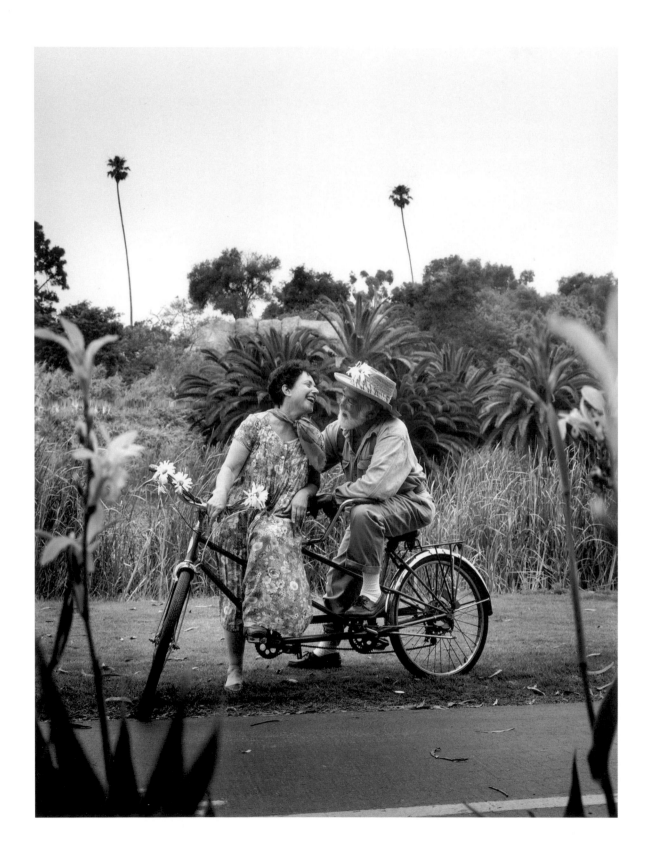

if given the chance, she'd surge ahead to become the best damn pianist she could be just to please me. She's not the kind of person to say, 'Hey, enough of that.' No, she'd encourage me to sing all evening like I did. She likes me to have a good time, and I like her to have a good time, even if that means tiny sacrifices. I had no idea she was feeling a little jealous; we both try to be sensitive to each other's feelings."

"And Harris is very sensitive to mine," adds Fredda. "As busy as he is, he never forgets my birthday. Last year he had no time to get a cake or card for me, but on the morning of my birthday he got up very early and went to his art studio and drew me a humongous card. He also baked a Bisquick birthday coffee cake, which he served to me in bed."

"We work at bringing a sense of joy into our lives," says Harris. "We have a poster hanging in our kitchen that says, 'Don't take yourself too seriously.' And it's Fredda who helps me to lighten up when I need that message the most."

"A doctor takes everything seriously," smiles Fredda. "That's why I create the kinds of surprises I do. Once when he was working very hard at the hospital and needed a break, I made a deal with his secretary to kidnap him. I picked him up and told him that we were going to have lunch with friends of mine who were visiting town and staying at a certain motel. When we got there, I opened the door and pushed him in, and there was his suitcase and swim trunks and everything else he'd need for the next two days. The place was great! It had a round, pink waterbed, and I'd put incense in the room and champagne and deli in the ice chest to last us the whole weekend. It was hysterical; the incense was so strong that it sent us sneezing from the room."

"With Fredda," says Harris, "unpredictable things can happen—like when we moved to Stanford to begin my medical residency. I think it was around my birthday, and we didn't know anyone, but that didn't stop Fredda from having a surprise party for me. She invited the garbage man, the movers who had moved us in, the supermarket butcher, the ant exterminator, the newsboy, and the tree trimmer to the party—people we had only met that week. We sat on unpacked boxes, eating and drinking champagne and getting to know one another. It was the best party I ever had."

"I like to surprise him," Fredda smiles.

"Like the time we were in the elevator," laughs Harris.

"I loved that," Fredda grins. "We were staying at one of San Francisco's Nob Hill hotels, and it was the first day of a week-long medical conference. We'd entered the elevator on the eighteenth floor, and the elevator filled up quickly and quietly, shoulder touching shoulder, everyone looking straight ahead at the elevator door. I got off a floor before Harris, and as I did, I threw my arms around him and gave him a big kiss, announcing loudly, 'Last night was wonderful. I won't breathe a word to your wife.' His colleagues were staring at him, and the color started rising in his cheeks. Later that evening, when we met again, we recounted the story and got into a fit of giggles; Harris thought it was really funny."

"It's because the element of trust is so strong in our lives," he explains, "that we can go out on a wing and be outrageous with one another."

"But we also try and be considerate of one another's needs," continues Fredda. "Harris gives 110 percent to whatever he does, especially to me. Maybe he doesn't do the little surprises that I do, but he's terribly thoughtful. If he knows I'm tired, he'll give me a foot massage. Or he'll bring me coffee in the morning and have a hot pot of oatmeal on the stove for me when I get up. Or if there are dishes, he'll say, 'Let me do those, I'll bring you a glass of wine.'"

"I'm the stabilizer," he says, "when it comes to being practical."

"And I'm impetuous and unpredictable," she laughs.

"Fredda makes sure that the practicality doesn't get too stupidly practical," he adds. "We've shared lots of laughter and tears, lots of ups and downs. We've been there for one another, lifted the other up when they're down. Like when we were on the Navajo reservation."

"We were with the Public Health Service then," explains Fredda. "Harris was a reservation doctor working side by side with the medicine man."

"Anyway, " Harris continues, "Fredda was pregnant, and she didn't tolerate the sandstorms and the 110 degree heat very well. One time I found her collapsed on the bathroom floor. Exhaustion from the heat, her pregnancy, and an epidemic of dysentery had caught up with her so she was hospitalized. She had two pregnancies, one right after the other, during the two years on the reservation. We were out there in the middle of the desert. No family to help out, no baby-sitters, no diaper service."

"We'd wash the diapers in the bathtub," Fredda remembers, "when there was no electricity for the washer to work. And there were other times when there was no water at all."

"Evenings, when I was able to be home and away from the hospital and field duty, we'd read to each other," says Harris. "There was no television."

"And when he couldn't come home," she adds, "I'd type up his poetry that I'd found on the backs of envelopes and scraps of paper. I even sent some of it out to be published."

"Some of those poems were published," he adds, "and she presented their publication to me as the surprise.

"I guess my mind keeps returning to the question of commitment," he continues. "I've had concern for the generation of the last twenty years who've had such a hard time committing to each other. If relationships are taken as temporary, disposable things, then it's harder

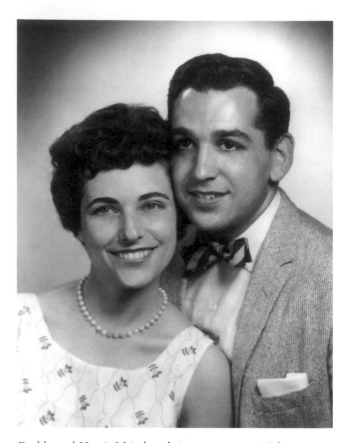

Fredda and Harris Meisel at their engagement, 1956.

for these relationships to be strong. Take the idea of living together for ten years and not being married; it's not the moral issue that bothers me, it's the idea of long-term noncommitment that I question. How long do people practice and test? Is it possible to say, 'This is an important person in my life and I am committed to them?'

"I think commitment is a matter of choice. I've had 200 employees, 190 of them women; and I've been in vulnerable positions, tempted and tested in all kinds of ways. I've had very exciting professional opportunities, but none of them measures up to having an uncondi-

tional, loving relationship with somebody who is comforting and comfortable, somebody I can grow with.

"Fredda chose to be a homemaker. She had offers to advance herself professionally, to become a television anchorwoman. Really, that was a sacrifice for her."

"Wait a minute," Fredda interrupts. "It was my choice, not a sacrifice."

"She was a radio commentator and had her own prime-time television children's show in the fifties and sixties," he adds.

"But being a wife and mother was what I really wanted," Fredda explains. "Building a family with a soul mate was more important to me. I admire women who can maintain a professional career and a family, but it was not my choice. Even today I wouldn't choose a profession over raising a family. That's just the way I am."

"I think what's made these last thirty-eight years so wonderful," offers Harris, "is that deep down we like each other and want the best for each other. There's no question that this is a better place because she's in it. Although there are times when…"

"Ahh, now we're getting into that," Fredda jumps in. "I know what he's thinking, 'It's not always the la la la…' See, Harris is a constant teacher: 'This is how we do this, I'll show you how to do that.'"

"Oh, it drives her crazy!" Harris chuckles.

"It just gets a little much at times," she admits. "Our kids will say, 'Dad, all I want is a yes or no answer. I don't want to know the history of the pen; I just want to know if I can borrow yours.' And sometimes his explanatory nature causes a certain tightness in my throat that I have to eat ice cream for."

"And guess who brings her the ice cream?" twinkles Harris.

Tomas and Elme Bermejo are originally from Mexico and have been married for forty-two years. Tomas came to the United States in 1953, and Elme followed ten years later, although their children did not join them here for another five years. They are an energetic duo who run a very popular restaurant together, with the help of two of their five children. He is sixty-three years old, and she is sixty-one.

Tomas and Elme Bermejo

"Monogamy?" says Tomas. "What is that? One woman all your life? I don't believe in it. It's not natural. I tell my wife, 'How you like your husband to be? Dummy or smarty? If he's a dummy, he's only going to stay with you, but if he's smarty, he'll go with this one and that one.'"

"But he's supposed to stay just with her," Elme breaks in.

"No," Tomas says. "You see, I'm a Capricorn; I'm never happy with what I have. I tell my wife that if your husband is a dummy he says, 'This house is good enough.' No! He should get the better house. If he's a dummy he gets the ten dollar shoes and says, 'These shoes are good enough.' But if he's a smarty he says, 'I want the Florsheim shoes, the better shoes.' What kind of shoes I want now?"

"Rockport," Elme laughs.

"Rockport!" he shouts. "The same with women. I had relationships with many women, this is natural.

Whoever want me, I go with. But my wife, she never see it."

"I didn't know," explains Elme. "This was during the time that my husband first came here from Mexico, when we were just married. I found out when I came here to be with him and the telephone was ringing all the time, 'Is Tomas there?' Girls! Girls! Girls! Until they finally noticed that *I'm* in the house, then they stopped calling. And then I hear rumors, 'Tommy used to go with this one and that one.' I cared a little bit, but I'm not a person who gets angry forever. The past is the past, and he's not doing it now."

"I only stop doing it when I sleep," smiles Tomas.

"We don't know, right?" laughs Elme. "So I pray a lot. I pray for my peace of mind, and then I feel fine. I think, 'Well, what can I do?' The Mexican guys always have something on the side. The trouble comes when something on the side becomes serious. But sometimes they want to do it because they're far away from home

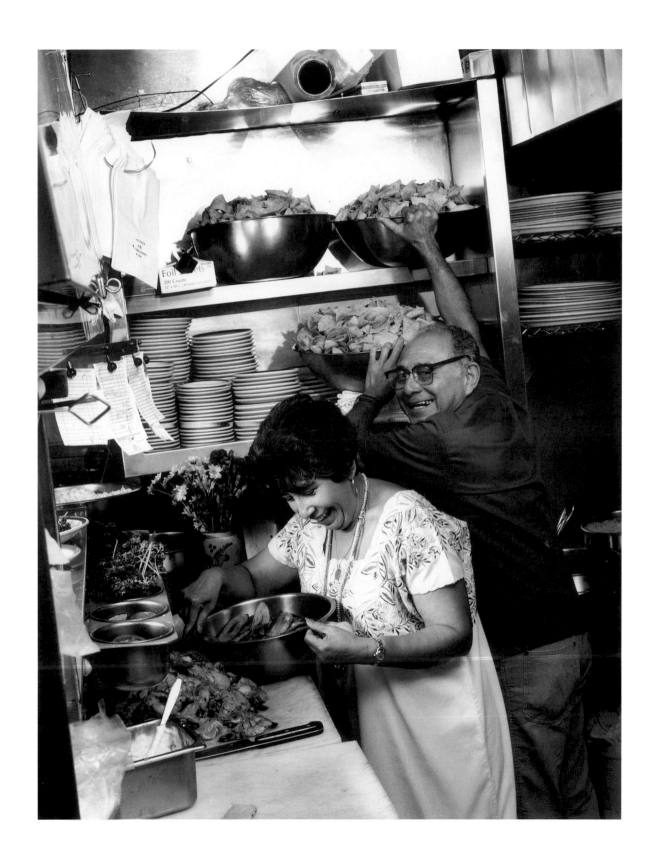

and it's just for today. And then it's like nothing, you forget it."

"When I married my wife, I think it is forever," says Tomas.

"We always think that," says Elme, "forever."

"But then I see the nice girls and I like them," he explains.

"And *they* like him," Elme laughs.

"And then I lie to them," he laughs. "I tell them whatever comes into my head."

"Now it's a little more calmed down," Elme explains with a smile. "But we had a business in Mexico in 1979, a hotel and a restaurant, and he used to go back and forth. He spent more time there than here. And it was a problem because my mother-in-law—she used to call me Elmita—'Elmita,' she'd say, 'don't let Tomasito come alone.' 'Why?' I said. 'He's there, he's happy, I'm here, I'm happy.' Until I found out that he liked to take the girls out. Party every day. At first I just mentioned it easy to him; but then somebody wrote a love letter, and I got this letter and *then* I got mad."

"And then all the women know," laughs Tomas.

"But when I get mad, he just leaves," she laughs. "But like I say, with me, time passes, and then I forget all about it. But he knew I was mad, and he stopped a little bit, and now we go *together* to Yucatan and on other trips."

"You know," Tomas explains, "if you take life too seriously you make it too difficult."

"You have to see if it's a good reason to finish a marriage," explains Elme. "For him, it's just a fling, so I thought, 'Why finish a thing of so many years for one little thing?' Myself, I would never, never have an affair, because when you get married you have to be faithful. When I was younger, people suggested things to me; but if you put a stop to it, nobody bothers you. But if I had a fling Tomas would say, 'Divorce! Right away!'"

"Well, I don't know what I would do," says Tomas,

"but I do something. It is okay for the man, but not okay for the woman. This is what I believe."

"And I believe in the prayers," smiles Elme. "They help me through this very much."

"This thing with young people living together," Tomas smiles, "this could be my life, but I couldn't do it because it's too late for me."

"Oh!" laughs Elme, "he'd have three or four different places to live."

"I would let the girls pay for the apartment," he jokes, "and when they start to say, 'I need some money, I'm short for paying for the apartment and we are living together,' then I leave and not come back. When they start complaining, I get another one, because I can't buy everything like I buy for my wife. You can't make the house nice for everybody."

"He says, 'I only do this for you,'" says Elme, "'only for you I do that.' He does everything for me—this beautiful house, vacations. It's funny, my brother-in-law and his wife live in Mexico, and they come here sometimes. The wife is a schoolteacher and she makes money, but she is under his thumb. He makes all of the decisions, and she cannot move without asking him. When she comes to visit I say, 'Let's go to the store, we'll do some shopping.' And she says, 'No! I didn't tell my husband.' 'We're just going to the store,' I say, 'we can phone him.' 'No!' she says, 'I can't go.' She didn't go with me because she has to ask permission. Can you imagine? I never have to ask Tommy. I say, 'Tommy, I'm going to the store.'"

"She's getting more liberated," smiles Tomas.

"But I still think we have a traditional Hispanic relationship," says Elme. "In the days we were married the man was the boss, and you have to do what he says. We started that way, but now I can say my opinion. Maybe it's not fifty-fifty, but it's changing. He still makes the decisions, but I can say I don't like it; and sometimes we can change it."

"I tell her," explains Tomas, "'if you want to direct

the house, direct the house. Just don't give me no problems.' But we go for vacation soon—Venezuela, Caracas, Colombia, many places—and I organize everything. I make all these decisions."

"Well, he tells me where he wants to go," says Elme, "sometimes I don't like his ideas so much. I need to think about things first before I decide, but Tommy wants to decide everything fast. But it's amazing, because he is usually right. Even my children will say, 'My God, daddy is always right.' In the beginning I might not agree with him and I say, 'Oh, it's going to be terrible, it's not going to work,' but it always does, beautifully."

"This is why we never fight," he says. "I don't like to fight. I have a temper and I talk hard, but I don't like to fight."

"Fight means hit or something?" asks Elme. "Oh, he talks, talks, talks, and I let him talk. Then he calms down."

"It's because I'm the Capricorn," he explains. "When I want something, I want it fast; and I want it done correctly because I'm an impatient person. I bother the people around me because I know too many things. I didn't go to school in Mexico, but I understand everything. I come to the United States in 1953 and I pick tomatoes, lettuce, and oranges. Then in 1960 I worked in Mountain View washing dishes. But I could also cook, so I got my cooking certification. Then I buy a building and make my own restaurant. I also got my legal residency. This all takes very hard work and a lot of energy."

"Oh!" says Elme, "you see him now, imagine thirty years ago! But I'm the Libra, the calm, slow one. I try to avoid all big fights and explosions. And when I don't like something, I have to wait for the right time to bring it up to him. I get a little nervous, but the thing that helps me most is my prayers, and then I feel okay."

"With the fighting," explains Tomas, "if one person doesn't want to fight, the fight isn't going to be com-

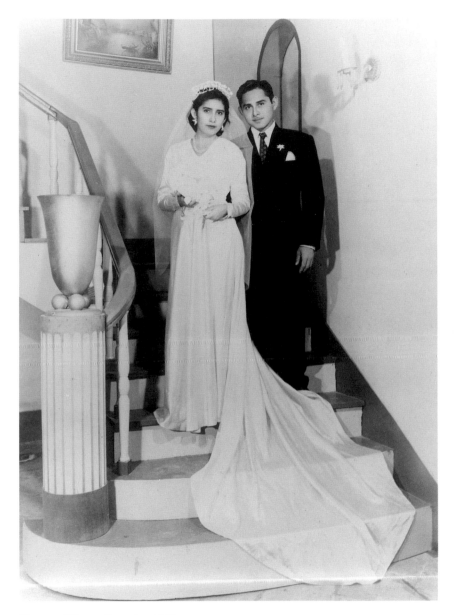

Elme and Tomas Bermejo, 1953.

pleted, because there is no one to fight with. I am not the fighter, I just like to do things a certain way."

"But when he wants to do something," Elme interrupts, "he gets a little angry."

"Like now," he explains. "She goes to the store and buys all these things for the house. Well, I'm going to rent a big garbage bin and put all the junk inside it. Twenty years of things that she bought, and we're going to throw it all away and make the house nice and empty."

"I like to keep things," Elme smiles shyly.

"I don't like that," says Tomas adamantly.

"So now he says he'll throw it away," she says, "but if I don't see him do it, well then it's okay."

"The important thing is that my wife is a very nice person who understands me," says Tomas. "She knows that we have problems here and there, but we solve them together. I believe If you don't get along with your husband or your wife, you have to think about divorce. The Catholic church says no, but I'm not going to agree with the Catholics. I have to make my own decisions."

"I don't believe in divorce myself," says Elme. "Married in the Catholic church is forever. However, if someone is beating you, then maybe you should consider it. In Mexico I have a cousin who died because of the beating. They used to say, 'This is your cross and you have to take it,' but all that is changing now. You can have a good marriage if you are understanding and work together."

"You must save money," says Tomas, "and you must enjoy life. But you can have a lot of money and still not enjoy life. They might give you a nice filet mignon to eat; but if they say, 'Come on, damn it, eat it!' you will not enjoy it. But if you give me a cup of boiled beans and a tortilla and I eat it with pleasure and love, I will appreciate boiled beans."

"My husband is a very hardworking, very nice man," says Elme. "Not easy sometimes, but inside he has a very good heart."

Leslie and Mort Gerson were married for thirteen years, separated for a year, moved back together for six years while their divorce became final, and then remarried. Their second marriage has lasted eighteen beautiful years. Mort, sixty-two, is a lawyer; and Leslie, fifty-nine, is a retired landscape designer. They have three children.

Leslie and Mort Gerson

"Let's see," says Leslie, "we were originally married on June 1, 1958. We separated in 1970, reconciled in 1971, and remarried in 1977. All told, excluding the separation and the divorce, Mort and I have been together a total of thirty-eight years."

"We were actually living together before, during, and after the divorce," Mort says for clarification.

"You know, I thought I was going to marry Mort," says Leslie. "We'd have a beautiful life together, everything was going to be easy, we'd have kids, and walk off into the sunset; but it didn't exactly happen that way."

"We met at a New Year's Eve party in 1956," explains Mort. "We were with different dates. At the stroke of midnight I spotted Leslie, went over, grabbed her, and tried to kiss her; and she pushed me down to the floor."

"My date was standing right there!" says Leslie, wide-eyed. "I thought Mort was crude, crass, and presumptive."

"I was so crude, crass, and presumptive," insists Mort, "that she proceeded to have a friend of mine approach me to see if I'd like to take her out."

"I don't remember what happened next," says Leslie, "except that his crude, crass, presumptive behavior continued after I asked him to my sorority formal. It was in this ritzy place in Beverly Hills, and he proceeded to do the bumps and grinds on the dance floor, which I found offensive and provocative."

"Hey, I was having a good time," he laughs.

"He was definitely a free spirit and very different in those days," Leslie smiles. "I think it was a love-hate thing with us. He went out of his way to antagonize me, which I found oddly compelling. I was also very attracted to him physically, because he was athletic and outdoorsy.

"Anyway, I was hooked, but I wasn't like the Generation X of today, analyzing and saying, 'I want someone with the same spiritual, moral, and political values.'

And yet looking back, I subconsciously knew what I needed. Mort was very genuine, honest, and emotionally stable. Plus, he did great bumps and grinds."

"We had a lot of fun," remembers Mort. "Leslie was game for just about anything."

"I was fun-loving," she says. "Trouble was, I didn't have a clue as to what raising children was about, and so much happened during our first year together: we got married, I got pregnant, Mort passed the bar, and our son David came along. That's when things really started changing—reality set in."

"It was an adventure," laughs Mort, "everything was moving so fast. We were rolling with the punches and very much in love. It was a great period in my life."

"But I had absolutely no experience with babies," Leslie continues. "When David was plunked down on my hospital bed, I freaked. I didn't know that you're supposed to burp a baby, so he proceeded to vomit all over me; and we were off to the races. He was the apple of my eye, but he was a colicky baby; it was very frustrating. Mort was so into his work that I had the whole responsibility of child rearing, and I felt very alone. I think our marriage problems started that first year, but I kept rationalizing it as the years went on, even after our second son, Robert, was born, saying, 'This is what marriage is like. Daddy goes off to work and mommy stays home with the kids.'"

"It all came to a head after our daughter Joanne was born," says Mort, "when the two boys were seven and ten. Leslie would call me at my office, complaining and asking me to come home. I was pretty authoritarian in those days; having a wife and children had made me more serious. I knew what it took to work and provide for us, and I probably spoke sternly to Leslie about the fact that there were certain demands that I had to meet."

"That was right before our breakup," remembers Leslie. "During the first ten years of the marriage I had

tried to be vocal about what was going on with me, but I was still extremely frustrated and resentful. I remember wanting to go to a marriage counselor, but Mort would say, 'You're the one who's unhappy, you go, I'm not having a problem.' That created a lot of distance for us."

"I was not tuned into Leslie in those days," says Mort. "I think our breakup had to do with a lack of empathy on my part."

"I think it was a lack of willingness to open up and share an emotional closeness with me," explains Leslie. "I felt very alone and angry at Mort's inability to hear me on an emotional level and help me cope with the kids and the frustrations. There was a lot of confusion for us, and total unpreparedness for family life. After thirteen years of marriage, I moved out with Joanne, and David and Robert stayed with Mort. It was a terrible time for all of us."

"I was miserable," says Mort.

"It wasn't what we wanted," explains Leslie, "but we had to do it in order to get to where we are now. I wanted a man I could really communicate with, who would listen and understand and whom I wouldn't feel ashamed to say anything to, and Mort didn't get that."

"I was very confused about what Leslie wanted from me in terms of an emotional relationship," he explains. "I went through a terrible time trying to understand the difference between feelings and things that are objective. You know, when I was a boy I'd never lived with a woman except for short periods when my father had been married, but nothing to really grasp onto. A young man who had grown up with a mother would have some idea as to the differences between men and women, but I had none. This caused me a lot of problems in our first marriage."

"God, it was really weird being apart," remembers Leslie. "I was so confused. I didn't want to be married to him, but I didn't want him out of my life. Here we'd had thirteen years of marriage, and suddenly we were

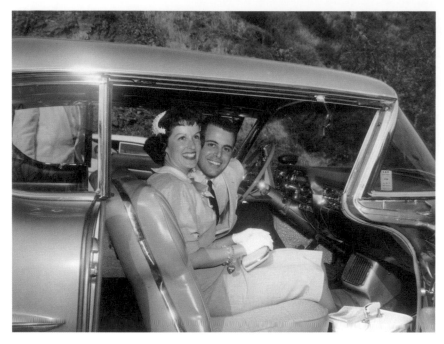

Leslie and Mort Gerson, 1958.

Monday morning I brought the boys back to Mort's house after a visit with me. The housekeeper answered the door and said, 'Sshhh, señorita sleeping,' and I lost it."

"I think our separation was probably more valuable for Leslie than me," says Mort. "I didn't want it in the first place, and the dating game was an experience that wasn't particularly satisfying. I guess if I learned anything, it was just how much I really wanted Leslie back."

"So Mort started making noises about being able to listen to me," says Leslie, "not necessarily to talk to me about *his* feelings, but to listen to mine and accept what I was feeling. At the same time, I was beginning to realize that *most* relationships have problems, and since I had this huge investment, with three kids and a thirteen-year history, it became obvious that this was something I valued. So about a year and a half into the separation, I moved back into the house. Mort really showed what an exceptional man he was; any other man's ego wouldn't have allowed his wife to leave and then move back in, but Mort never gave up on us."

"Six months later, the divorce that Leslie had started came through," says Mort. "By then she didn't want to divorce anymore, but I insisted we should go through with it because I felt that there had to be some kind of finality to what we had started. For me, it was a formality and not that painful."

"Well, it was for me," says Leslie. "I cried on the way to the court to get the interlocutory degree. My lawyer looked at me and said, 'Why are you crying?' and I said, 'I don't know.'"

"After our divorce, I realized I'd better tune in if I wanted to have a marriage," says Mort, "and I made a commitment to take a better look at who Leslie was and what was happening. Our serious changes came about very gradually, over a long time. But that first year back together was tough. And later on, it was rough having

living totally separate lives. I was dating other people, and Mort was doing a lot of…"

"It might be more discreet to say that in the seventies I was able to live the life of the sixties, but it was not that satisfying," Mort instructs.

"Prior to our divorce," says Leslie, "I had this fantasy of wanting Mort to share with me, of him being emotionally available and less logical and analytical. It became apparent during our year apart that these last two qualities actually meant a lot to me, because I'd become involved with a man who was very emotional; but I found that I never knew where he was coming from. I realized that Mort had all the qualities that balanced us as a couple and that I needed a husband and a father for our children. Then when I started hearing about this woman whom Mort was spending a lot of time with, I realized how much I still loved him, despite what we had been through. The clincher was the

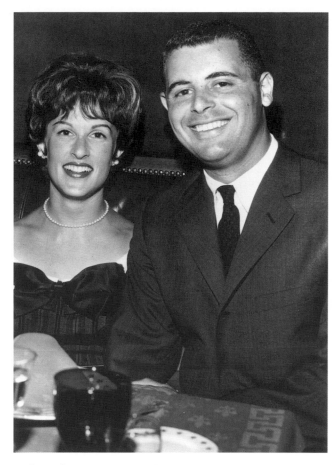

Leslie and Mort Gerson, 1961.

two teenagers in addition to dealing with the process we were going through."

"The roughest time in our lives was ahead of us," says Leslie. "We had serious problems with David and Robert. It was the late seventies and it was sex, drugs, and rock and roll."

"Life is not for amateurs," says Mort, shaking his head.

"But you know, I liked being divorced and living together," says Leslie. "It felt different to me. We were very careful with each other and worked on our relationship when we weren't married, and I was afraid that

if we remarried things would go back to the way they had been, so I sort of milked it for as long as I could. I went back to school, got a degree in sociology, and began a certificate in the landscape design program. I worked in this career for twelve years; I needed to feel independent and have my own income. In 1977 we remarried because it finally felt right."

"I think since we've been back together," says Mort, "we've both moved toward the middle and can appreciate the other person's position. This is something that we had to learn."

"Mort became more emotionally available," says Leslie, "and more able to listen to me. Now I can call him at the office and say, 'I really need to talk to you,' and he's learned, through sad experience, that he'd better drop what he's doing because my call is important and he needs to listen to me. By the same token, I've learned to appreciate his analytical nature, which balances my tendency to be impulsive.

"Even with today's generation I hear so many people say, 'Well I thought marrying him would change him,' or, 'I thought he would change if I loved him.' With all the psychology and all the knowledge available, people still want to believe that something magic happens when you marry and that everything will be wonderful. That was me thirty-eight years ago. Now I realize that successful relationships are very hard-working, on-going struggles, where people learn to compromise and give and take and give and take. We both realize that marriage is not fifty-fifty, it's seventy-five–seventy-five."

Howard and Cecil Waite have been married for sixty-three years. They live on six wooded acres in a rural, coastal village. They have three daughters, six grandsons, and eleven "Little Greats." Howard was a civil engineer for most of his life, and Cecil was a registered nurse. They have traveled extensively and are still very much involved in various civic affairs. Cecil is eighty-nine and Howard is eighty-eight.

Howard and Cecil Waite

"In spite of the fact that we have been successfully married for sixty-three years," says Howard, "I don't think I was prepared at the time we were married. Cecil and I were the essence of naive. In fact, before I took her out, I had never dated a female in my life—aside from my cousin, who acted as my date on several occasions. I was timid and too broke to have a girlfriend. My parents were separated and there were divorces in my family that had made quite an impression on me. I had decided that I wouldn't get involved in the mess of families splitting up and a husband and wife squabbling. I planned that I would have a house, a lot, and five thousand dollars in the bank before I would even ask a girl out for a soda. That was my plan, though it got changed more than slightly one night.

"It was close to our fourth date, and Cecil and I were driving in the hills above Hollywood. I think I felt obliged, that the sort of thing you were supposed to do on dates was to drive around the hills and put your arm around someone. The overwhelming need in my case that night was to sleep, so to keep from going to sleep at the wheel I'd bite my tongue and slap my face. I thought it would be very embarrassing to drive off the road."

"I had put my head in his lap as we drove along," Cecil continues brightly. "When I looked up at him he was shaking his head and slapping his face, and I thought, 'Why is he doing that?' He did it again and again and I thought, 'That's funny, maybe it's some kind of nervous twitch because he hasn't had any sex.' Then I started to feel guilty because we hadn't had any sex, even though I didn't believe in that; but then I thought, 'Well, hmm?' So I decided that I'd better do something about it. I was projecting that he needed sex, when in fact he was just tired. Nine months later we had our beautiful Nancy."

"It is interesting," adds Howard, "that the misapprehension on both of our parts—her thinking I needed

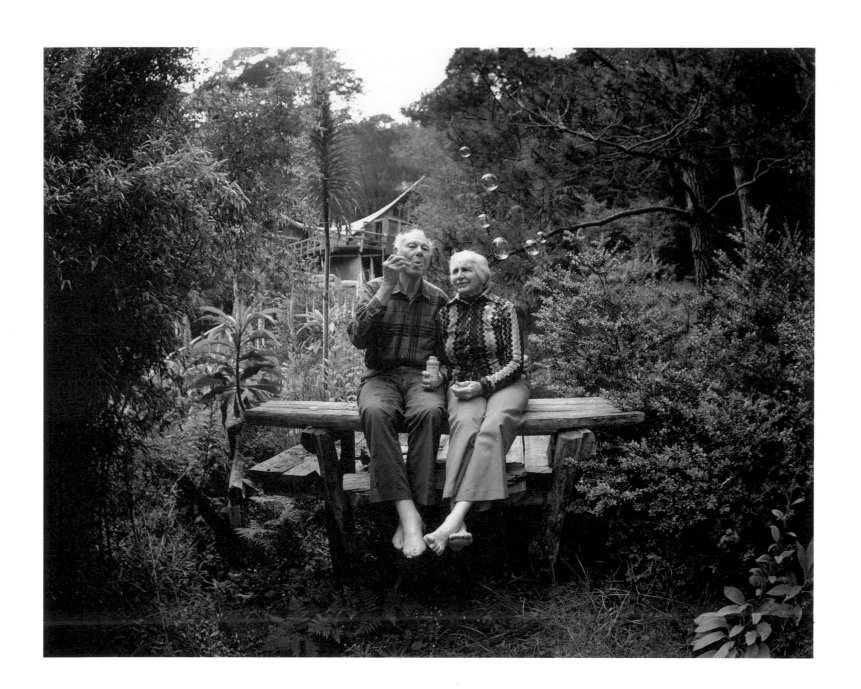

sex and me trying to be a good date and stay awake—resulted in a lifelong commitment."

"In those days, if you found yourself pregnant," says Cecil, "you had to get married, which we did a few weeks later. It was 1932 and premarital sex was a no-no in words, if not in actuality. Hypocrisy was rampant. We were leftovers from the Victorian age when people called a leg a 'limb,' and women didn't sweat, they 'perspired' or 'blushed.' Anyway, getting pregnant, in or out of wedlock, was embarrassing. You didn't talk about it, and you tried to hide it."

"I remember how Cecil told me the news," says Howard. "She came to me and said, 'Well, we're both very healthy; in fact, we're pregnant.' I can't say that I was shocked, but you have to understand where my life was at at that point. I had just been discharged from

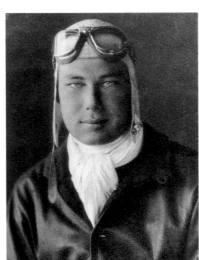

Howard Waite, 1932.

the air force because in a routine check-up they had detected a heart murmur, and they told me that I wouldn't live past forty. My whole world was crumbling. Here I had a masters degree from Cal Tech in aeronautical engineering, and I'd been training to become an army pilot, which was my life goal. So around the time I was dating Cecil, I was walking around psychologically numb because suddenly there was nothing. My life, as I had known it, had ended. Cecil could have told me that California had broken away from the union, and I would have responded the same way that I did when she told me that I was going to be a father. I said, 'Uh huh.' I didn't concern myself with how we would get through it. It was one foot in front of the other."

"It was scary," Cecil admits. "The only one we told was my father, who was very sympathetic. He loved

Howard and he loved me, and he said, 'If you love him, that's the main thing.' So we said we might go to Yuma, Arizona, over the border, to get married. We didn't tell anybody about it—I mean, I hadn't completely digested the idea myself, but it was something that we needed to do. I had to take a long time to make peace with myself that this was actually happening. I had always anticipated having children, but not like this.

"Driving to Yuma," she continues, "I was one-quarter thrilled, and three-quarters intimidated by the awesomeness of life, by the idea that things turned out that way. I loved Howard and I knew that we were going to make a wonderful couple, I just didn't expect things to start off like that. I was taught to make the most of things, and that's what I did, living from moment to moment. When we got to Yuma we were married by a justice of the peace. I have to say our honeymoon night was exciting, but not as I would have ordered it."

"Yuma was a place that didn't require advance notice, and it took only two hours to get there," explains Howard. "There was a certain judge who used to marry people by the trainload. They'd all step out of the train and the judge would come out and say, 'Do you all want to marry?' And they'd all say yes in unison, and he'd marry them in a great big group, just like that.

"So we went to this judge's house, and he came out in a housecoat and we handed him the application we'd filled out in the clerk's office. Then he asked us to stand in a position in his living room that enabled his son and his wife to view us from their open doorways and to witness our marriage. And that's how we were married."

"Thinking back, I can't say that I actually felt I knew Howard well," says Cecil. "But I knew him well enough to feel that what I didn't know about him was okay, because I perceived that he had an ability to grow. He cared about what was right, and I could see that. Thank goodness we both had a sense that we could weather this; in some ways it brought us closer. But

don't ever get a new husband and a pregnancy at the same time! It's very difficult! You have to get acquainted with your own body changes and with the new personality that you have chosen to be your life-mate, and you have to get along and work on so many things that we didn't know how to work on. The disagreements, the conflicts, they would add up to so much, but we had our deep love and this carried us through."

"We had troubles," Howard says, "but divorce was never on my mind. I knew that if I was married, I was going to stay married. I was impressed with the problems of marriage, yet we were in the depths of the Great Depression, so there were problems everywhere. I don't remember making the distinction between the problems of being married and the problems of just living. I knew bachelors who were having a rough time. I had no work whatsoever, but we lived on the property of close friends. We fed their chickens and milked their cow, in return we got free milk and wheat, which we separated from the chicken feed. I sold my slide rule when I needed cash and sold my father's gold railroad watch for two dollars."

"We had lots of disagreements in those early days," adds Cecil. "Here I was, getting used to being pregnant and having babies, and we didn't have any money and didn't know how to cope with all of that. In those days I was ignorant about sex, so I'd withhold it when I was upset. Sadly, I learned only decades later that this was wrong because sex is as important for men as eating. We were naive and completely perplexed as to how we should act.

"About twenty-five years ago," she continues, "we joined a wonderful consciousness-raising group, and this made our marriage easier. One thing I realized was that nobody does anything *to* me. I do things *to myself*. It's the way I react to the things that I need to look at. It's so easy to blame the other person. Sometimes he still drives me up the wall, but we don't mind 'going at it'

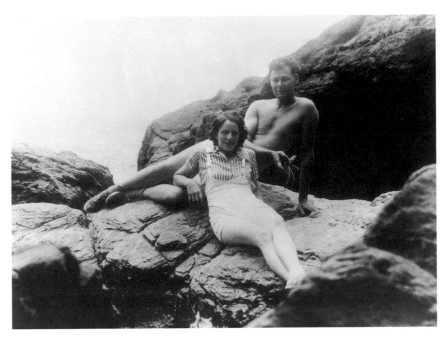

Cecil and Howard Waite, 1934.

once in a while; we know we're not going to end up in divorce court. There have been times that I have wanted to walk out on him, and I've said things like, 'If you do that again, I'm going to get in the car and go someplace, and you won't know where I am!' It's a way for me to try and make an impact, but somehow we always work it out."

"It's amazing," adds Howard, "we laugh about how we can use the same language, and even the same words, but have completely different meanings, and sometimes it takes quite a while to realize that we are actually talking about two different things. One of the things I'm sure we have is good will between us. No matter how much misunderstanding or how much anguish is caused, what's the bottom line? What's the intent? Is there a goodwill intent or is it an intent to be evil?"

"I did learn a surefire way to break a deadlock between us when things get tight," Cecil confides. "If I

start tickling him above the knee, he starts giggling uncontrollably, like a girl, and starts screaming, 'No, no, no, no!' He's so cute—he can't catch his breath, and he tries to push my arm away but can't because I have a very strong arm. Honestly and truly, we'll have this sparring match, and then everything has shifted. It's a loving thing that erases all problems.

"Our relationship has always been very open," she explains. "We always talk about whatever feelings we have—about other people and so forth."

"Probably the best example of how we really get along was regarding our sexual situation," says Howard. "It was some years after we were married that I had a friend named Lucille, and we became quite fond of each other. And Cecil had a friend named Earl. On one occasion Cecil drove me to Lucille's house, then she went on to Earl's place; later she came back and picked me up, and we went home. After that there were other do-your-own-thing relationships. One main relationship that Cecil had was with the children's dancing teacher, a man who looked like Rudolf Valentino."

"It all started when Howard was getting ready to go on a trip," Cecil continues, "and I said, 'You're going to be gone for a while, so if you want to find some sweet, redheaded, young thing, it's all right with me.' So he did and told me about Kathleen afterwards. I felt okay and surprisingly unthreatened. A few weeks after his return Kathleen phoned, and I was so nice to her she freaked out and hung up. She never called again!

"One time Howard asked if I wanted a divorce, and I said, 'Heavens no!' So we've never had any really intense feelings about separating; it's just that feeling of wanting to have adventures and try things."

"It's unusual, we know that," says Howard. "I think it's a matter of taking in the total awareness of what's really real. In this situation it's a case of human frailties, yearnings, pleasures, and desires. But it makes life worthwhile to be honest and admit the reality of the human psyche, that having sex is fun, that we're attracted to other people. We didn't believe in injuring the other, so we said what we were going to do and what we had done. It's essential to be honest about it. The situation was solely based on mutual respect, admiration, and integrity.

"Over the years our marriage has definitely changed," he explains, "And there are a lot of words that one could use to describe the change—mature, improved. It's resulted in making life much more worthwhile. It's been a marvelous challenge, a difficult challenge, a happy challenge. It's been a fantastic opportunity for growth."

"It's hard to see in him very much of the cute boy I married," says Cecil. "He's more lovable, in a way, because I understand him better. Often we hold hands, and I love it because we're almost ninety years old. I mean, how can we be almost ninety when one's not supposed to think straight at ninety!"

John Burnside and Harry Hay have been together for thirty-two years. They met while working at the Mattachine Society, the first gay organization in the country, which Harry created in 1952. In 1979 they organized the Radical Faeries, a group of men who come together for strength and healing through love. Harry is eighty-two and John is seventy-seven. They live in a tiny apartment filled with books and continue to hold workshops around gay consciousness.

John Burnside and Harry Hay

"Harry is the Duchess and I'm Mighty Mouse, and this is the way we characterize ourselves, " John laughs. "He was given the name Duchess in the theater when he was a young man, but he has this quality about him. When he was two years old he was standing at the top of the stairs all dressed up. His nanny was about to take him out, and he said, 'No, I won't go. Where are my gloves? I've got to have my gloves.'"

"Yes, John," says a droll Harry, "I have always said that queens can be raised to their highest states by marriage, but duchesses are born."

"And I'm Mighty Mouse," John smiles, "because I have a very mechanical bent. I love to do things and fuss about. Harry's commitments in life are more toward being with people and working out plans around gay consciousness, and here is Mighty Mouse trudging along taking care of the mechanical part."

"John and I met in 1963," explains Harry. "I had established the Mattachine Society, the first gay organi-zation in the country, and we set up a little magazine called *One Magazine* and a series of classes that became known as the One Institute of Homophile Studies. I was at the institute one afternoon talking to the head of the institute about starting a gay square-dance group, and suddenly I hear this cascade of silvery laughter coming from across the hall; it was just beautiful. The fellow I'm talking to says that John is one of our latest finds and he's a very important part of our group there. He said, 'Tonight we're putting out a newsletter,' and why didn't I stay and meet him? So that's exactly what I did, kind of checked him out.

"So I sat next to him that night and, oh, he wore terrible clothes and had an awful haircut—a typical hetero businessman. This was a period when we all did that; everybody was sort of buttoned up and tied down, so you had to learn to read between the cracks in the uniforms we all wore. Well, he had this lovely laughter and a beautiful face behind the mask. But more

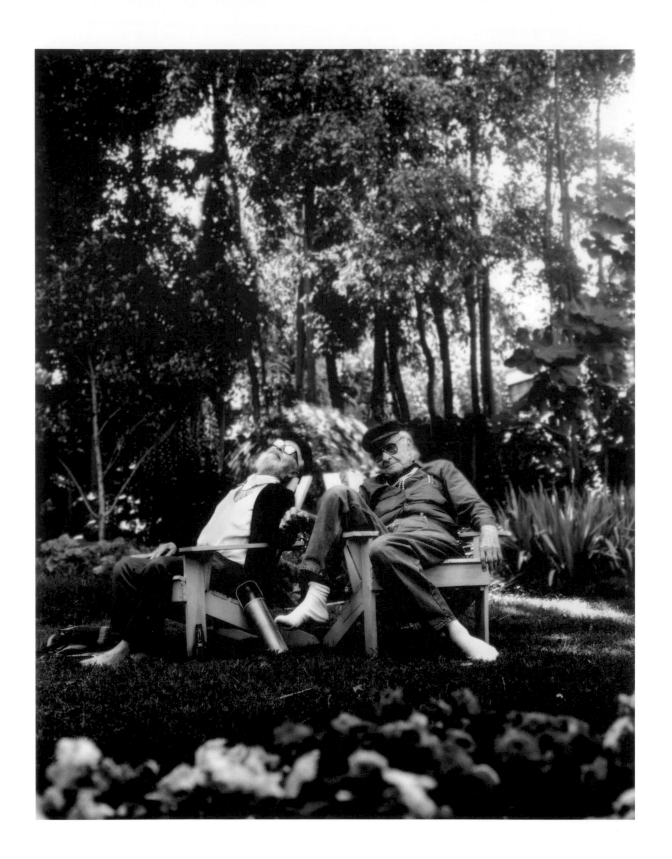

important, he was close to my age; I was fifty-one at the time, and he was forty-seven. I'd been married for thirteen and a half years and divorced for eleven years by then, but he had been a hetero married man and was still a hetero married man. I was the other woman for the next three years. We had a lot in common. We'd been through hetero experiences, we were both ex-Catholics, we'd been trade organizers, and we were both into radical politics.

"This was on a Friday, and John said that he'd be there the next day, building a stage for a performance, and would I like to come by and work?

"So I go home and go through all my clothes and I finally find this perfectly beautiful, yellow Angora sweater, one with the long hair. It was a little tight, but I managed to struggle into it, along with a pair of pants that were fairly well fitting.

"I go in the next day, and John is working like crazy on this stage in a perfectly gorgeous little two piece—bright red shorts and top, which you don't exactly work in for carpentry. We're both being terribly indifferent to one another, and of course these costumes had nothing to do with being carpenters on a dirty old stage. You have to realize that we're playing a hetero-imitative game here. I mean, after all, he's the young cute one—well, he would be after I worked on him a little bit. I was going to have to get his hair longer, and then we would cut it into a Roman style—which was what everybody was doing then. And he had no sense of color, so I was going to have to tailor him. But I thought I should be very subtle because he's not going to put up with that."

"Well, I thought Harry was a very wonderful person in every way," explains John, "and I wanted to form a gay relationship and know what it was to live together. I was very eager to be transformed, because by this time I had shifted my point of view completely away from being a man and was now exploring life with a freedom that we have as gay men. We consider ourselves not to be men because the man has a certain restrictive pattern. To be gay means to be exempt from that and to do what you like. So I wanted to explore that world and I was flattered to be better looking—everyone wants to look nice. Harry had the key to this; he had a background in theater and design."

"And don't forget," Harry adds, "men have a tendency, when they fall in love, to be romantic immediately."

"Which was beautiful," recalls John. "Harry wrote me beautiful poetry and sent me flowers. It was rather clear that the obvious thing was that we would form a deep attachment, and it began with our discovery that, as we embraced, there was a strong electrical current between us. It was a physical thing and a metaphor for the deep spiritual connection that to this very day we enjoy in each other's presence. It seems to be very healing.

"Of course, when Harry and I began, we ran into friction. I would be the one who wanted to be perfectly reasonable, and Harry would storm out. And when he was gone, both of us would be miserable. But Harry would be back again, and over the years we have learned that friction is an important aspect to a couple's existence. It's a truism to say that sex is always better after a quarrel, but it goes deeper than that. My feeling is that if you are in love with someone, that person, to be lovable, must also be a good fighter. You wouldn't love a wimp, you know. You want the feel of the bite, the fierceness of the other being and yourself; and that need is what generates the quarrel. Now if you're wise, and we both were by this time, you mustn't turn the knife. You can shout your head off and complain about everything, but don't do the thing that the other can't accept."

"Well, John knows that I'm the Mount Vesuvius type," admits Harry. "When I blow my top, the moment the heat is off and the pressure's gone, I'm sorry and worry whether I hit somebody down there and want to go down and fix it immediately."

done. I said, 'For heavens sake, it didn't matter that much to me.' Because I know him as a fiery person, I can say, 'Oh, he needs rest.' Now with Harry, he has what he calls his principles, and his principles are very important to him. If they seem to be treaded upon, well, up goes the fighting flag. I recognize that and also know that he will come back to a harmonious relationship with me. But something that has helped is a saying that I heard many years ago which went, 'Nothing in life is all that damned important.' And that's assisted me in letting go of the little trifles that become magnified and getting back to the relationship.

"We relate in a subject-subject relationship, which is something that Harry teaches to many of us in the Radical Faeries. In a subject-object relationship one person will say, 'Well I'm going to get all that I can out of him.' But to the degree that this is present in a relationship, then love is impossible, because if I'm acting that way toward Harry, only trying to get what I want, then I'm there by myself, me and this object. So the real union occurs when I see Harry as another subject. If I'm the subject in my life, then Harry is too; and so I get over on his side as soon as I can. It is one of the many beautiful things that Harry has taught me."

"This is what John and I have been doing for twenty years," says Harry, "holding workshops and talking about our experiences as gay people together. The gay movement is reinventing a language for itself. Hetero language and psychology never did a damn thing for us.

"You know, when John and I came together there was no pattern for study," he continues. "And there were grim predictions for the aging homosexual. You know, sitting at the bar, unattractive and yearning for the young. We found that there was a tremendous life that opened up for us and unfolded away from that fate."

"Harry says that loving is giving the other person room in which to grow," explains John. "It entered our lives in this way: when we came together we had a very

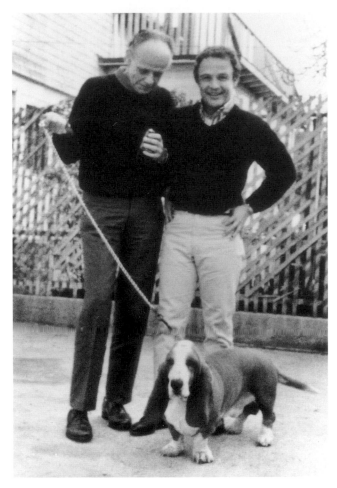

Harry Hay and John Burnside with a friend's dog, 1966.

"Because I'm conscious of this," John explains, "if Harry does say something that's intended to hurt me, I just say, 'Don't be ridiculous.' Just the other day we were having a discussion, and Harry got so exasperated with me because I wouldn't grasp a point he was making. He finally said, 'You're so stupid,' and so I went off and left. Well, Harry brooded over my leaving the whole day, he was so dejected. This morning we got together, and he told me that he was feeling horrible about what he had

immediate sexual response, but with age you lose the capacity to become erect. Usually when this happens, couples have a tendency to split and search for a younger person who restimulates this sexual impulse. But since we both hit this place at the same time, we saw it as a wonderful opportunity for understanding and supporting each other. So we stayed together, and back came the powers of capacity in a new form. We still engage in regular sex, but there's no pressing need; instead, the sexual vitality connects us in a day-to-day way. We can be sitting across the breakfast table and just look at one another and say, 'Isn't this wonderful?'

"When I was a child," John continues, "I was lucky enough to have access to older people. Typical of the little gay faerie, instead of throwing balls back and forth with the other boys, I was finding out what the girls and the old folks were doing; and I ran into a lot of unclaimed love there. Old people's visages, the wrinkles and the different qualities, have become very dear to me. As Harry has aged before my very eyes, he has not become an ugliness; he has moved rather into positions of beauty and humor. I think that old age is very funny, and I enjoy the comical aspects of it in both of us. Old people have a tendency to have funny little habits that they've never examined. They fuss about silly things, they can't think of words; and I see these things as comical. I don't resent these things."

"It's always been spark, spark, spark between John and me," says Harry. "When we moved in together, we'd come home from our different jobs on Friday afternoon and sit down at the table, and on Monday morning we'd get up to go. We'd be in a constant dialogue the entire time, and it hasn't changed so much since then."

Harry Hay, 1968.

John Burnside, 1968.

Norm and Fran Grant have been married for fifty-five years. Norm, eighty-six, was in the navy and then worked for the government for many years. Fran, eighty, is an independent pilot who cofounded Fear of Flying, a school for people who are afraid to fly. She still flies small planes today. Norm has a tendency to grumble a little bit, but Fran is always there to give a good, loving poke. They have two children, three grandchildren, and two great-grandchildren.

Norm and Fran Grant

"Were you a virgin when you married me?" Fran cocks her head towards her husband, Norm.

"Ha!" he laughs. "Certainly."

"Now in today's world you wonder how that could happen," says Fran, "but a Catholic like myself could avoid sex if she practiced her religion. And that, along with Norm's Scotch stubbornness…"

"Stubbornness!" he shouts. "Ha!"

"Now I was the weaker of the two with this sex stuff," she says. "I would just as soon have gone ahead and said, 'To hell with it; let's have some sex.' But he was more considerate of me and what might happen, and he was strong enough to help us through the six years that we dated before we married.

"I think we'd have gotten married earlier, but our families were creating some problems for us. Even though my side was a very freewheeling, Irish, open-hearted, loving group, my mother couldn't see me marrying anyone who wasn't Catholic—although my father

wasn't. Totally idiotic. And Norm's background is Scotch and English—very tight-lipped, with many things that you did not discuss. His mom didn't think I was good enough for him, and she and I never did become friends, though we tried very hard and I endured many Sunday night dinners at their place. She was a rotten cook, too—not that I was much better."

"Well, it wasn't Fran," explains Norm. "My mother would have felt that way about anybody. No one was good enough for her boy."

"So we ended up getting married secretly in Reno," laughs Fran. "We continued to live with our own families, and nine months later we told them. My family reacted just great; but his mother, well, she spent a couple of days in bed after that.

"When we started living together," she continues, "our marriage got a lot stronger because we started to get acquainted better. Sure we were different, we still are. We each have different ways of doing things;

Fran and Norm Grant, 1940.

Norm's still Norm, and I'm still Fran. But we blend together. I'd say that Norm is more the scientist, working in the background, whereas I'm a person who likes to talk. He would be very comfortable just sitting, holding my hand, and not saying a word. And then, of course, I'm nuts for flying small airplanes, and Norm would just as soon stay home and read a book. Right, honey?"

"This is true," says Norm, "so we just let each other be. There are always things that you'd like to change about the other person, but you just can't do that."

"I remember the first time I ever took Norm up in a plane," smiles Fran. "It was the day I got my license, in 1940, the same year we got married. I was twenty-five years old and I'd learned to fly a J-3 Cub in six weeks. Right after I took my check ride with my boss, he said, 'Well, let's go ask the old man if he wants to come fly

with you.' So Norm got in the plane, and as we were getting ready to take off, I said, 'Now Norm, don't put your feet on those pedals (which acted as turn indicators). I was lumbering down the runway and having these problems, and I said, 'For god's sake, take your feet off the pedals!' He lifted his knees up just as I was headed straight for the tower at the Oakland Airport; luckily we missed it."

"It was great fun," he remembers. "I wasn't scared, I had a lot of confidence in her; and if she didn't have it at the time, why, my having it was enough to make her have it."

"I'd wanted to fly ever since I was small," remembers Fran. "I'd wanted to be a bird because there's something very peaceful, very symbolic about being able to get in a plane all by yourself—get up so high and talk out loud about your worries and your woes. It's very therapeutic. Norm always supported me, even though he never really cared to fly."

"Well, this was Fran's thing," he insists. "That's just what she does. But I was in the navy for four years; and although I wasn't a pilot, I flew all the time. I just never cared for all that turbulence."

"He's a great navigator, though," says Fran, "but the kids and I always knew when he had to fly because he'd be so grumpy and silent when he came home. I think this lack of love for flying all started at the end of the war, when Norm was flying in the South Pacific with a crew of five and their plane went down and was totally demolished. The guys had little or no injuries, but a few months later another plane he was in went down. Same thing.

"I didn't know about these crashes until some time after they happened," she continues. "I think they had a big impact on him. Since Norm's job with the government was pretty hush-hush—he never did talk about the crashes—and I think keeping it in made things worse for him. I was worried about him, but my mom

kept telling me, 'Look, he's here, he's okay. Put it out of your mind.' Anyway, since Norm's work with the navy would take him away for seventy-two hours or more sometimes, just to keep from getting worried I took my loneliness out by working with the navy myself.

"After the war I continued to fly, and Norm always supported me. I did a lot of weekend flying, and Norm and my mother were great keepers of the kids. We had an aviation map in our breakfast nook; I'd call the kids when I was away to tell them where I'd flown to, and they'd find it on the map. They knew a lot more geography than the average kid. But I missed Norm; I would have loved to do more flying with him, but I understood. I never fought him on it, though we did argue about other things. He never abused me though."

"Ha!" Norm shouts. "Never!"

"We never exchanged blows," she adds. "Sure, Norm's got some little habits that I would just as soon he didn't have, but that's part of being a human being. For instance, he doesn't like change. To get him to change the way he does something is very hard, but we always find a way through it. When I was working up at Peninsula Hospital, I'd get up to go to work and come bouncing into the kitchen very happy, turn on the TV, and start making breakfast. And here's Norm, grumpy and just wanting to be left alone to read the paper. He liked his routine of getting up early and being in the kitchen. One day he said to me, 'Here's the sports section. Go back to bed and I'll bring you breakfast.' So he's been bringing me breakfast now for twenty-five years."

"It gets her out of my hair," Norm laughs.

"Isn't he a loving character?" Fran smiles.

"It prevented an awful lot of battles," he continues, "but on the other hand, Fran can fly off the handle very easily at things that I would completely ignore."

"Like when he doesn't put things back where they belong," she says. "This drives me crazy."

Fran and Norm Grant when Norm was a Sea Scout, 1936.

"So when she gets upset, I just shut up and pay no attention to her," he says.

"That's why we don't fight much," she says, "because when he shuts up there's just me. I don't want to fight with me, I want to fight with him; I don't have much of a chance."

"And we have different interests," he says. "If there's something that she's particularly interested in, like something she's reading in the paper and wants to tell

Fran and Norm Grant on their second anniversary, 1942.

me about, I'll half listen and say, 'Yes, yes, yes,' and basically ignore it."

"He just tunes me out," says Fran. "And sometimes that bothers me. But that's all right. What's wrong with that? He's not that interested, so let's go on a different path. I think it's being considerate of one another.

"You know, I do think there's something magic about staying with somebody for so many years; but if you try to identify any one thing, it's really wrong because it takes a number of things to mold a life together. Like communication and romance. Even today, you'll always see us holding hands if we're out somewhere. And communication is so important. It's so easy to misinterpret the other person. If that happens, you have to take time out and talk about it. We've always tried to give and take with each other and tried to understand how the other is feeling.

"I started the Fear of Flying clinic with Norm in mind," she continues. "It got lonely going off on these wonderful flights and not having him with me. So in 1976, when I was sixty-one, a flying buddy of mine, Jeanne McElhatton, and I were in a small plane flying up to Coeur d'Alene, Idaho, while Norm was driving there on the highway below. So Jeanne and I are looking down at the freeway and saying, 'God, that's dangerous. What will happen if Norm gets caught between two trucks?' We started talking about what we were

going to do to help Norm. He'd never said, 'I'm afraid to fly.' He'd say, 'Oh, I don't want to.' I don't think I ever came right out and confronted him either, did I, honey?"

"I don't think you did," he remembers. "I think you kept your mouth shut because you didn't know what the reaction would be."

"Anyway, he was getting close to retirement," Fran continues, "and he'd told me that he wanted to take a freighter to Australia. I said to Jeanne, 'it's twenty-seven days over and twenty-seven days back. I know I could handle it one way, but twice would be a waste of fifty-four days. I'm wondering how I can get him to fly at least one way.' So we started looking at what the problem with this guy was, because he doesn't bear his problems out loud. In fact, he doesn't even really tell me what's going on with him until he has a real handle on it. I knew that every time he was in turbulence he thought the plane was going to crash, and this was such a deep, emotional thing with him that he'd react very quickly. It got to where it was no fun even to have him *say* he'd go flying with me. So that led to the start of the clinic. It's all run by women pilots, and now we have operations in Seattle, Australia, and Portland, Maine."

"I knew that Fran had me in mind when she started the clinic," says Norm. "I figured, 'What the heck, I might as well try it.' I wasn't scared when we took our first flight because there was so much in the course that was routine for me in the navy, and I ended up helping a lot of other people. I didn't have a chance to think about my fears."

"We were so proud of Norm on that first flight with the clinic," remembers Fran, "but we didn't know how he was going to react. Jeanne said, 'I can't look at him.' And I said, 'I don't want to look at him.' I mean, was he going to jump up and say, 'I can't do this,' or would he start crying, as some men do? So we sat him behind us with one of our pilots, and they got to talking electronics. It was a very easy trip for him. In fact, he became a

member of the board of directors and a role model for all of the classes.

"We'd fly a lot of places together after that, sometimes just to get a bite to eat. There's a restaurant in Napa called Jonesy's that we'd go to, and then there's the Harris Ranch on Highway 5 that we flew to a lot."

"Last time I checked," he says, "I'd flown about 235,000 miles."

"And I've done about three thousand hours of personal flying," says Fran. "Unfortunately, we don't fly so much these days because Norm has prostate cancer, and I've had three back surgeries; and this sort of decreases a lot of our activities. I'm considered legally disabled, but, you know, it doesn't stop me from flying."

"I'm retired," says Norm, "and my life has changed. A lot of the things I was doing before just don't interest me anymore. Now I'm interested in our Siamese cat 'Sumphun,' my flowers, and taking walks. But getting older doesn't really bother me."

"But he doesn't really want to do anything," insists Fran.

"That's true," he says, "why should I?"

"Well, I'd still like to travel," she says. "I'd like to go to Asia and to South America."

"But I'm not interested in other parts of the world," he says. "I'm a meat-and-potatoes man. I don't go for all those foreign dishes. They can have them all, as far as I'm concerned."

"So we won't go," explains Fran. "I know I'll keep flying, but I don't think we'll do any more flying together. Norm's just not that comfortable in a small plane."

"There's too much up and down," he says, "and that upsets my stomach. Regardless of the fact that I know flying is perfectly safe, my uneasiness is still there, and I'll have it as long as I live."

"As long as you want to hang onto it you will," adds Fran knowingly.

"Huh?" he says, turning to her.

"You could talk yourself out of it," she says.

"Oh, baloney," he laughs, "talk myself out of it."

"You could," she says. "You could ask yourself, 'Is this realistic or isn't it?'"

"Oh, great," he laughs, shaking his head.

"So there you have it," Fran smiles. "Besides, how are we to know how many years he has left? And I want to spend every minute of them with him."

47

George and Bertha Miller have been married for sixty-five years. They are Polish immigrants who met in Paris in the late 1920s. Except for five war years, they were in Paris until 1949, when they moved to the United States with their two daughters and worked in the garment industry. They recently moved to a tiny house, on a short street, to be closer to their daughters and two grandchildren. Bertha is ninety and George is eighty-seven; they speak to each other mostly in Yiddish.

George and Bertha Miller

"Before we begin," says Bertha, "I want you to know that in this house you will hear two different sides for every story. Okay. It was 1928 in Paris when I saw my husband for the first time at a Jewish cultural club. He was talking with somebody about the relationship between a boy and a girl, which interested me. But when I heard him say that he would never marry a working girl, I'm thinking to myself, 'What does this guy know about girls?' Here I am, a working girl, working very hard, who is this provincial?"

"You know," explains George, "people have always said that I have a sense of humor, and many times I would be joking about something that *somebody* I know would take seriously. When I'd said that I was such a revolutionary that I would never marry a working girl, it was a joke. And sometimes my wife likes so much the joke that she takes it seriously."

"When we met," he continues, "we were immigrants living in Paris. I was twenty-two and my wife was twenty-five."

"This goes into the difference between the old-time marriage and the younger generation," says Bertha. "We took the marriage very seriously. We had the kind of moral approach that we are going into marriage to build a family, and we were in very bad shape financially. The only way to achieve something was by working hard and building, which was the long and hard way; but it was also the cement of our marriage.

"I would also add that George was disappointed that I was a feminist. I was very much independent and I wanted to remain myself. Okay? A woman is a possession of a man, but I was not his possession. I was a person with both feet on the earth. Very little illusion took place in my life. Sometimes I didn't laugh at each of his jokes, and it hurt his feelings. My sister would laugh her heart out, but I'd heard the joke so many times that I didn't feel I had to laugh anymore. You know, you are the only person who has to listen to your husband at the table until you go to bed. You have to

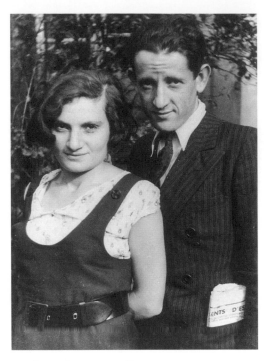

Bertha and George Miller, 1930s.

listen to his childhood, and how often can you take it?"

"I would have to say," George says patiently, "that the spirit of her feminism was to be against. If a man says something, then naturally he must be wrong. Once we had a discussion in our cultural group after reading Dostoyevsky's *Crime and Punishment*. I was expressing my opinion about whether punishment was efficient, and all of a sudden *a certain person* walked in the room while I was in the middle of talking and said, 'I'm against it,' without even hearing the conversation. So this anecdote characterizes the state of things for a long while, though I took it very easily because I understood that she has to be against as an expression of independence. If she's independent, then she's not submissive like other women who always agree with their husbands."

"Well, anyway," says Bertha, "let's move on."

"I did my share of washing dishes," adds George, "and shopping and cleaning. This was a big deal. In other families, the wife, whether she works or not, has to prepare the husband a good breakfast before he goes to work. But my wife, she owes me maybe a million breakfasts over the years! No, I'm joking, I never wanted it. I expected to share the obligations and joys."

"I told you before," says Bertha, "that you will hear two different sides. What kept us together? We were busy working, struggling, and building our life, but we were a part of history and constantly under the menace of war."

"We wanted children," says George, "but all the young couples were scared to death for two reasons: the Depression and the fear of war. Finally, in the worst of economic conditions, we did have our first child, our daughter Odette."

"And then the worst of it came," she says. "When Germany invaded Poland, George volunteered with the French army."

"I was gone for five years," he explains, "in the Jüdenlager, the prison camp, for most of that time. During the day we did hard labor and at night we were back to our cell. We had some news from the underground, and when I heard what was going on with the war, I wrote my wife and told her to leave Paris. She was in the Resistance, and we knew that although the women of prisoners were exempt from being sent to concentration camps for a certain time, eventually they would take everybody. I advised her to go away, save herself and the child."

"So I went into hiding," explains Bertha, "in a French village made up of simple, extremely religious people who had never seen a Jew in their lives, but they hated them. You know, the Jews killed Christ, that kind of thing. And that's where I lived for almost two years, under an assumed name. I told people that my husband was a French prisoner, but that I was a Catholic from Czechoslovakia. I had sent Odette away to the countryside eight months earlier with a really beautiful movement of underground people who saved the children of prisoners. I didn't see those people I'd sent my daughter to. She was at the time seven years old, and this was difficult. By the time I came to this countryside, Odette was living seven miles away in the village; and even though I could walk to her, I didn't because she was living under her father's name and I was supposed to be another person, a Catholic. My life was at risk from minute to minute."

"These were the most tragic years of our lives," says George. "When the war was finished, there was no transportation because the bombs had ruined everything in Germany. So we, the prisoners, had to lay rails for a train, mile after mile, and this took us over three months. We mostly walked back from Germany, and during the eight months it took us, my wife and I were without any communication from one another. For eight months, we didn't know if the other was alive or dead. When I finally arrived back in Paris, I went directly home, but my wife was not there. The concierge took me to the school where Odette was. It had been five years, and this child, she grew twice as big. The child took me to my wife, who was just leaving my sister's house. When she saw us in the street she froze, and the child started screaming hysterically, 'Mama! Papa! Mama!' My wife was stone, she couldn't budge, she couldn't believe it."

"Ahh, this is my part," Bertha begins.

"So I took her in my arms," George continues, "and we went to the post office to call our friends, and the child started yelling, 'Papa! Papa!' This is the only word she could say, she was so emotional."

"Let me tell you my part," says Bertha. "France had over one and a half million prisoners, so when the war was over and I was able to get back to Paris, I went to the train every day to see if George was there. And out of the trains would come thousands of people calling to their loved ones, and George was never there. Every day, until the last trains came, this is how I spent my days. I always had these fantasies, 'If George shows up, what will be my reaction?' And then on this day, there he is, walking toward me with Odette. And I'm looking at him and thinking, 'This is it?' I wanted to reason out my feelings. I had just come from the station fifteen minutes ago and he wasn't there, and then he is there with the child. I was frozen. Mind you, he wouldn't forget this thing. He was disappointed in me that I

wouldn't run after him and cry like in the movies, you know.

"But there was a much deeper cause of problems. Scars were left, and this time the scar was our daughter Odette. Here he is missing these five years, and he misses very badly not being with the child. She was five when he left and ten when he returned. And when he returns, she has a big problem. When I sent her away in 1942 to escape the concentration camp, she was with a Catholic family, being raised as a Catholic child. She was happy. You know, children need very badly some fantasy, and here was the church with angels and all those beautiful decorations and holidays. It opened up a whole life for her. But one time the person who was taking care of her wrote me that the priest wanted the children to be baptized, and she didn't know what to do. All the children were Jewish, but no one else knew that. So I wrote back and said, 'Madam, we appreciate very much what you are doing, and please, if there is any danger, go ahead and do it. When she's older she will understand, but it is important that when her father comes back he find the child.'

"But when the father came back, he had been persecuted. He had passed through hell being a Jew, and this child, whom he was dreaming of, had been following a Christian upbringing and had internalized the religion very strongly. It was a problem for him. He felt that I did not do my duty as a mother."

"It never, never happened like that," states George adamantly. "It would never come to my mind, such an accusation. You see, Hitler not only created such tragedies and annihilation country to country, but even family life suffered—it was broken apart in most places. Only the strongest ties of good, loving couples could stay together in loving cohabitation, bringing up the children and grandchildren, and living happily ever after. We had a lot of suffering, and it took a lot of moral strength to be what we are. My wife couldn't

imagine how it was with me, and I couldn't imagine how she went through all of this."

"Here, I am again to my first point about two sides of the story," says Bertha. "Each of us thinks that he or she was a bigger victim than the other. This is characteristic of us and has created a lot of misunderstanding. But in marriage nobody can influence the other person. The illusion that you can rebuild a person's character, forget about it. After sixty-five years it hasn't made a difference. Each of us has a point of view. He doesn't know how I truly felt, and I don't know how he truly felt."

"We are not made in a factory," adds George. "We are each individual in our way of thinking."

"Which is good," says Bertha. "Differences are important in life."

"Not to make a fetish out of it," he adds.

"That's right," she agrees. "I had a cousin who was wishy-washy, and he always went along with his wife. I would never marry a man who would tell me, 'Yes, darling, yes, you are right.' I'd hate it! I would rather fight with him if he stays solid in his point of view and I keep my opinion. So we are fighting, so what? Crisis? There were serious crises. There were moments when my husband said, 'Go ahead, take a lawyer, we are going to divorce.' This was about sixty years into the marriage, but I didn't take him seriously. I know his character; he is a very moody guy. If there was a nunnery for men, he would go in. I knew that these times would pass."

"People have emotions, they get excited," adds George. "But then the heat is over and you cool off and forget."

"But my husband has a good memory," says Bertha. "He has a hard time forgetting things."

"And I know that my beloved has some fantasies about the way things happened," he adds, "but they are not dangerous."

"Ahh," she sighs, "we may never agree. But these days are very different. Here in Berkeley we have joined the YMCA. Six mornings a week George is going for the fitness machines, about two hours a day, and I am there for the swimming, about fifty-five minutes without stopping, mind you. And we are very physically fit, as you can see."

"In fact, she works so hard," says George, "that her appetite is excellent, and I have to prepare a good lunch for her."

"This is good for us," says Bertha. "We are both going to the YMCA, and so there is something to talk about. If the husband is going with the boys, and the wife is playing bingo or cards, what can they talk about?

"And we walk a lot," she says. "And he prepares the breakfast and the lunch, and on weekends he prepares a special breakfast with an egg and bagel. He is quite the guy. He even washes dishes. Sometimes I can't forgive myself that I am so spoiled."

"I love my wife in *my* way, and she loves me in *her* way," says George. "We should forget our failings and be grateful for the beauty of life, for our accomplishments and our togetherness. There was really never any adversity."

"That's right," Bertha agrees.

"Little episodes," he adds, "little anecdotes of a few minutes of excitement are not a marriage crisis. The little quarrels which are blown out of proportion, this is not our life. Our life was devoted, happy."

William and Mazie Price have been married for thirty-one years. Mazie has been teaching at a school for business and commerce for the last twenty-six years, and William has worked as a mechanic for United Airlines for thirty years. They are devoted Baptists and love to travel. They have two children and live with his mother; 'Price' is fifty-six years old and Mazie is fifty-eight.

William and Mazie Price

"I think it's realistic for people to be monogamous during their marriage," Mazie begins.

"Well, there is temptation," adds her husband, Price, "but you have to learn to deal with that."

"I never had that problem," Mazie laughs.

"Well, see, men are different from women," Price explains. "When a man looks at a woman, his mind runs; he's thinking about getting into bed with her. This macho thing is built into us; the man, he got to have things *his* way. Men think that way, and they are wrong. They have to learn. I did, I was definitely macho when I first met Mazie."

"Yep," she laughs.

"I'd get together with other men," he remembers, "and we'd brag about how cool we were with women or what we'd said to a woman. A lot of it would be lies anyway, but it makes you stand up among your peers. I had to ask God to help me because he understands that *you will be* tempted. By studying the Bible and

understanding what he want me to do, when temptation come, I just turn away from it. Now when I see an attractive lady, I don't look at her in a sexual way; I try to see her as being an attractive *person*. Still, even at fifty-six, I catch myself and have to ask God to forgive and help me."

"Well, luckily I never had a problem with Price *doing* anything with other women," says Mazie. "And he never had a problem with me cheating on him."

"It's easy for a married couple to stay together if they both come to know the Lord Jesus Christ," says William, "because Christ is about love and forgiveness; and once you start understanding this kind of love, you'll look at your wife or your husband differently. Now Mazie, she was a fine lady when I met her. At first I was looking at her sexually; I was young and ready for action. But as you get older, your body changes; and if you only have that sexual love, it will fade away. It's the God love I'm talking about, the agape love of giving

without receiving that causes the real heat. Young men need to learn this."

"Price has changed a lot," says Mazie with a nod. "See, *I* was the church-going one when we met. He wasn't so interested. After about a year of marriage he stopped coming with me, and I was worried because church helps to build cohesiveness and togetherness in a relationship. I remember telling him that he should go, but he got real angry, so I just backed off."

"Well, I knew I should go to church," he confesses, "but I didn't like nobody telling me to go. See, I'd been brought up in the church, but when I left home I wanted to feel my oats and make my own decisions. I didn't want to give in and let her know she was right."

"So I went by myself," she says, "and with our two kids, after they came along. I figured he'd come when he was ready."

"I felt bad," he says, "but it was the 1960s and I was trying to find myself. The Black Panthers were on the move, and I went to their rallies and was really into Malcolm X. Plus, I'd experienced a lot of racism in the air force and things were happening to the blacks that I didn't like; the police would arrest you for nothing, and I had a lot of anger built up. I felt like, if Jesus loves us, why do things have to be this way for the black man? I was looking for the truth, and I didn't think to look to the church for it. I had to do my own thing."

"I worried about William getting lost in those days," says Mazie. "I prayed all the time that he'd find his way back to the church and become a better person. He was also playing a lot of cards back then, and it worried me because he and his friends would play all night long. By the time the sun would come up he'd be coming home, and that wasn't good for the children. I got so angry that I locked him out a couple of times; but Price, he just knocked the door down!"

"That door was like paper!" he laughs. "It came down so fast, I thought, '*Man*, it would be so easy to break into this house.' We never fought though; I'd knock the door down and go to bed. Even to this day, if we don't agree on certain things and one of us starts getting hot about it, we'll just break off and go our own way. We learned that. And later on we can come back and talk about it."

"Sometimes you say things you don't mean," says Mazie, "and you need to apologize to each other."

"That's something I had to grow into," admits Price. "It was hard for me to apologize, even though I knew that I was wrong. Now I have no problem apologizing, even if I'm right. But I'll never forget one of the last times I was out all night playing cards with the guys. I came in on a Sunday morning, and there was Mazie getting the children ready for church; and I felt terrible. I knew I was going down the wrong path, and it really hurt me."

"But even during those times," Mazie explains, "we always loved each other. He was doing what he wanted to do, and I was trying to keep the kids rooted; and in our own way we supported each other. But we got together. We'd go fishing and camping with the kids. Our son Kenyon was a part of the Pals League and Theda played the piano, so we were involved with that. Sure, Price did things that I didn't like—we *still* do things that bother each other—but that doesn't erase the fact that I love him."

"Oh, boy!" he laughs. "Mazie snores! I mean *loud, crashing* sounds. Now *that* bugs me, but I've learned to live with it. In fact, now I snore myself. I had to learn how to snore; I get on my back and go at it. But when we first got married, she didn't snore. Did you snore then?" he asks his wife.

"I don't think so," she laughs.

"And then *another* thing she does," he goes on, "is she talks on the phone *a lot*. Now, when I call someone, I call for information. When I get what I want, that's it, unless we get to talking about the 49ers. But Mazie, oh!

Mazie and William Price on their wedding day, 1964.

I thought we'd have sex every night, but it wasn't so. When I was younger I used to pout, so I tried to use some psychology on her to get my way. When she'd say she wasn't in the mood, I'd say, 'Oh, I don't want to be bothered with you, you getting old,' just to make her see it my way. I know it was childish, but it worked," he laughs. "But now it don't work too good because she knows my ways. I had to learn over a period of years that she may not be up to it, and I have to back off and not feel rejected. I'm more patient now if she don't want to. I know she will come back some other time."

"In a marriage you never reach a plateau," says Mazie. "You always have to build, and that means you have to give and take and commit yourself to that individual. His mother's been living with us for three years, and that requires a different kind of patience and love in our marriage."

"It's been tough," says Price. "My mother's got Parkinson's disease, and besides that, she's a stubborn person, which makes the situation harder."

"She can't cook for herself," says Mazie. "She *can* keep her body clean if she wants to, but she doesn't want to. So we've learned to live with it. And you know how mothers-in-laws are—their sons are golden. One time she said to me, 'This is Sonny boy's house.' And I said, 'No, this is my house, and Sonny boy is mine, and now you're mine too.' And she said, 'That's a lie, I'm not yours.' She was letting me know that this was his house and she could do what she wanted. Sometimes she can really put an act on."

"You'd have to live with us to see my mother in action," says Price, shaking his head.

"Yesterday she stretched out on the kitchen floor and laid down," adds Mazie. "I asked her to get up, but she wouldn't. I felt bad because I was leaving the house, but I didn't want to leave her there."

"It's hard for me because it's my mom," says Price. "And then I'm married to Mazie, so I'm in between the

She can call her friend at 6:00 P.M., and again at 9:00 P.M., and get up in the morning and talk to that person all over again. How can you talk to the *same person* over and over again?"

"Well," says Mazie, "Price isn't perfect either. He burps a lot. And now my son has picked it up, too. After they have their dinner, they'll both go, 'Urrrp.' It annoys me, and I'll say, 'Why you have to do that?' And they laugh at me."

"Look, there's no perfect marriage," he laughs, "because you got two different individuals coming together to form one, and the personalities can clash at times. Sex is a good example. When we first got married,

two of them. I try and do a lot around here to keep the pressure off Mazie, and I try to keep peace between them. But it's hard because our kids just finished college, and we sacrificed a lot for them. We had plans to do some traveling, but then this came up and now we can't just pick up and go wherever we want to."

"Before she came," says Mazie, "we had fun things to talk about, like what we were going to do next week and where we were going to travel. But now conversation has to center around her. We used to go to Los Angeles to see our daughter, Theda, or spend a weekend in a hotel, because we didn't have any babies. We didn't cook if we didn't feel like it; instead, we'd go out to the Sizzler. But now we have to stay here and cook every night; we've got to keep food in the house."

"It's a test," says Price. "Mazie's not required to put up with my mother, but she does it out of her love for me. If it weren't for my wife, I don't know what I would do in this situation."

"Well, I think about my mother, who's alone and lives far away," says Mazie. "If I show love to my mother-in-law, somebody will show that love to my mom. But Price helps with the cooking and the dishes and that makes a difference. When the children was growing up, he didn't do those things; but since his mother came, he has. The roles have changed in this house, and it has a lot to do with his return to the church. Before coming back to Christ, he was more self-centered, he had to have things his way, telling me what to do and doing things on his time. After he became a Christian, he started treating me differently; he became more caring and wanted to take me out, just the two of us. He's more loving, he teases more, and he shows a lot of respect."

"It's something I had to grow into," he explains. "Without my religion I would be the same old selfish person I was before. I was childish, I liked things to go my way, I didn't share as freely. But now Mazie and I act as one, and we're going to stay that way. You know, there's a judgment after death—you can go to live with Christ in heaven or you go to hell. And Mazie gonna go with me to heaven 'cause she believes in Jesus."

Identical twins, Bob and Al Murray are eighty-one. Their wives, Vera and Verna, also identical twins, are seventy-eight. They married as a group fifty-seven years ago in Leroy, Kansas; and today, retired from the grocery business, they live on a beautiful spot overlooking the city of Topeka. They had five children between them and have all lived in the same house together for fifty-seven years. Each set of twins has dressed identically throughout the marriage, and they wouldn't have it any other way.

Bob, Vera, Al, and Verna Murray

"Well, we didn't start going together until 1933," says Al. "We all went to the same school in Leroy, Kansas, and we used to hang out with their brother. We knew who they were, but they were younger and didn't pay attention to us. I guess we just took a liking to them. So Bob and me, we talked about it and we thought, 'Well, they's city and we's country.' We didn't know if they'd want to go out with country kids, but we thought we'd call the girls and see about a date. So we flipped to see who called; we always flipped on everything. So I was supposed to call. We didn't know 'em apart and we said, 'Whoever I call, that's the one I deal with.' And Verna answered and it just went that way."

"I guess I liked him, too," says Verna. "At the time we thought that it would just take too much trouble to try and figure out which one to go with."

"Well, I never thought anything about it," says Bob. "I got Vera and that was that."

"And I never thought about trading Bob," Vera says. "It worked out pretty well. There were two of them and two of us, and it just made it handy."

"On our first date we went for a ride with them," smiles Verna.

"Yeah," Al remembers. "I called Verna and we picked them up in our car."

"And it was real romantic," she giggles, "because they had a one-seated car and one of us had to sit on somebody's lap."

"We didn't like the girls because they was twins like us," explains Al. "Twins was the least part of it. In fact, there were several sets of twins in our small town—there still are—and everybody used to say that it was something in the water. We liked them because they had beautiful faces and they were nice."

"Ooohh, boy, listen to that," laughs Vera.

"Well, you were," insists Al.

"That's sweet of you," says Vera.

"We could always tell the girls apart from the start,"

Al continues. "You can tell from their voices. But one time Bob and I did try and fool them. They had a swing on the porch at their mother's house, and we always used to sit in the same places. One night it was dark and we switched places on them."

"We never had any trouble telling the men apart," says Vera. "Maybe sometimes from the back, or when you pass one of them, you don't know which one it is for a second; but Bob and Al are very different, though I could not tell you how. Could you, Verna?"

"No," her twin answers, "I know they're different, but I can't say how."

"When we were going to school, we didn't dress alike," says Bob. "We lived on a farm, and we didn't have any money; Dad would just buy us what was handy at the time. But then when we came to Topeka, we started dressing the same."

"And we always dressed alike," says Verna. "We both had the same taste in clothes, though sometimes we'd take turns if one of us liked an outfit that the other didn't."

"After we met them," explains Bob, "it was four years before we got married. It was the Depression, and we was trying to buy a grocery store; we didn't have any money to afford to get married. But I knew that Vera was my choice, none of the other girls really interested me."

"And I always knew that Verna was my special one," Al adds. "As I recall, when we asked them to marry us, we were sitting on their mother's swing, and Bob and I asked them at the same time. I tell you, I was so scared I didn't know whether she said yes or no."

"And when you'd gone home that day," adds Verna, "I just didn't believe for sure you'd asked me."

"Anyway," continues Al, "after we was married, we rented a house together, the four of us. People say it's unique, us living together, but we don't think anything of it. We've been doing it for fifty-seven years. We raised

five children here between us. Me and Verna had two, and Vera and Bob had three."

"The children have been a real blessing in our lives," Vera says. "They're fine people. 'Course if they ever thought about doing something wrong, they knew they'd have had to face four parents!" she laughs. "'Course that's just a joke."

"We don't think being twins is anything different," says Al, "though we do have a joke that sometimes it takes all four of us to say a sentence. But other people seem to think being twins is different. One time we were on Geraldo, but we didn't know what we were doing. We went there, but we decided we didn't want to be on."

"See, the subject was different kinds of twins," Bob explains. "There were two men twins dressed as women, and one of them was gay. Then there was a fellow there who had married each twin and then lived with their sister. I mean, it was a typical Geraldo show."

"But we didn't want to sit on the stage, because we didn't really approve of those lifestyles," explains Vera. "And if we went, it would seem like we approved. They've asked us back, but we've refused. It was really sad because Geraldo is really nice."

"There's one thing about being twins," says Al. "Sometimes it's hard for the spouse of the twin because twins like to be together so much, sometimes more than with their spouses. See, I like to be with Bob a lot, but because Verna and Vera are twins too, it works nicely. We all have each other."

"Another thing with twins, "explains Bob, "is that sometimes there's jealousy between the twins, because maybe one is doing better than the other. But with us, the Murray twins, I think because we all had to work so hard together, we just didn't think about it."

"Well, we were all in the same boat," Vera adds. "Especially in hard times, if we needed something, we all had to work for it. We couldn't depend on our folks to help us out."

"See, we ran our grocery together in Topeka for forty-seven years," Bob says. "Al and I usually worked at the store, and the girls were at home raising the children, though they did work with us sometimes and took turns being home.

"Since we retired, we spend most of our time working these eighteen acres we live on, and we volunteer for things at church. We walk almost every morning to keep active, and we play some dominoes."

"We're not trying to tell you everything's been perfect," says Al, "but I wouldn't have it any other way."

"Well, just yesterday we had a tough day," explains Vera. "That's our hardship these days, the air-conditioning. It was hot, and the air-conditioning man was not here when he was supposed to be. Bob and Al were out digging up the yard, and we were ready to eat our dinner. Al came in and said he couldn't find his glasses. We thought that this was just the final thing. Verna went down and she said, 'Lord, just show me the glasses.' So she came out of the house and went past where they had been digging and found the glasses."

"I suppose in a way it's like one marriage," Al says, "but I can't say I know Vera as well as I know Verna. Vera is like a sister to me."

"And I don't think I know Al better than I know Bob," Vera explains. "I don't *hang out* with Al, he's a friend. The four of us all go together. We work together. I tell you what, though, Verna is our pie maker and our piecrust maker."

"And Bob likes to garden," says Al. "I don't. I cut weeds instead."

"Al took care of the meat at the grocery," says Bob.

"And Vera usually makes the bread," says Verna.

"We speak of it often," says Vera. "Sometimes we just sit here together and we talk about how fortunate it is that we are together."

"Yeah," says Bob, "you always got someone to sit on the porch with."

Vera, Bob, Verna, and Al Murray, 1935

George and Eva Low have been married for sixty-one years. They have four children, fourteen grandchildren, and eight great-grandchildren. They've lived in the same apartment, in a building which they own, for the last twenty-seven years. Eva, eighty-seven, is a homemaker, and George, eighty-two, has worked a number of jobs. For many years he owned and ran grocery stores.

George and Eva Low

"I never work at my relationship with my wife," George smiles. "It come easy to me because I have a one-track mind; I love her, that's it. No other woman going to come between us. All my sons, they just all have one wife, and that's the way it is. Nowadays, the young people divorce for the money. One little argument and they want to throw him away. They can't stand each other and they say, 'I can make it on my own, goodbye!'"

"Too independent," Eva nods.

"Nowadays, everybody want to make money," says George. "Everybody go to work. My sons take after me, all the grandsons too; their wives don't go to work."

"One of them go to work," Eva corrects him.

"Yeah," he admits, "but she don't have to."

"Four sons married," says Eva proudly, "and three wives stay home."

"I think that's better," says George. "If you have a family, you have to take care of your own."

"Nobody can teach your kid except yourself," Eva chimes in.

"You want family or you want money?" asks George. "Money don't mean so much, you can always make money."

"If we make it, everybody can make it," Eva says proudly. "We struggled to save every penny. When we first met, in 1932, we were very poor. We worked in a garment factory in San Francisco, and that's when I first laid eyes on George. I see him smiling and doing the sewing, but he never knew that I was looking. He was handsome, too."

"I didn't see her at first," admits George.

"Well, he's a shy guy," explains Eva.

"My family background is, you know…" he starts to say.

"He's from the old country," she adds.

"My father had an arranged marriage," says George, "married my mother, and that's how it is."

"I finally met him," Eva continues, "through an elderly lady who sat between us doing the sewing. She invited us to her house to play mah-jongg and have dinner. But those were the olden days, it wasn't easy to date, especially for Chinese families—very old-fashioned."

"I thought that she was very gentle," George remembers. "I can see in her face that she is a very caring person. The first time we kissed was in her sister's house, and that was the first time I kissed a girl in my whole life. I was so scared. A girl wanted to kiss me in Hong Kong before I come here, and I ran away from her. We don't do such a thing, you know."

"We really didn't know what kiss is," remembers Eva.

"But we just looked at each other," says George, "and then, you know, we…"

"I guess meant to be," adds Eva, "because he came from China, so far away; and I grew up in Marysville, in California. There is only a small chance that we meet at all, but we did."

"And because I was alone," says George, "and I want to raise a family, I think, 'Eva looks like the right one to me.' So one day I said, 'Well, we both working, you live in one place, I live in another place. We don't make much money, so we might as well combine together and live cheaper. And I love you, so we might as well get married.'"

"Two live cheaper than one," says Eva. "So I said, 'Okay.'"

"We had no money," says George, "but one day I won a raffle. With a fifteen-cent ticket I won a washing machine. But in our little one-bedroom apartment on Jackson Street in San Francisco we got no room for the washing machine. So I turned it in for a radio and a hot plate. Oh! We went through the hard times. The gas and electric bill would come, maybe it be one dollar and ten cents, and we can't afford it, so we cut down."

"Every light we don't need, we turn off," she says.

"Even at grocery store we have to be careful," he says. "You buy a little piece of pork, and they give you some green onion and a little ginger for free."

"Or you buy a piece of beef," adds Eva, "they give you a carrot and a stalk of celery."

"Maybe we had a little catsup," says George, "or some lard, and you mix it with rice and you have a meal. These were Depression days; we only make a dollar a day sewing. But we were happy because we had each other, and it is better than being alone. Our first baby come that year."

"I think we conceived the first time we go to bed," says Eva.

"And I delivered the baby," George beams. "The doctor was an old lady in Chinatown, and she tell me what to do. There's nothing like it, I tell you; I feel so good. My first baby, and a big baby, too! Ten-pound boy, oldest son! I wasn't even nervous."

"Too young to be nervous," laughs Eva.

"I built a little bed for him," George continues. "I use a board and make two legs, and in the daytime I fold it up and put it aside. We still had nothing, but we were working very hard. By that time I had left the sewing and I was working in a restaurant, sometimes staying there until three in the morning. Then we have more kids."

"And I stay at home with the kids," Eva adds, "taking care of the household and sewing at home until maybe four in the morning. Then I have to wash all the diapers and run up to the roof by eight in the morning to hang them up; otherwise people will take your line and the diapers won't get dry. Don't get too many hours of sleep! It was a lot of struggle, and we had our arguments. But you never let that get to you, you never go to bed mad.

"In fact, I usually start the fights," Eva laughs, "over little things. George is very hotheaded and he gets mad easy, but he never start a fight with me."

"I don't believe in it," he says. "I am hotheaded, even as a kid, I don't change. One time I'm working as the second cook at The Forbidden City and the boss come in and saw me standing there, and he say, 'Why don't you mop the floor?' And I say, 'I mop your floor? I'm the second cook. You mop your own floor!' So I take off my apron and quit."

"See how he is?" says Eva. "He got a family to take care of, and he quit just like that."

"Well that was a long time ago," he says.

"Yeah," she agrees. "He's mellowed down."

"Well, I never look at another woman," says George proudly.

"That's true, for sixty-one years he's very faithful," says Eva.

"That's the way I was raised," he says. "Nowadays, I think people fool around too much. They don't understand the human relationship. They don't wait, they try anything, they don't care."

"Nothing close like a husband and wife," Eva agrees. "Never share the private life with somebody else."

"When I have the grocery store," says George, "a lot of ladies come in, and some of them flirt with me. They want to get me, and I was afraid. I think they're going to take everything away from me because I own the store. So I never get into any kind of relationship. I say, 'I got a wife and I always come home to my wife.'"

"He come home and tell me about it," says Eva. "We're very truthful with each other."

"But I did have a bad habit in my younger days," says George. "I liked to gamble. But you know why I gamble? People don't realize this. They think I'm a bad guy, gamble every chance I get. I do it because I want to make a better living. I want more money! I don't make enough!"

"I knew this gambling was a little problem," concedes Eva, "but I never make a big thing out of it."

Eva and George Low, 1935.

"But sometimes we fought because of it," says George, "because sometimes I don't even come home."

"But we never had a big fight over anything," insists Eva. "I just wondered where he was, and when he come home he told me all about it honestly, and I don't get mad at him."

"I don't do it anymore," he says. "I don't even play the nickel slot machine, I don't even buy a little ticket. That shows you how I can control myself."

"These days we just enjoy each other," she says. "We watch some television; I watch soap opera and he watch sports. You have to give and take. I never watch sports before, now I love to watch football. He taught

me how to watch tennis and baseball, too. Only thing I don't watch with him is basketball because it's too fast. We stay home a lot because senior citizens don't go out at night. I don't like to go unless my kids go with us."

"Besides," adds George, "I don't know how she gonna feel. A lot of times she gets an attack anywhere."

"Last night I have to take two pills," she says. "One day I feel pretty good, then another day I'm down. I got sick last year. I had internal bleeding, then a heart attack and a stroke. I had to call 911 and go back to the hospital six times after that. George was so nervous."

"I'm lost without her," he admits. "I depend on her so much. All these years she's been taking care of me, the whole time we've been married. I don't have to raise a finger. She cook, wash, take care of household. Everything! She's always been that way, ever since we marry."

"But now he have to do things," smiles Eva. "I still like to be independent, but I can't see too well, so I can't do too much. I still want to do my own cooking, but George helps me. I say, 'George, what is this?' Then he tell me, and I use it for the cooking."

"Yeah," he agrees, "I help her with the cooking, I get her the medicine, help her in the bath."

"He afraid I'm going to fall in," she smiles. "I always need George."

"We need each other," he says.

"One thing that helps me is that I believe in God," says Eva, "but I don't go to church."

"You know why I don't go to church," says George, "even though I believe in God? Church is a place for people to gather and gossip and that's all."

"It's the social life," says Eva.

"It don't mean a thing," says George.

"But I pray every night," says Eva. "I pray for God to take care of us and watch over my children and grandchildren."

"She kneel down every night before she go to sleep," George says. "But I never did that. Look at all the crazy things the heads of the churches do. You listen to the news, bad things, crazy things."

"But if it weren't for God," Eva reminds him, "we won't be here today. We went through very hard times."

"Life is very different now for the young people," says George. "Our world is the olden days…."

"Granddaughter marry a Caucasian," says Eva, "but it is okay. Modern world, you know."

Ada and Lee Spanier, both of whom had been divorced when they met on a blind date, have been married for forty years. Lee, seventy-four, was a salesman for most of his life and is now the director for a nonprofit organization that recruits volunteers to visit nursing-home residents. Ada, seventy-five, helps older people make the transition from living in their own homes to living in a convalescent home. Energetic and feisty, they have one son and two grandchildren.

Ada and Lee Spanier

"I would say this about marriage," cautions Lee, "and I don't say it in jest. My advice is to divorce your first husband or wife and marry a second person. Your chances of having a happier life increase by a factor of ten."

"Oh, Lee," chides Ada, "ten? A factor of ten?"

"Yes, Ada," he continues. "I think second marriages have a higher rate of success than first ones because you know who you are and you know what you want."

"Well," says Ada, "when I met Lee I had been divorced for two years and had a nine-year-old child, Harris. I decided that I wanted to get married again because I wanted to have a man around. I decided one Sunday morning to find a husband. I had been reading the *New York Times* in bed, and as I finished the paper I threw it on the floor and said, 'Hmmm, not bad.' I didn't have to bother with anyone, make breakfast for anyone—I mean, a little kid doesn't care what he eats. But then I said, 'Wait a minute, this could be a dangerous thing.' I didn't want to spend the rest of my life alone,

so I shaped up. I went to Klein's to buy four dresses, one for each date I would get. By the fourth date, I would be on my last dress, and if it didn't work out I would stop seeing this person because I was wearing out my clothes. I told this to my friend Agnes and said that I wanted to get married. And Agnes said, 'Foolish woman, spending money on clothes—you should invest in the stock market—but I do have a man for you to marry; it's someone I can't use anymore.' And that was Lee. So she gave this party and Lee was supposed to pick me up. When he came, my son said, 'Ada, I think you're going to get us into trouble; he looks like a gangster.' And I said, 'You don't know anything about gangsters, you're only a little kid;' but I told him if Lee was a gangster, I wouldn't see him. Turned out he wasn't a gangster.

"When we were on our way to the party, I wasn't even sure I knew his name; but I mentioned that I didn't have enough money to pay the rent, so Lee said, 'Well,

how much do you need?' And I said, 'ninety-three dollars,' so he gave me a check. I said, 'Oh, what a wonderful check,' and I immediately opened it up so I could find out his name, and then I took it and put it in my bra. He said, 'I'll give you the check, but I never want to discuss your rent again.'

"Anyway, we had a wonderful time at the party. I was wearing a dress with a white pique skirt. I spilled spaghetti all over it and Lee was very gallant, wiping the spaghetti from my dress. I figured that I'd probably have to throw it out because it was one of the four dresses, but I also figured that I wasn't gonna need it anymore.

"From that first day, we had dates every night. Lee was not a smiling person, and I was always a laughing person. He was serious and handsome, and wore nice clothes, but we always had so much to talk about. We seemed to be unreasonably hypnotized. Being a divorced woman wasn't pleasant in those days, you were fair game. Men had a strange idea of me. They thought I was sexier than anybody. I was sexy, but not that much. And dates were a big hassle, mentally and physically. So when I met Lee I thought he was a real person, and he wasn't hounding me. The second day he sent me a beautiful book of poems and gave Harris a football. And we became a unit, the three of us, connected."

"The attraction was immediate for me, as well," Lee says. "Ada was very upbeat and eccentric, off the wall. My impressions of her haven't changed from day one, and I think we have a very unusual relationship because we agree on 98 percent of the things that come up. We see the world in almost exactly the same way."

"Our humor is the same," Ada insists, "and we think that's very important. We'd rather be with each other than anyone else, because other people are so tiresome. We've had a lot of experiences together."

"I think the most fulfilling times were the fifteen years when we had our craft business," says Lee. "Ada's very creative. She decoupaged images onto light switches,

and we sold them on the weekends in outdoor craft shows in Ohio, Pennsylvania, Michigan, and California. Big shows, in the sun. Saturday mornings at 6:00 A.M. we'd load up the car, drive for two hours, get there, set up on the wet grass, and by 10:00 A.M. thirty or forty thousand people are coming by. By 6:00 P.M. that night, we've made eight hundred dollars. We go to the hotel, shower, eat, and collapse. Same thing the next day. End of the show we'd be the first people out of there. We'd race home in an air-conditioned car, jump in the shower, have a dinner of hot corn, tomatoes, and beer, watch *Masterpiece Theater*, go to bed, and make love. It was a great time."

"Yeah, we did that a lot," Ada remembers. "I think Lee and I give off this image that may be intimidating to people. We're romantic, we love each other, and it sticks out. Not everybody at this age acts this way. We started our life together when we were about thirty-two, thirty-three years old. We weren't stupid kids anymore. And at that age, to be in love with somebody was kind of strange, because most people had already lost the bloom. But we were still blooming idiots."

"That's not to say everything's been perfect," Lee points out. "We've had our violent arguments. I have a very unforgiving personality."

"And I make a very loud, explosive eruption when I get mad," adds Ada. "You can hear me in Pittsburgh. I don't hold back. I sneeze loud, I laugh loud, and when I get mad I make a lot of noise. I believe in fighting when you have to, but don't fight all the time. If it's a real issue, go to bat and fight like crazy. But a lot of things don't matter. Don't kill the good of it, don't kill the gentleness by winning unnecessary points. There are so many things that Lee still does, and I'll say, 'Oh, he's doing that again;' but it's so easy to destroy somebody who loves you, you can easily make a wreck out of a person.

"Like Lee takes the dishes out of the dishwasher and puts them away, but then I can't find anything. Potato

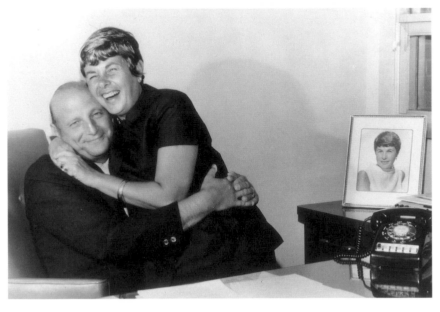

Lee and Ada Spanier 1978.

peelers, they disappear. But I don't say to him, 'Don't do it.' I buy another potato peeler. Somewhere we have three or four of them. The thing is, when to let go.

"There are priorities," she continues. "Eleven years ago I had cancer."

"I think it was the most traumatic time in our lives," adds Lee. "It was earth-shattering, the thought that she'd die or be chronically ill."

"It was scary all right," says Ada. "We were incredibly close to one another, but we tried to keep some humor about it. The day before my operation we took a picnic out on the Huron River. It was so beautiful; we drank champagne to calm our apprehension. We had to let things be—we didn't know how the operation would go."

"Luckily, the surgeon caught it in time," says Lee. "I think we've been lucky in our lives, but we've made adjustments where we've had to. One thing that has changed dramatically is our sexuality over the last few

years. I don't like it; I feel less of a man. You don't know if your level of passion has fallen off because your physical apparatus has fallen, or if it's a mental deterioration. I think it's the physical that causes the lack of interest. You're impotent. We haven't talked about it much."

"Wait a minute," says Ada, "I thought we did. Wasn't it you I talked to? Well, I feel it's a change, but I still feel we have great intimacy. It's not the same as it was, but I don't think sex performance is as important to me as it is to Lee. I think men have a different view of it. I think he's as much of a man and a lover as before."

"Oh, Ada," he says, "that can't be."

"But, Lee," she says, "if I say so, then, oh, stubborn."

"That can't be," he insists, "because in discussions I've had with other men this is a constant theme. We laugh about it, but it's a defensive laughter. I think men spend 95 percent of their time thinking about sex. Here's something that you've always been able to accomplish as part of a fulfilling life, and when that main activity has deteriorated to a point where it's almost nonexistent, that's got to have a dramatic affect.

"Nobody can give advice on how to make a relationship work," Lee adds, "because each individual will act out his or her own needs. I think we've been very lucky.

"Once when we were living in Ohio, we had another experience that was as bad as Ada's cancer. About nineteen years ago, when I was out of town, a man entered the house and Ada was nearly raped. Flying back from Reno, Nevada, to Ohio was very trying, and not being able to see Ada for seven hours was torturous. The only thing that saved me was that a long-time friend of hers joined me on the flight."

"It was terrible," Ada confides. "I had to go to the hospital; I was hurt and shaken, but I got over it. Once you have that experience, you have sympathy for so many other experiences that people can have. Rape is prevalent, people don't even talk about it, and you

become a soiled person if people know. But I'm not a soiled type of person. And of course it was very hard for Lee because he wasn't home; he was traveling in those years and had to leave me. It took a lot of discipline and growth to accept the changes I went through. They never found the person who did it, though we figured out that he knew me because it was a very small town. It was something that you live through, and you come out of it somehow with an awareness that cannot hurt you."

"I think another woman would have had a long-term negative reaction, but Ada did not," says Lee.

"Well, I did," she insists, "but I have this impossible disposition. I was born that way. My will to be OK is very strong. Now I don't think about it at all."

"I don't think about it either," says Lee, "and I wouldn't say that I'm more protective of her now; I was always protective of her because of her vision."

"Oh vision, pooh!" says Ada. "See, Lee can't drive and I refuse to have him drive me. He's a nervous wreck. When I was learning how to drive we had a nice yellow car. One day we were driving, and he was supposed to be giving me instructions. There wasn't a person as far as you could see. Flat. Ohio. One mailbox. And Lee was yelling, 'You're gonna hit the mailbox! You're gonna hit the mailbox!' So I drove up to the mailbox. I stepped on the brake and got out of the car and I said, 'I didn't hit the mailbox, and if I did, we have insurance, and I'm never gonna drive with you again.' And I haven't; this was about forty years ago. I'm tough! But isn't that a great statement?"

Del Martin, seventy-four, and Phyllis Lyon, seventy-one, have been together for forty-two years. They met in Seattle, Washington, and cofounded the Daughters of Bilitis, the first national lesbian organization in the country. Phyllis spent many years working as a journalist and as an activist in the field of human sexology. Del worked as a bookkeeper and was also a freelance writer for many years. She has a daughter by her first marriage and two grandchildren. They are the authors of Lesbian/Woman.

Del Martin and Phyllis Lyon

"Del and I met on the job in Seattle in the early fifties," says Phyllis. "I was working for Pacific Builder and Engineer, and I remember the staff was all really excited because we'd heard that a gay divorcee was coming up from San Francisco to work with us. She turned out to be Del."

"*Gay divorcee* was a term used in those days to describe divorced women," explains Del, "but nobody knew I was actually gay."

"Anyway," Phyllis continues, "our building had a long hallway with offices on each side, and on the day Del was supposed to arrive we were all hanging out in the hall waiting to see this gay divorcee. Here comes Del, trotting in with a briefcase, and I was very impressed because I'd never seen a woman carry a briefcase before. So I had a party for her because she was new, and I thought it was a little bit strange that she spent all evening in the kitchen with the guys smoking cigars. They were also trying to teach her how to tie a tie, but she never learned."

"I might say," adds Del, "that smoking cigars had nothing to do with my being gay."

"Oh well, I know that," says Phyllis.

"I know you do," chides Del, "but other people don't. See, I'd smoked cigars with my husband when we played pinochle."

"Anyway," Phyllis says, "some time after that, Del and another woman and I were having drinks one night and somehow the conversation turned to homosexuality. Del finally said something to the effect that she was a lesbian, and I found that really exciting. I'd never thought about lesbians; I didn't know anything about them.

"I was so excited that when I got home I called all the women I knew and worked with and said, 'Guess what? Did you know that Del was…' It never occurred to me that was not a good thing to do. In fact, one woman's husband said that as long as I was going to have anything to do with Del, his wife shouldn't have anything to do with me.

"But I didn't think anything of it," she continues. "I really liked Del and we became good friends. Then one night in my apartment, she finally made a half-pass at me, and then I made the other half."

"I was so nervous," laughs Del, "because she could've rejected me."

"But I didn't," says Phyllis. "In fact, we didn't even talk about it, we just got into bed. Up until then I had gone out with men, married men mostly. I guess I assumed that I would eventually get married, because that's what we all did. The reason I didn't make any move towards Del was because I realized that, when I went after men, it was interesting only when I was going after them, not after I'd caught them. I was afraid the same thing would happen with Del, and I didn't want to lose that friendship, so I held back on doing anything until she made a pass. But I have to say that I was fascinated by the concept of being with another woman, and when Del made the pass at me, I think I just felt really curious."

"I remember her flirting with me," says Del. "I guess I wondered about that because I just assumed that she was my really good straight friend. I didn't know about her sexual orientation, and it wasn't easy in those days to approach the subject; but I did feel that I was in love with Phyllis. She was attractive and we had a lot in common—like politics, and organizing, and do-gooding —and I really liked being with her."

"For me it was so exciting," says Phyllis. "It was kind of scary, but I found it easier to be with a woman because there weren't all those crazy things that women are told about men. Anyway, we eventually came back to San Francisco and, in 1953, started to live together on Castro Street."

"At this point I figured it was a lifelong commitment," Del says. "I remember taking her down to the bank and opening up a joint checking account. We didn't know any other lesbians at the time, but we found out later that a lot of them had separate bank accounts—and the attitude, 'This is your piece of furniture and this is mine,' so it was very easy for them to break up."

"I think the reason we didn't break up that first year was because we couldn't figure out how to divide the cat," laughs Phyllis.

"We did have some problems," says Del, "like with family on holidays. My folks would expect me at their place, and hers would expect her."

"So we'd meet on street corners in between," Phyllis says.

"We never spoke of our relationship to our parents," Del says, "but I think after we bought the house and the car they must have known. I know my mother certainly accepted Phyllis."

"Remember she used to give us the same thing for Christmas?" says Phyllis. "Those frilly little blouses with lace that you just hated?"

"I'd forgotten about that," says Del, "though I do remember that we tried to get the families together one year. We invited all of them over to our place for the holidays, but it didn't really work out. Our parents were so different. The next year we all went to a restaurant, and then we just gave up on it. Anyway, it was time for us to create more of an extended family. We needed to meet some other lesbians and expand our circle."

"You know, there are a lot of people who wouldn't think of us as being shy," says Phyllis, "but in those days we were."

"We'd go to the bars in North Beach," explains Del, "hoping to meet some lesbians, but they'd be sitting around in cliques and we didn't know how to break the ice. We'd be watching them as if we were tourists or something, and they wouldn't come over to us. Finally a couple of gay men around the corner from us introduced us to a lesbian named Noni."

"And it just happened," says Phyllis, "that she was one of six women who had been talking about starting

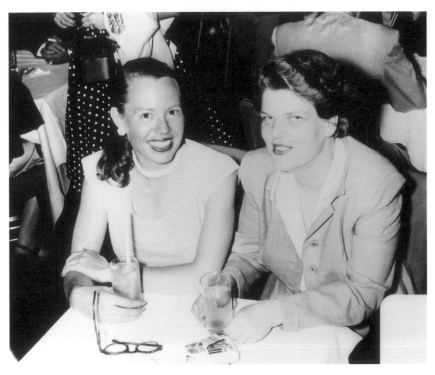

Phyllis Lyon and Del Martin, 1950s.

a secret social group for lesbians. It was inspired by a Filipina woman named Rose, who wanted a place where lesbians could dance and be safe from police raids. She wanted a way to get together with other lesbians away from the bars. So when Noni called us on that fateful day in 1955 and asked us if we'd be interested in getting involved, we were pretty excited. What was created was Daughters of Bilitis (DOB), the first lesbian organization in the country. And it grew; eventually there were chapters in New York, Los Angeles, Chicago, and other cities."

"We became peer counselors for the group," Del explains. "In those days there were no protections. Lesbians were thought to be immoral and sick. You could be fired from your job, thrown out of your house or your family, put into a mental hospital, and kept there for ages. We wanted to help lesbians build their self-esteem and develop a sense of self-acceptance, because they had internalized a lot of homophobia. We figured if they could accept themselves, then they could cope much better in this society. At one point, our house was a real sanctuary for lesbians."

"Well, we had most of the DOB functions here," Phyllis says. "We'd have these Gab 'n' Javas here—you know, coffee and talk parties, which years later became known as consciousness-raising groups."

"I remember a lot of the members said if Phyllis and I ever broke up it would be just awful," Del says. "And Phyllis said, 'Why don't we do it for a while just to see what happens?' But we never did."

"We had our ups and downs," remembers Phyllis. "We fought over silly little things, like Del's tendency to leave her shoes around. One time I threw them out the window into the backyard."

"You know, we'd each lived alone long enough before we met," explains Del, "that we had some trouble getting this 'together thing' in sync. But we question couples who never fight; we think something's wrong with the relationship."

"It's not natural," adds Phyllis. "In fact, I taught Del how to fight because she was inclined to be very withdrawn and quiet. When we'd fight, she'd go out and slam the front door and walk around the block several times."

"I think Phyllis regretted having taught me to fight," says Del. "I remember one time that I did stay and fight—we were standing up and really going at it."

"And then suddenly we both burst out laughing," says Phyllis.

"Now when we get mad at each other," explains Del, "sometimes we don't speak for a while; but it's hard to stay focused on being mad about something for too long. To relieve the tension maybe I'll say something, or give Phyllis a hug, or pat her on the butt."

"I think we've both grown a lot; we're certainly older," Phyllis says. "In fact, we're feeling a little bit creaky, and we lose our memories occasionally."

"Yeah," Del says, "you get a little twinge here and there. We admit to being old. Now we're members of Old Lesbians Organizing for Change, and we're trying to deal with ageism."

"I don't know if we see these years as the golden years," says Phyllis, "but we did buy a sundial that says, 'Grow old along with me, the best is yet to be.' I'm not sure if that's the truth, but it's a nice concept. I think Del and I have had a really good life together. The thing is, we don't have any secret that everybody seems to think exists, some magic ingredient that's kept us together for so long. I keep saying that if we had it, we'd be millionaires at this point."

Tony and June Giambalvo have been married for thirty-eight years. Tony is a dentist who works exclusively with HIV-positive patients, and June is a school nurse. They have six children and seven grandchildren. They met in Boston, where Tony was studying to become a dentist, and June was a nurse. He is sixty-two and she is sixty.

Tony and June Giambalvo

"I think if there was any point in our marriage," explains Tony, "when we were, not in trouble, but under a lot of stress, it was about twenty years ago, when June realized that she wanted more in life than just being a wife and mother. She had gone on a church retreat where the emphasis was on you and your self-worth, and I think she realized that, while she was happy, there was more that she wanted."

"Yeah," says June, "something was missing for me."

"And this was troubling when she first verbalized it," Tony continues. "I'm saying to myself, 'What did they do to her on this retreat? Who's messing with my marriage?' You know, we had almost twenty years of marriage behind us at that point; it was working well, and what do you want to fool with that for? I was angry and I was hurt."

"We fought about it a lot," adds June.

"Well," he explains, "I was extremely threatened because I'm thinking, 'This is not my wife, this is not

the loving mother of my six children.' This was somebody who wanted to be, I don't know what…."

"Different," says June. "I wanted to be different, and Tony didn't want me changing. But I needed more independence, and I kept saying to him, 'It's good, it has to be good because this is the church.' We were very entrenched in the church, and I told him that he needed to go and experience this retreat for himself."

"And I did," says Tony. "And when I came back, I was able to verbalize the fact that yes, I understood where she was coming from and where she wanted to go with herself."

"So that's when I went back to school, took the refresher course for nursing, and went back to work," says June.

"And I supported her," Tony insists, "because I realized that she had so many talents that she needed to use and many gifts to give people.

"I know this sounds corny, but to me, June is what

love is," Tony says, starting to cry a little. "I think that's what troubled me when she wanted to go on her own, because I figured, 'This is mine.' I didn't want to share her with anyone, and I was hurt that she wanted to share with others."

"Tony is a very sensitive man," June explains. "He's very loving, caring, and extremely supportive in whatever I want to do. I had been away from nursing for seventeen years, and he encouraged me to go back. I think it was about us realizing what the other person needed and what they had to give to the world. When you're in the medical profession, as we are, you're in it because you're there to help, to do good for people, and you don't know where that's going to take you. Just like the work that Tony is doing now."

"Yeah, that took some talking," says Tony. "About six years ago one of the directors for Catholic Charities, a priest, told me that I had a talent that nobody else had because I was both a dentist with thirty years experience and an alcoholism and drug counselor. He said that there was a terrible need for people with AIDS and who were HIV-positive to get dental care. I thought about it and didn't know if I wanted to do it. It seemed a very risky business because it's a fatal disease, and I knew it could be spread through blood, and in dentistry you work with blood everyday. So I asked June about it, and we finally decided that yes, I should do it. It had to be a mutual decision because, if I got infected, I could pass it on to her. The work has absolutely changed the way I think about life. I've come to appreciate everything a lot more because I'm dealing with people who are coping with very serious problems, and it's helped me set my priorities about what's really important—and that is loving June and my children and grandchildren. I think I'm much more affectionate now than I was in the past."

"If that's possible," June laughs. "He's always been really loving."

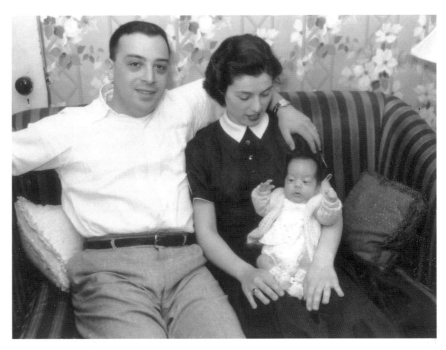

Tony and June Giambalvo with their daughter, Maria Elena, 1958.

"June and I are both very touchy-feely, huggy-kissy kinds of people," says Tony, "and that's very important. I think in our early marriage it was important because it gave us a sense of who we were for each other. But in the early days I think some of our disagreements were because I wanted more sex than June wanted."

"Well, I was worn out," she says.

"I didn't know how to verbalize it then," he says. "I would pout and be a spoiled brat, and I thought I was perfectly justified. It took me a while to get it into my head that if my wife says no to sex at a given time, that's OK; it doesn't mean she doesn't love me, it just means that she doesn't feel like having sex at that time. This is hindsight, but at the time I'd get annoyed and feel that I loved her more than she loved me."

"And I would get angry at him," says June, "because at the time I had three babies and all this work to do.

Tony and June Giambalvo with their children (clockwise from left) Tom, Maria Elena, Anita, and Kenneth, 1966.

How did he possibly think that I could drop everything and make love? When we got into bed at night I'd say, 'Honey, I'm so tired I can't even think about that.' He'd be like, 'What do you mean you're too tired? I work just as hard,' and I'd say, 'No, it's not the same.' There were a lot of times when I felt very overwhelmed by all that I had to do with the children and the house."

"When we had my dental office attached to the house," Tony explains, "I would come inside the house when it was quiet and expect to be entertained—sexually, or just sit down and talk."

"And I think I felt guilty," June continues. "I was supposed to make him happy, but I was so busy."

"And I tried to make her feel guilty," Tony admits. "But then I started having some idea of what she was going through. I could hear what was going on through

the office door during the day with the kids—you know, her yelling at them and the kids coming in to ask me questions when I was with patients—and I began to realize, 'Wow, it's not that easy.'

"But it was an overwhelming time. Here I am trying to start a new dental practice, and I have the responsibility of a wife and so many kids. I was working six days and five nights. And if you want to know the truth, June was too good a wife and mother at the time. Not that I was slacking—I was working my rear end off—but she made it easy for me. When I'd come home from working, I wasn't worrying about a thing; the kids were there, there'd be dinner ready. I had no idea how overwhelmed she was."

"What made those times harder," he continues "was that June was very verbal during those arguments, and she was hurtful, too hurtful. It was the only thing I didn't like and didn't understand. I'm intense, but June was the screamer. I'm also the I'll-never-talk-to-you-again type, an I'll-show-her type of person."

"I remember one fight, I don't know if this was our first fight," says June, "but it was a whopper."

"Oh, that time I slammed the door and it almost came off the wall?" asks Tony.

"Right," laughs June. "I'd threatened to leave—don't even ask me what it was about—but Tony got very angry and he said, 'You walk out of this house and you will never walk back in!'"

"And then I left," Tony says.

"Which meant I wasn't walking out," June adds with a smile.

"But that was a very good argument," insists Tony, "because afterwards we had a little discussion, and we decided that no matter how angry we might get, no matter how much we might kick and scream, we'd never say to the other, 'I'm going to leave you.' Never put the marriage on the line.

"It's changed. Now June doesn't do that anymore,

and if she did, I would probably know where she was coming from and ignore it. In the past I would just not talk to her. I'd say to myself, 'I'll show her,' but now I'd be more apt to say, 'What you said really hurt me, it made me feel so and so, and I don't know why you said it.'"

"And that helps me," says June, "because I don't mean to hurt him."

"Also what I love," adds Tony, "is that June can very easily say, 'I'm sorry, you're right.' I have a lot of trouble saying that. I can demonstrate sorry, but to verbalize it is not easy."

"I think how we handled a lot of those fights and our differences," June explains, "was that we just grew with it, and we began to recognize the other person's needs more."

"I think we're freer now," Tony says. "We don't have that crazy, young, wild sex, but I think the quality is much better. It's a different kind of love, we have different expectations."

"It's because I understand him more," June explains. "And I understand myself more. We don't get in our own way so much."

"For me," says Tony, "I've realized how much more my marriage is when there's a spiritual aspect to it. I think spirituality is the key. I think God is present in our marriage in the sense that He's there in each other. He's present in the love and the kindness, the compassion and understanding, in our marriage. Maybe this is why our sexual experience is deeper now than when we were younger. I think the most important sexual organ is the brain, and when things are right between me and God, and between me and June, and our spirituality is very strong, this affects us sexually. It's kind of like a love triangle with God and June and me. The closer I get to God, the closer June comes to me—like in an equilateral triangle, you know, the sides always stay equal—so If I get closer to God, June automatically gets closer to keep the three points equal."

Dona and Frank Irvin have been married for fifty-eight years. Dona, seventy-eight, worked in the education department of a major university for many years and became an author at sixty-five. She is currently at work on her second book. Frank, seventy-six, is retired from the university's engineering department. They love to travel and collect art; they have one daughter.

Dona and Frank Irvin

"You know, Frank is a very handsome man," Dona begins. "He's also a very caring and sensitive person, and people of all ages are attracted to him. So much so, that for years I felt that I was in his shadow and that people tolerated me because I went along with Frank. Frank is also a giving person, though I don't think he's quite as understanding of people as I am. Wouldn't you say that, Frank?"

"Let's just say," Frank smiles, "that I'm not as understanding of people as you think you are."

"Okay," she laughs, "I'll accept that. But you do get impatient with people, like when that young fellow was playing that rap music and it just drove you up a wall. You see, Frank had been gardening, and he came inside the house and asked me to come out and see if I heard the same kind of music he thought he was hearing from this car parked in the circle. Sure enough, it was some of the rap music that we can't stand—you know, violent, sexist, and obscene—just the sort of thing we don't want coming inside our house. So I asked Frank if he would ask the young man to turn it down, but Frank said that he was too angry and couldn't cope with it. So I asked him if he'd like me to talk to the young man, and he said he would. And, sure enough, the young man did turn it down. So we're like a team, we work together. When he can't cope with something, perhaps I can, and vice versa."

"I think in order for a marriage to work," says Frank, "you need to have positive expectations. We were eighteen and nineteen years old when we wed; but young as we were, we said that we're in this marriage forever, until one of us dies. We aren't in this to try and see if it works in the next few years and then split up."

"Plus, we learned to make compromises," adds Dona, "and that's been very important in staying together for fifty-eight years; because if you were to follow us around the house, you'd wonder how we get along because we're so different."

Frank and Dona Irvin, 1962.

"We're different all right," Frank nods. "Daylight and dark different. But having been married so long, we've had to mesh someplace; and I think it's our differences that have brought us together."

"And we've made these compromises," adds Dona. "Like Frank tends to be a very messy person, and sometimes this drives me crazy. He has a room in the house, and we keep the door into it closed because you can't physically walk inside. His things are everywhere—he doesn't know where his mail is, or his files, and I just wish… But on the other hand, his personal bathroom is spotless; you go in there and it doesn't look like anybody's used it. It helps to have our own spaces; this way we avoid an argument. The issue of time also has been very hard for me. I tell him I'd like to leave the house at 10:30, but 10:30 comes and Frank is never ready to go. So I just grin and bear it. That's all I can do. That's a compromise I make over and over again."

"And I have to compromise, too," says Frank, "like getting places a half hour before you're supposed to."

"But that way you get the seat you want, Frank!" she insists.

"Well, I like being on time if it's convenient for me," he laughs. "You know, Dona likes things up to snuff and very exact. She'll ask me, 'Now what exactly did so and so say?' And I don't remember what they said exactly, and I don't care about these things."

"But you know," says Dona, "this is what I mean by the compromise. You can't get your way all the time when you're living with someone. Besides, these kinds of differences shouldn't have to destroy a marriage.

"There are problems and there are problems. We disagree on the minor things; but on the major things, like our belief in God or how we want our lives to go, we're in agreement. We've been through some situations that could either pull people apart or bring them together, like when our beautiful little son died in 1943, when he was just five years old."

"That was a rough period," Frank agrees. "His name was Frank Edward Irvin, Jr., but we called him Juggie. I'd taken him to the hospital to have a tonsillectomy, but what we didn't know was that he had an enlarged thymus gland. When the ether was given, it cut off his breathing and killed him."

"I was at home with our ten-week-old daughter, expecting Frank and Juggie back in a couple of hours," says Dona. "It was just a routine procedure. And Frank calls and says, 'I'm coming home but I have some tragic news.' I thought I'd never smile again. I had dreams that the doctor came and said, 'Mrs. Irvin, we made a mistake, that wasn't your little boy.' I dreamed that for years, but not anymore, it's not so tender anymore."

"I still think about it some," adds Frank. "That was the most difficult period of my life. I had so many hopes and aspirations for Juggie and me. He'd told me once that we should buy a store because he wanted to be the

cashier. There was so much I wanted to do with him. But the incident brought Dona and me closer because as devastated as we were, we consoled each other and refocused on what we were going to do for our daughter."

"The other tough situation, which we went through more recently, was in regards to the faith we had in one another," explains Dona. "As I said, Frank is a very popular person, and recently I've wondered if maybe some of these women who get to know him are interested in more than just a fatherly relationship. And we've talked about this."

"I'd say that we saw this in a slightly different fashion," says Frank. "I felt that the younger women *were* interested in a fatherly image and someone they could discuss things with from a male perspective, like talking about younger males with an older male who had been along the path."

"Well, I didn't object overall to the way the younger and older women reacted to Frank," she says, "but there was one young woman who took it a bit further than I was comfortable with, and she just got under my skin. After fifty-eight years of marriage I found myself jealous, which I didn't think was bad because I feel that it's normal to have some sort of jealousy for a mate who has made a commitment to you. But it also made me wonder, at seventy-eight, about my ability to still keep his attention. This young woman was in her thirties, and that's some competition. I looked at myself and I wondered, 'Are you losing it, Dona? Are you not doing something that you should be doing?' But I think the hardest part for me was not being able to talk about it with anyone. All my women friends adore Frank, and I didn't want to talk to our daughter because she loves her father and I didn't want her to know that I was having those kinds of feelings."

"You know, at first I didn't quite understand where Dona was coming from," says Frank. "But then, as we talked about it, I could understand. I think the atten-

tion I get from younger women is of my own making, because I'm interested in people from the standpoint of what I can bring them, and not what I can get from them; I want to be of help to other people, but at the same time I don't want that to infringe on how my wife is feeling— someone whom I dearly love and have been associated with for over fifty years. No one is as valuable as your mate, not even your own child."

"But, in all of this," says Dona, "as unhappy as I was during the situation, I kept thinking, 'You know, this is pretty good of Frank. He's past seventy-five and I have to be worried about him.' It was a compliment to him!

"I happen to think that Frank and I are soul mates. We started out with young love based on lust, and now we've matured into a love that includes our souls as well as our bodies. When you spend fifty-eight years with someone, you have an opportunity to grow in so many ways. In the last ten years our spiritual lives have opened up for us, and this has really brought us together."

"We practice the Science of Mind," explains Frank, "and it's certainly made me more understanding of Dona and of other people. There were times that if people didn't see things the way I did, I felt that they were wrong. Dona has been able to progress a little better than I in this area, like the example of the fellow playing the rap music."

"It's really helped me in the area of my self-esteem and confidence," says Dona. "When I was young, people couldn't deal with the way my name was pronounced,

Dona Irvin with her daughter, Nell, 1947.

Frank Irvin, 1948.

85

so I let them call me Donna because it was easier. But through my discovery of my self-worth, I got the nerve to call all of my friends and tell them to call me Dona. I also think Science of Mind has given Frank and me an important area to agree on. Now we meditate together and talk about things of a more spiritual nature on our morning walks. It's deepened our connection and given me a spirituality that I can internalize. I don't feel that I'm in Frank's shadow anymore.

"And part of the reason that Frank and I can still come together sexually is our spirituality, which has allowed us to become who we really are. We were inexperienced when we met, and we developed our sexuality together. In my new book I write about how even now, at seventy-six and seventy-eight, we have developed a comfortable frequency with sex. We might go two weeks without having sex, or we might have it twice a week; but at the same time we have these embraces and kisses, which I still think of at this stage in our life as sexual."

"I think the frequency is the only thing that's changed," says Frank, "though I remember the time this year that Dona and I had sex twice in one day!"

"And another time," Dona says with a smile, "Frank and I had been out somewhere. We came home feeling good and had sex, and it was great. The next morning we had sex again, but the phone rang during it and it was our neighbor needing a ride to work. So Frank took him and we didn't get the enjoyment of the second time, but at least we knew it could happen. We felt great about it and wanted to tell everybody, because we wanted to encourage other people that if a seventy-six-year-old man and a seventy-eight-year-old woman can do it, they can, too."

il and Becky Johnson have been married for thirty-three years. Gil, fifty-eight, was born with limited vision. He could read large print until he was fourteen years old, but since then has had no sight at all. Becky, sixty, is legally blind, with no vision in one of her eyes. She spent many years teaching the blind and continues to substitute at a school for the blind. Gil works at the American Foundation for the Blind as a western director and employment specialist. They have two daughters and one grandchild.

Gil and Becky Johnson

"I know this may sound strange," says Gil, "but I don't think of myself as blind. I realize that I don't see, but it's not a central thing in my life. I don't think about it, and I guess I've figured out ways to accommodate it. And in our marriage, I think we've created a way to work past the fact that I can't see and Becky has limited vision."

"Well, there are some logistical aspects of being blind that you have to plan for in terms of how you live," explains Becky.

"Like Becky reads the mail and writes the checks," adds Gil.

"And Gil does the book balancing with a calculator or a braille ledger," says Becky. "I do most of the cooking and cleaning, but Gil can cook, and he can survive when I'm not here. I spent last week in San Diego with one of our daughters, so he pretty much had to fend for himself."

"Well, I can cook all right," Gil laughs. "I can cook a burger and do up a toasted cheese sandwich. But when she goes away, she does a really nice job of lining things up and pulling things out of the freezer. I did run into a problem when I wanted to sauté some mushrooms, though, and thought of calling her to ask how much butter to use; but I decided that I'd just try it and see what happened."

"Start with a little and add some," instructs Becky.

"I think what we've worked out here after thirty-two years is a flow," says Gil. "I think I came to appreciate this about three years ago when Becky lost her sight for a week and I became aware of how it had really taken two of us to run the house. Becky had gone to the eye doctor that day and found that her retina was in danger of detaching, so that night she had surgery. For about a week after that she had no vision at all. The mail would come, and I wouldn't know what it was because I'd come to depend on Becky for that. There were basic responsibilities, like house payments and checks to

write, and I really became aware to what extent having sight determines what you do in life."

"Well for one thing, I usually help him choose his clothes," Becky says. "You know, he'll ask me what jacket goes with what shirt and stuff like that. So during the week I couldn't see, he had to call a friend over to give him some advice."

"And the other thing I realized when Becky lost her sight," continues Gil, "was that previously she could go wherever she wanted to, whenever she wanted to. Then all of a sudden didn't have that kind of freedom, and I was sad for her. One night we walked over to a friend's house, and I was guiding, her using my cane. I'd never done that with her before. Usually she'd guide me, arm in arm. I felt very sympathetic to her; she was very vulnerable and I understood that. If I say this incident made me appreciate her more, it cheapens it. It's more that I came to appreciate the kind of lifestyle that we've carved out—you know, I do this, and she does that. We complement each other, and we've developed this over time."

"It was the same with raising our girls," says Becky. "We always worked together in guiding them."

"Having kids changed our lives immensely," says Gil. "For better or for worse, who's to say? There were times we could have done without, thank you very much. There have been some good points and there have been some…"

"Struggles," adds Becky.

"I hadn't pictured myself as a father," Gil explains. "In fact, I'd never really thought of myself as ever getting married. Certainly being a father wasn't a central issue for me. But it was real important for her, and I remember one Saturday afternoon before we had the girls, we'd taken a walk around Lake Merritt, and she basically gave me an ultimatum, something like, 'Well, is we or ain't we?' And I said, 'Well, I'll think about it.' But she wasn't going to have any of that. She was going to make a decision then and there."

"I was always real adamant that I wanted kids," Becky says, "and lucky for me I could have them. But I think especially lucky for him, if you know what I mean."

"She means our relationship wouldn't have gone on without them," grins Gil. "Had I said that I wasn't interested in kids, I think things would have gone real bad."

"Well, we have felt differently," says Becky. "I remember one conversation we had after Kellie was born. Gil said that if something real bad happened, you know, like…"

"A fire or something," Gil pipes in, "who would I save, the wife or the child? And there was no question in my mind that I'd save the wife."

"And I said that I'd save the kids over him," she says.

"That's the way she is," he explains. "I always joke with her that genetically she has two things that she was born with—one was that she wanted to be a school teacher and the other was that she wanted to have a child named Kellie."

"And I did both," says Becky proudly.

"In a marriage," explains Gil, "there are many compromises that both parties have to make if it's going to work. One example would be having kids, because it meant so much to Becky. Another compromise would be the way we travel together. One of the things we disagree on these days is street crossing. When I come to a street corner, I will determine when it's safe to cross by the sounds of the traffic. I totally rely on my ears and my instincts. So if I hear a car and can judge that it's far enough away, then I'll cross the street. And I have to believe that if cars are flowing along a street, they're probably not intentionally going to run me over. Now, Becky has enough vision that if she can see a car, as far as she's concerned, it's too close, whereas I know that I could cross without any trouble."

"Well, the thing is," Becky follows, "I have no depth perception. I can't see how fast the car is coming, so we usually wait at the crosswalk because I'm too chicken to cross."

The Johnson family, 1971.

"I'm definitely more of a risk-taker than she is," says Gil. "And if I've misjudged the cars, I know my body will respond with quick reflexes and get me across the street faster. But she's not in as good shape as I am—I'm better coordinated and have longer legs. Now, if Becky found herself in the middle of the street with cars coming, she'd either panic or run like hell. From time to time this is a source of irritation for both of us, and, predictably, a little argument will ensue. But the truth is, if I were going to insist that we cross when I think it's safe, we probably wouldn't walk anywhere together. But you know, whether or not we wait thirty seconds for a car, in the balance of things it doesn't matter a hell of a lot. At the time, do I think it's dumb to stand there? Yes. But am I going to convince her? No."

"And would you like me to fix you dinner later that night?" laughs Becky. "No, I'd say that most of the arguments we have don't last overnight."

"Hardly," says Gil. "You didn't like it when I was burning up that box in the fireplace recently."

"Well," adds Becky, "aside from the fact that flames were shooting up the front of the fireplace and I couldn't convince him to stop....I'm scared spitless about fires, I left the house. If he likes to play with fire, that's not my doing."

"So she walked outside and cooled off," Gil remembers with a chuckle.

"Each of us has his or her own areas of stubbornness," admits Becky. "I deal with it differently, depend-ing how long a leash I have on my tolerance that day. Sometimes we just back off from each other. We recognize that each of us has our own needs, we don't have to do everything the same way. I go to a singing group, and he likes to ride his tandem bicycle with his friend. We respect that we're different."

"Well, we both love our hobbies," says Gil. "Mine is woodworking, and that's a central part of me. If I can't get downstairs to my shop two or three times a week and cut a piece of wood or nail something together, then I feel like something is missing in my life. She has the same kind of drive for gardening. She knows a lot more about gardening then I ever will know or will want to know; I think that's wonderful. I know a lot more about woodworking and electrical wiring than she'd ever want to know. If I need help with something in that area, she's there to help me."

"And by the same token," Becky explains, "he does the grunt stuff in the yard that I can't do, like building planter boxes for me if I need them."

"If I could wish for anything," Gil says, "I'd wish there were more hours in the day because there are so many interesting things to do, and I'd wish that our oldest daughter could reach her potential. But I wouldn't wish for sight, because that's just not going to happen. Sure, I'd like to drive a car, but that just can't be."

"So then maybe we ought to wish that our public transit doesn't go on strike," laughs Becky.

"Our marriage isn't spectacular," says Gil. "It's not razzle-dazzle. It's something that has evolved, grown, and matured. I don't know where it will go, I can't predict that. It won't evaporate, that I'm sure of."

"Yeah," agrees Becky, "we've never faced any real tragedies; we haven't lost children or gone through a tornado, our kids are healthy, and we'll stay healthy, knock on wood, for a reasonable length of time."

"Maybe ninety, ninety-five years, something like that," Gil says with a smile.

Paul and Inez Jones met as jazz musicians in Kansas City and have been married for sixty years. They played jazz professionally all of their lives and raised four children together (at last count there were ten grandchildren). Paul is eighty-one; Inez died in May 1995 at age eighty-two.

Paul and Inez Jones

"Well," begins Paul, "when I first met Inez it was at 18th and Vine in Kansas City. She was playing at a piano bar there, and I came in. One of my friends introduced me to her, but it didn't have no meaning to me about what we were later to get into. Weeks and months passed. I was playing at an after-hours club, and our piano player got drunk all the time. We ended up with no piano player once halfway through the night. So this girl, Earnestine Davis was her name, she said, 'I'm gonna get rid of him and get my girlfriend to play the piano.' And who did come? Inez, the one I'd met before. She started to sing—and I knew she could sing—but she sang to my heart at that time."

Inez continues, "The first time I saw Paul, he didn't leave the right impression. He said he'd buy me a drink, and I said 'I don't drink.' But when I saw him on the job, that's when I fell in love with him. He liked my singing, but I liked him, period."

"I guess it was love at first sight," Paul chuckles.

"We went together for about three months, and then we got married. I could see the truth in Inez all the time. She was honest, that was the one thing. What she done with her music was like she felt. She lived the songs she sang. I'd sit up there in the bandstand and put a cap on my horn and just listen to her."

"Well, Paul was very nice to me," remembers Inez. "We'd get together when I'd get through playing the piano, and we'd stay and play some more."

"And we could go on all night," adds Paul. "Inez would be singing 'Kansas City Here I Come' all night, even though we were already there.

"And she guided me," he continues. "She kept me straight. I used to run with a bunch that's no longer living. Charlie Parker, John Coltrane. All those guys have left. Charlie used to sit in this house here. He would get high right here, cause you know how musicians do. I used to smoke and drink quite a bit. I think I'd be dead if I hadn't married Inez. I was traveling in a fast crowd,

in the fast lane, and I wanted to get there fast. What changed me was her. She was a family woman and a career woman, and I said, 'well that's something, that's quality.' She pulled me into the right path, and I been there ever since. Gonna stay that way too.

"When I married Inez, she had been married before and had two children. I come from a broken family with no father, and I thought I could be a father to her two children and have a ready-made family. It was beautiful.

"When Inez was playing at the Fairmont Hotel in San Francisco, some people come over and heard her play. She was just what they wanted for the piano bars they were starting all over the country, she sacrificed her career by not going off to Europe to play piano for the chain of hotels they were opening up there. She was a mother and a family woman first, and a career woman last. If you asked her kids about their mom, they'd say she was the tops, the best. We had four beautiful children in this family, and I lost two of them. My oldest boy and the one next, they passed. The oldest, he was a drummer and a singer and a drinker, and the latter took him."

"Well, he'd stopped drinking, honey," adds Inez, "but it was too late. He had, what do you call it?"

"The liver," says Paul, "his liver went. My boy next to him, we used to call him 'The President,' because he was the guy that had the brains. He was way up in the painters' union; he was an organizer, but this arbitration between the job and the bosses played on his nerves, so he'd just smoke one cigarette after another. Three or four packs a day. And one day his landlady called us and said that the ambulance is taking him to the emergency. When we called there they said, 'are you the parents of Edward Jones? Now hold still, we couldn't save him; he had a heart attack.' And when that came on the phone, my wife and me, we all fell out and started crying.

Paul and Inez Jones in their band, The Earnestine Davis Combo, 1930s.

"The death of my sons was tragic to both of us, but in a sense it brought Inez and I closer together, realizing how we loved each other and how we loved our family. To lose one link in our family was hard to take; and when I'm missing them, I hug her because I know this is where my two kids come from.

"Sixty years, and I still feel the same way about her. She's a beautiful woman. She stuck with me through thick and thin. I been sick a long time, but she's right here to help me get through this crisis. She goes with me to dialysis, because sometimes when I come off I'm staggering and she holds me up. We lean on each other. She'll see something that needs to be done, and she'll say 'You help me with this and I'll help you with that.' I do the cooking and some cleaning. But she takes care of me and our daughter."

"Well, she's sick, baby," adds Inez.

93

"I know that," he counters, "I'm just saying all the work you do. Look how old you are."

Inez laughs, "I'm two times seven."

"You eighty-two," he laughs. "I'm trying to protect you, honey, so you can take care of me. See, couple years ago Inez had a stroke."

"Two, baby," Inez corrects him, "two strokes."

"Yeah," he agrees, "but we're hanging in there with good humor. We see the bright side of life."

"I don't argue with him," Inez insists. "That's the thing."

"No, we've never had a bad one," he agrees.

"Not a big one," she says, "'cause if we had, honey, I'd be gone, you know."

"Yeah, well, in my case, I'm slow to fire up," says Paul. "But when I do fire up I'm hotheaded. And she knows that, and she'll get up and go sit outdoors. Then I'll start dropping things and knocking things over, but in general it don't last. Being sick has changed me quite a bit. Some days I come in irritable, and she understands that and gives me a little room. 'Cause everybody has moods, you know. But when she gets all disturbed, I just grab her and squeeze her and hold her and pretty soon I feel the trembling going down."

"Well," says Inez, "if you're hottempered you ain't going to stay with nobody. You better boil that temper down; and if it gets real hot, just walk out the door, stay gone for about thirty minutes till you come to yourself, and come back home. You gotta work together with your husband. It isn't at all peaches and cream—till you get a little older—but you can't both have a hot temper. For one thing, one is going to have to give over to the other. It's got to be somebody who's a little cool. And talk if you get mad. It's a give-and-take thing."

"One problem I see with a lot of couples," says Paul, "is that they can't maintain their house because there's not enough income. Money is the root of all evil, you know. We never had that problem because she worked, and she had a good job playing at the Rainbow Club in San Francisco. And I had a day job and played music at night. We had enough to put my kids through school; they went to the university.

"See, with me and Inez, we're lovers, we're buddies, we're everything together," he says.

"We were mates before we were married," laughs Inez. "Getting married was just a technicality."

"And we're part of each other now," Paul insists. "If Inez goes first, I won't be long behind her because we are so close together. I feel like I'd be half a man without her; but with her, I feel like two men. I feel good. But everybody has to go sometime, and I would hate to lose her."

"You ain't gonna lose me, baby," she says with a smile.

"You know," he remembers, "there's a tune that goes, 'If I should lose you.' Every word in there, if you think about the tune, is what I'm trying to say about Inez. 'If I should lose you.'"

Mildred and Alden Wagner have been married for sixty-six years. They spent the last sixty-four years living near the small town in Pennsylvania where they grew up. In 1994, they said goodbye to their family and lifelong friends to make a cross-country trek to live with their daughter and her family. Alden was a butcher and a power engineer for many years. Mildred was a housewife. He is eighty-eight and she is eighty-seven. They have two children, four grandchildren, and three great-grandchildren.

Mildred and Alden Wagner

"Mil is outgoing," exclaims Alden. "She never passes anybody without speaking to them."

"I know everybody," Mildred agrees.

"She'd walk up and take hold of their hand," he continues, "and hug them, and it don't matter whether they're big, small, black, white, or all hairy. Don't make any difference to her. It has never bothered me because I felt she was mine, and I had all the confidence in the world in her and never thought that she'd step out of line."

"Oh, heavens no," Mildred laughs, "I have to say, in our marriage Alden went along with whatever I did. I said to him once, 'Do I embarrass you?' and he said, 'Well, I can tell you one thing, gal, you keep things pretty interesting.'"

"I think we were well-suited for each other," Alden explains. "I was pretty serious and I needed somebody who was going to set me up, bring me out a little, and Mil was very outgoing, very aggressive. We met at a church party in 1928. Mil was with a friend of mine, but he was a little slow on the trigger, and I took Mil home that night, stole his girl. A little later I'd gotten hold of a Model-T Ford roadster two-seater, and that started the dating good, you know. I'd take her to work and things like that, but it wasn't too romantic."

"We'd hold hands," Mil explains, "and he would kiss me good night and that was it."

"We weren't rushing like they are now," says Alden. "We didn't live that way in the 1920s; you didn't think that way, at least I didn't. I thought she was pretty nice, and when I finally decided that I'd be all right for her, why then we got going together a little better. I got out of high school and got a job, so I had some money and we could go to the movies, put gas in the car, and go on little jaunts. That's the way we lived."

"Until we got married," says Mil. "Alden came over to my house one night and sat with my mother and father and said he'd like to ask if we could be married.

My mother said, 'Alden, I don't think you can keep that girl in stockings,' and Alden said, 'Well, at least I'd like to try.' He's been buying me stockings ever since."

"Well, I'm not keeping her in stockings yet," Alden shakes his head and smiles, "but we got together then, realized that we were really attracted to one another and that it was time to get married."

"We spent the first night of our honeymoon in a cottage in Falls, Pennsylvania," Mil smiles. "We were virgins, you know, and this little cabin was a wonderful chance for us to become acquainted, know each other's sleeping habits, eating habits, and other things."

"Anyway," Alden takes over, "we went up to the Falls and there's a railroad that goes right by there. We had both worked all day from seven in the morning to nine at night, and then got ready to have this wedding at her mother's house that very night. So we're here to consummate the marriage, but we decided because we were so tired and worn out, it was silly for us to get into a big passion about something that should be very meaningful and nice. We opened the trunk to get our nightgowns and found everything was all sewed up."

"My folks had gotten into 'em and tied 'em all in knots and sewed them with the sewing machine, so we couldn't get into a thing if we wanted to!" Mil laughs.

"So we said, 'To heck with it, we'll go to bed this way,'" adds Alden.

"Bare naked," she adds, "Cause we didn't want to bother taking the stitches out."

"So we went to bed and fell asleep," he continues, "in each other's arms, of course. In the middle of the night the train went by and tooted its whistle, and that did it. I always say that we brought our son Alden back from that honeymoon.

"I'd say sex was always important to us. We're two very loving people, very sexually oriented to each other; I think that's one reason why we have such a happy marriage. One time, when we were living in a third-floor

apartment, we were in the process, you know, and it starts to rain and Mil says, 'Alden, the baby carriage is downstairs getting all wet.' I says, 'Well, you wait until I come back,' and I hopped off the bed, went and got the baby carriage, and came back and finished the job. We were suited for each other like that, comfortable. The only thing that's changed that was my prostate operation; it didn't take it away, but it

Alden and Mildred Wagner in Huntsville, Pennsylvania, 1945.

slowed it down. Well, you know, you've lost your flag, you've lost your cheering section. So now if sex is there, okay; if it's not, then that's the way it's gotta be."

"I felt the loss for him the same way he felt the loss for me," says Mildred. "We have a kiss in the morning and hugging and kissing all during the day. I'm just grateful to have him.

"We were never real argumentative," she continues. "During the Depression there was some difficulty because we had Alden's family with us. His father had lost his job and we had room for them in our house, so they came and lived with us for three years. At that point Alden was supporting everyone with his job as a butcher."

"They did what they could," explains Alden. "My dad picked coal and went around putting circulars on houses, and my brother had a wagon to deliver groceries, my sister minded kids—anything they could do—and we pulled them right out of the Depression."

"But during that time I did do something once that

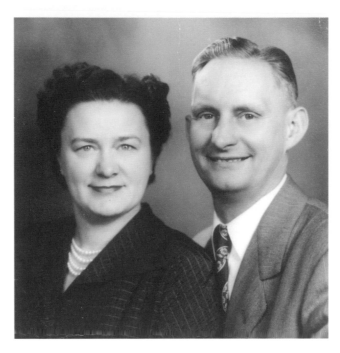

Mildred and Alden Wagner, 1954.

was very disgraceful," says Mildred. "Mother Wagner was a rather difficult lady to live with, and one day I couldn't take it anymore, so I took our little girl Carol, got in the car, and drove away, went to visit a friend of mine in Lacyville. Didn't tell anyone where I was going; didn't even say goodbye. I just had to get away. The only one I was hurting was Alden, which was a very wrong thing for me to do."

"Well, I tell ya," Alden laughs, "I knew she'd be back, I didn't worry."

"And I did come back," Mil continues, "two days later. I just went right back into his arms and everything was fine."

"Those were hard times," explains Alden. "I didn't have much, but I guess Mil must've thought I was the Rock of Gibraltar. She must have had faith in me because…"

"I sure did," Mil nods.

"I told her, 'No matter what,'" continues Alden, "'you stay with me you'll always have enough to eat and a place to live.' See, I had learned a trade. I had become a meat cutter and there was always work for a person like that. I don't like to brag, but in the Valley I was as good as any of them, and when we finally got married I was running one of the biggest stores in the Valley."

"These days, I'd say the only thing we argue about," says Mildred, "well, let's come right out and say it, is football games!"

"She can't stand them," he laughs, "and I can't do without them."

"Yes, I'm a sports widow," she confesses, "because I do not like to yell and scream at the games like he does. And I feel he's very selfish because there's a Friday night game, there are games all day Saturday and Sunday, and there's one on Monday evening. And I don't get to see him."

"Yeah, you can see me," he says incredulously. "I'm right here in this chair; I'm not going anywhere."

"However," Mildred continues, "since we've come into the age that we are now, and see that our friends are leaving us, there are so many widowed women who would just love to have their husbands sit and watch TV in their homes. I have to keep my mouth shut and let him watch whatever he wants to watch, and he has to admit this."

"That's why we get along," he says. "It's a give-and-take thing, but I tell ya, we went out for milkshakes this week and the lady at the counter says, 'What size, small, medium, or large?' and Mil says, 'Small.' So I say to the lady, 'Make it a small.' See what control she has?"

"Well, everybody thinks I'm the boss in the home, but I don't know about that," Mildred adds.

"She's the boss as long as I agree with her," he chuckles.

"We've had it pretty good, but I almost lost Mil here. One day last year she says, 'I can't breathe, I can't

breathe.' And here she's having a bad heart attack. I was shaking like a leaf. We'd always made our decisions together, and now I have to decide whether to let them do this or that to her."

"And I said, 'No heroics,'" says Mildred resolutely. "If it's my time, let me go.'"

"This is what we'd talked about," says Alden, "but I just couldn't let Mil go like that. X-rays showed that she had four blockages in her heart. She's eighty-five years old, she's had a good life; but what's possible for her in the future? And do I want to put her through all this pain and discomfort? Well, she went through it and it was terrible. Afterwards, I went to see her and she said, 'I'm not going to make it.' And I said, 'Well, maybe you're not, but remember, we've had a good life and you leave me now, it's okay, if it's your time to go.' The doctor came in and he said, 'I don't want to put a pacemaker into her.' And I said, 'Well, if it's going to help her, do it.' And now look at her, boy, we've got the flag back on top of the hill now, don't we?"

Daniel and Violet Chu were raised in Hawaii and have been married for fifty-two years. Daniel, eighty-one, is a "jack-of-all-trades," who has had many jobs, including being a policeman, owning a wig shop with Violet, and being the warehouse manager for a Trader Vic's restaurant. Violet, seventy-two, was on the San Francisco Asian Arts Commission, although both she and Daniel are noted for their community activism. They have three children and five grandsons.

Daniel and Violet Chu

"If I had to rate Violet on a scale of one to ten," explains Daniel, "I'd probably give her a nine; she's not perfect, but nobody's perfect, not even I. I *can* tell you, though, that I wouldn't have married her if she were a Republican."

"Oh, the Republicans," adds Violet, shaking her head, "they bring him down terribly. He becomes so angry, and then he uses strong language; and I say, 'God, don't fight with me, fight with whomever is doing it to you.' He's a very contentious man, but I don't let it bother me."

"I am contentious," he admits. "But the Hakkas are very contentious people; it's part of my heritage."

"You know, I never thought I'd ever marry, much less date Daniel," says Violet. "For one thing, as he said, he is a Hakka. My mother had cautioned me about marrying someone with this background, even though my sister had married one. You see, the Hakkas are a Chinese minority, a nomadic tribe going back to the

Tang Dynasty, who were supposedly very low caste. The elderly Chinese called them *San Yang*, which literally means 'mountain goat,' and my mother's and father's generation still believed this. My mother said that one mountain goat in the family was enough."

"Well, I just dismissed this elitist way of thinking," explains Daniel. "The Hakkas are a very proud people. They were kicked out of central China, and as they migrated south, everybody else kicked them out too. The reason Violet likes to refer to us as mountain goats is that the latest influx of people always gets the worst land, and the worst land is up in the mountains. So we were called mountain goats as a joke."

"Anyway," Violet continues, "because of this I never told my parents I was dating him, so I'd sneak out at night to see him."

"This was the beginning of World War Two," adds Daniel. "We were living in Honolulu, and Pearl Harbor had just been bombed. In fact, I saw the beginning of

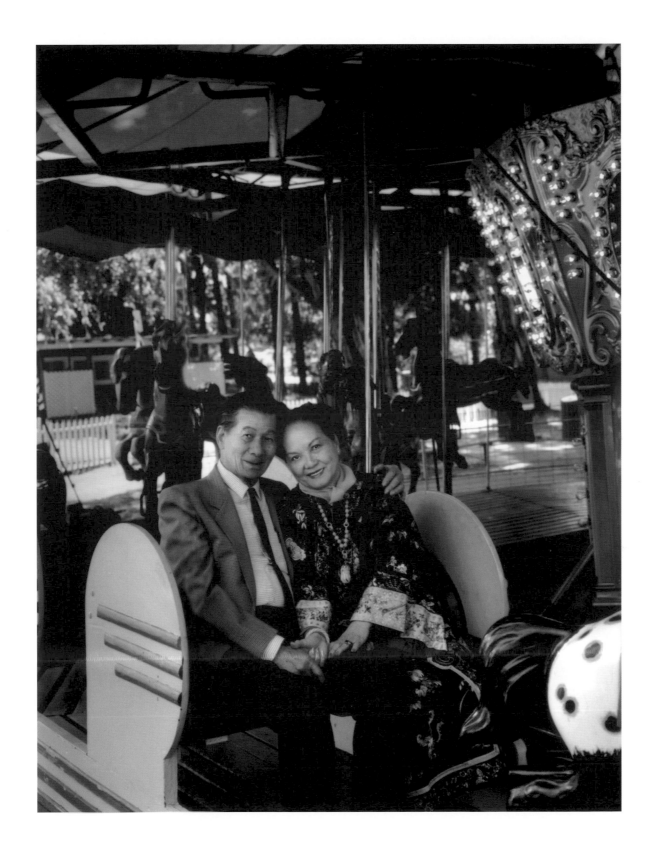

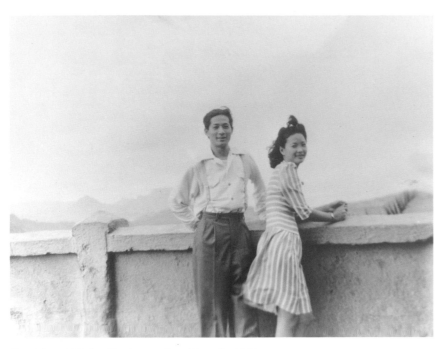
Daniel and Violet Chu in wartime Hawaii, 1941.

the war. We had begun to date, and I was working the midnight shift near Pearl Harbor. I saw these airplanes flying overhead, and the first thing that came to my mind was, 'Oh, I must go home and tell Violet about these realistic maneuvers.' Before long I saw the bombs dropping, and I thought, 'These people are *really good* bombers to drop bombs *right offshore* into the water;' but then I saw the ships being blown up."

"They were on fire," Violet whispers.

"I can't describe the emotion that takes place," Daniel continues, "to think that in your lifetime you are seeing the beginning of a war. I think this brought us closer because, for one thing, we had blackouts and curfews, which began that night. By 6:00 P.M. you couldn't have any lights on, you couldn't drive, we couldn't go out for dinner or to the theater; nothing was open and everybody stayed home."

"But *we* didn't," laughs Violet. "We'd sneak out

when Daniel wasn't working the night shift as a policeman. We were horrible," she laughs.

"Our friends Al and Tina Coler lived five or six blocks away," explains Daniel. "They had a lot of good records, so we used to go up there and listen to music."

"The classics," adds Violet. "Bach, Beethoven. We'd walk there, and every time we saw the blue lights of a police car, we'd sneak into some bushes and hide until the car passed. When we got to the house, we'd sit by candlelight or blue light, and it definitely added to the romance. My mother would've gone through the ceiling if she'd known I was sitting in the dark with a Hakka!"

"While our romance and subsequent marriage did take some edge off the war," Daniel adds, "I think being in a traumatic situation brought us closer. I mean, there were subs hovering around the island, and I remember seeing army trucks piled full of bloodstained pine caskets. I was now part of the military, and I never knew when they would send me out; but I was fortunate never to leave the island. I could even go home to Violet and the kids after we were married.

"Even with the war," he continues, "everything seemed to fall into place for us. We didn't do a lot of thinking about it. I think sometimes people create their own problems. They say, 'Gee, now that I'm married I have to give this up....'"

"Or do this or do that," adds Violet.

"Or mend your ways to accommodate your spouse," says Daniel. "We didn't think like that; we still don't."

"We argue," says Violet. "There's no question about it. We don't see eye to eye on everything, especially when it comes to politics. Daniel has such deep convictions, and it's very difficult to move him from his stand. Sometimes he comes on too strong, and this can make me angry."

"Well, I'm a radical," Daniel laughs. "I march to the beat of my own drum. I'm not afraid to be a maverick, and I'm not afraid to stand alone. I marched in every

Vietnam parade, and I know that in a dictatorship I'd be a political prisoner. Although Violet tends to agree with my politics, I feel that she can be too traditional. She feels that you have to do things a certain way, that if Emily Post says do it this way, you should."

"Well, not everything," says Violet.

"And I say baloney!" he shouts. "Who the hell is Emily Post that she knows everything? For instance, I'm one who will argue politics at a dinner table, especially if I feel that a person is entirely wrong. I know that Violet, being traditionally nice to people, would really object to my being so…"

"Caustic?" she offers.

"Militant," he adds, "using cusswords at nice functions and with so much rancor in my voice."

"He's so confrontational," she adds, shaking her head.

"Oh, I make some terrible enemies at the table," he smiles, "but I do calm down—after I get the last word in. Everybody loves Violet though, but they must wonder how she can stand me."

"Daniel is literally a political animal," says Violet, "whereas I was raised by a very mild and cultured mother. I don't like to argue with him, so I usually keep quiet to avoid an issue. Perhaps this has elements of a traditional Chinese marriage in it."

"Although in a traditional Chinese marriage," adds Daniel, "the wife is required to be very obedient, and Violet is definitely not obedient—not that I would ever want her to be. I remember the first time I met San Francisco Mayor Dianne Feinstein, after Violet had been appointed to the Asian Arts Commission. I went up to her and introduced myself as Mr. Violet Chu. I told another fellow about that and he said, 'No! no! no! You shouldn't do that.' He was a real male chauvinist and felt that the man should be the head of the family. I felt sorry for his wife."

"But another one of our friends," adds Violet, "has taken on this Mr. Violet Chu business, and he calls him-

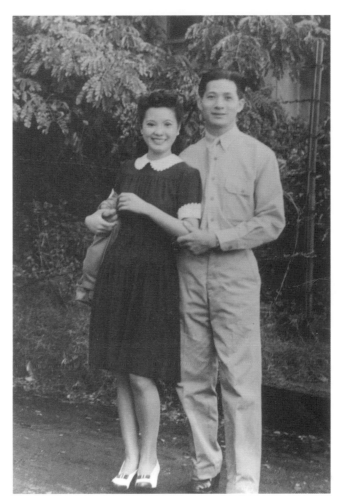

Violet and Daniel Chu in wartime Hawaii, 1942.

self Mr. Virginia Gee because his wife is active like me."

"I don't know why some husbands are jealous of their wives," Daniel says, "because women are just as capable as men. And Chinese women are worshiped. Did you ever see a Chinese man who's up there? Not very often. It's always the women: Connie Chung, Amy Tan, Joan Chen."

"It's been a matriarchal society," explains Violet, "from time immemorial; but I wouldn't say I wear the pants in the family."

"She *has* accomplished more than I have," admits Daniel, "but it doesn't bother me."

"He doesn't care," she says.

"I'm a confident person," he explains. "I don't care what people think of me. There's a phrase we use in Hawaii—hang loose brother—and I live by that philosophy. I don't let things get me down, except maybe the Republicans."

"You must have understanding in a marriage," explains Violet. "It's a give-and-take, two-way street; there's no way, otherwise. And even though Daniel upsets me sometimes, the funny thing is that after so many years I find that some of his contentiousness has rubbed off on me."

"I must tell you something funny," Daniel adds. "We were riding BART a few months ago, and this man had his feet propped up across an extra seat."

"His dirty, big old shoes," says Violet with a grimace.

"I told Violet," says Daniel, "'look at that uncouth person. I wasn't going to say anything to *him*, but when we were ready to get off the train, Violet said to him, 'You shouldn't put your feet on the seat.'"

"'People need to sit on it,'" she continues, "'and they'll dirty their clothing.' When we got off, I said, 'Did I say that?' I couldn't believe myself. I mean, he was a big guy; his shoes were huge."

"I was so proud of her," Daniel laughs.

"Another time I was in Chinatown trying to park," she continues. "I had found a parking space and pulled forward to parallel park when this little sports car dove right into my space. So I braked and walked out and said, 'Listen, mister, I was here first. You've got no right to slide right into my space.' And he said, 'Well, tough.' So I said, 'Okay, mister, you can have the space, but remember, this is Chinatown; when you come back, you're gonna find four flat tires.' He looked at me, got into his car, and drove away, and all the Chinese people in the shops started clapping. And I said, 'Oh, my God, this is Daniel coming out of me. I don't believe I'm doing this.'"

"But the best incident happened in China," says Daniel. "We were at Dunhuang, a site of ancient Buddhist carvings and statues in sandstone that go back to 300 A.D. We were in one of the caves, and there was some erosion, so they had used straw in some of the sculptures in order to hold them together. Well, there was a little break in the foot of this one sculpture. This tourist was picking at it—I guess he wanted a little souvenir—and Violet, without saying anything, just slapped his hand!"

"No," Violet laughs, "the first time he did it, I told him he wasn't supposed to touch it. But then he did it again, and I was so annoyed, that's when I slapped his hand. Everybody around us said, 'Yeah, yeah, yeah.'"

"You know, I was never like that," she admits, "but the longer I live with this man, the more like him I'm going to be!"

Sylvia (Sue) and Emmanuel (Emil) Siegel have been married for sixty-four years. For sixty years they have lived in the same apartment, which is directly across the street from where Sylvia lived with her parents as a child. Emil, eighty-five, owned a grocery store and was a food distributor most of his life; and Sylvia, eighty-three, was a house-wife. They have two children, five grandchildren, and two great-grandchildren. Six years ago Sue lost most of her memory, so Emil does most of the talking for them.

Sylvia and Emmanuel Siegel

"I met Sue on June 15, 1928," Emil begins. "That night one of the fellas and I went to a graduation party where the hostess gave everyone a playing card that matched somebody else's card. So this fella comes up to me and says, 'Will you change cards with me, because I know this other girl that I want to match up with?' So I said, 'All right,' because I didn't know anybody anyway. I had the king of spades and Sue had the king of clubs, and that's how we met. Later that night I walked her home. We got to her door and I said, 'Good night,' and ran."

"I remember meeting him," adds Sue, "but it was very casual."

"Well, Sue's memory is not what it used to be," Emil adds.

"It's not so good," she concedes.

"The first time I kissed her we were on Angel Island with a group of kids," Emil explains. "We walked around the island, and when we came back one of the girls said to her, 'What happened?' And Sue says, 'We walked the whole time, we didn't do anything.' And her friend says, 'What a dud.' So that night I kissed her."

"And then he ran like hell," Sue laughs.

"That was our first kiss," explains Emil, "though Sue had gone out with some other boys before me."

"Yeah, but I don't remember kissing them," she says.

"You went out with that Kreeger boy," he says.

"Yeah, but I don't know," she says.

"Sal Menelovich, you went out with him," he says.

"Yeah, I did go out with him," Sue remembers.

"Sal Menelovich," Emil says with a grin. "She always used to tell me about him. He worked in a drug-store and I worked in a grocery store. One time I brought her candy. Sue was never aggressive asking for things, you know, so she didn't mean anything by it, but she says, 'Sal used to bring me perfume.' Well, a few years later Sal ended up in San Quentin. He'd gotten caught selling drugs, so I always had something to remember him by.

"Anyway, after our kiss, things got warmer," Emil continues. "We used to go out to a place we called 'Perspiration Point' and we used to get pretty hot necking. That's all. We never went all the way until we got married. The kids today are different. We had parties, but we never had liquor or dope. We played games and sang songs. My friend, he was a great piano player."

"Who was that?" Sue wonders.

"That was Babe," he says.

"Did he die?" Sue asks.

"Yeah, he did," Emil answers. "We had a lot of fun in those days. We used to go on hikes every weekend. We'd meet our friends under the clock at the Ferry Building, and we'd take a ferry over to Sausalito and then take the electric train to Mill Valley. From there we'd hike through the fields of Mt. Tamalpais and Muir Woods."

"It was so lovely," says Sue.

"Cedar Beach," remembers Emil. "We'd sing and hike."

"It was so nice," she echoes.

"Anyway," says Emil, "after two years my mother says to me, 'You know, it's about time you should be getting rings.' But I just didn't have the nerve to bring up the thing. I didn't have the guts. But my mother, she was…"

"She was a smart lady," Sue offers.

"So I got her a ring," he says.

"Do I still have it?" Sue questions.

"No, you gave it away to one of the grandchildren," says Emil patiently.

"And you forgave me?" she says sweetly.

"Yeah, I forgave you," he smiles.

"So that July 3," he continues, "my uncle says, 'I'm going to Reno to see the Max Baer–Paolino Uzcuden fight. Why don't you two come along to get married?' So her mother and father rode her down to the grocery store to say good-bye to her, and it was very tearful."

"Did my dad die soon?" Sue asks.

"No, it was a little while," he says.

"Anyway, we got to Reno the next morning," he continues, "and went into the courthouse to get a license, and that's where we had our first fight."

"We argued?" Sue asks incredulously.

"You were mad because the license was two dollars," Emil says, "and I was so happy that I gave him five dollars. Then we had to find the rabbi, so we drove around and Sue sees a secondhand store and says, 'The owners must be Jewish.' That was the way it was in those days; most of the little businesses like that were Jewish owned. And sure enough, the owner directed us to the rabbi, and we had to wait in his house until the first star came out at 8:00 P.M. before he would marry us. We sat there with several people who were there for a divorce. In those days, people came from New York to get a divorce because you only had to wait six weeks in Nevada. There was this one young woman who was crying, and this older woman says to her in Yiddish, 'Why are you crying? You *nar!* You fool! There are thousands of men out there. Look at me, this is my fourth marriage! My fourth divorce!'

"Afterwards my uncle went gambling, and Sue and I walked the streets of Reno. They were shooting skyrockets from one rooftop to the other, and one hit a window and showered us with glass. We all wore hats in those days, and I still have the hat with the burnt holes in it. We spent our first night sleeping in the car with my uncle on the ride home.

"With sex, I didn't know anything. Her father knew a young Italian man who had gotten married a couple of months before, and he asked him to talk to me. So he told me; he explained what I had to do and gave me a book.

"So on our second night back home we're in bed together, and she starts laughing. I says, 'What are you laughing at?' and she says, 'I'm laughing at myself. I was

Emmanuel and Sylvia Siegel, 1943.

worried because you're six-foot-two, and I'm so short next to you that I was wondering how we were ever going to get into bed together.'

"After we got home, we lived with Sue's parents. We were very poor. I was working at the grocery store; and, instead of paying rent, I brought home food for the house. We were happy, it was good times, but then we had a crisis. One day in the grocery store I was exhausted; I sat down and had a nervous breakdown."

"Yeah, that was bad," remembers Sue.

"So we took off for a while," Emil explains. "We went down to Los Gatos to the home of some people who took in boarders, and we rested with them for six weeks. We had a wonderful time, almost a honeymoon, since we never got to take one. The people also had a young man who was minister of their church, and we'd spend some time with him; but he was always trying to get us to change from being Jewish."

"Yeah, I had that feeling," says Sue.

"They were very religious people," says Emil, "but we had a good time. We used to pitch horseshoes in the park and get fifteen-cent milk shakes. We were very…"

"We were very much in love," Sue interrupts. "Yes, it never stops; I have always loved him."

"We were always in love," Emil agrees. "Over the years we bickered a lot. You know, over little things. We ran a grocery together, and she wanted things done this way and I wanted it that way. During the war she had to leave the children and help me run the place and there was a lot of stress; but that was the closest we've ever come to splitting up. Nothing ever lasted more than a day. The one and only time I bought a new car, a 1954 Oldsmobile, she was so mad at me for doing it without her she wouldn't even come downstairs to look at it."

"I was a bad girl," says Sue smiling.

"Our kids, they never gave us any trouble," says Emil, "though there were moments that caused some worry. When our daughter started going with this

Greek man it upset me because we'd rather have her marry a Jew. He was a good man, a nice man, but we didn't want them to get married. But we didn't fight her; we tried to talk to her, and I was pretty sick over it at the time. They had two great kids and broke up after about sixteen years. We didn't feel so badly when they divorced, but when our son divorced it was very sad for us because his wife was like a daughter to us; we were very close. We didn't tell him he couldn't do it, but we were sorry. They had three beautiful children who have been wonderful to us, so we've been lucky in that way.

"It does bother me when I see people getting divorced; I feel bad for them. None of our friends ever divorced; we all stayed married. Sure you have your ups and downs, but you move on.

"Since Sue got sick, we don't fight anymore. She always remembered things until the last six years," he explains. "She had a heart operation, and during the operation her heart arrested twice. Afterwards, the doctor said she'd either have a stroke or it would affect her immediate memory, and that's what happened. Like this morning, I put the toast in front of her and she said, 'What do I do with it?' And I said, 'You put butter and jam on it.' Or she can't remember our kids' names, but when she sees them she knows them. It's her short-term memory. I'm not sure how good her long-term memory is, but it's a lot better. Now she is essentially dependent upon me. I cook, dress her, and clean the house, and she's learned to live with it."

"Yeah, I don't remember things," says Sue gently, "he remembers for me. But it doesn't bother me because I trust him, he's my husband, and he's very bright."

"These have been tougher years," Emil explains. "Sometimes she gets up in the morning and she doesn't wear the right things, and I have to dress her and stay with her at all times. Sometimes she puts things in the wrong place and I can't find them, and sometimes I lose my patience and I'll raise my voice a little bit."

"I don't think anything of it," Sue says adamantly.

"It's not one of the pleasures of life," he contends, "but I do it. I had to learn to do a little more cooking and cleaning. But we're used to it and I'm just glad to have her.

"I don't look at it as for better or for worse; it comes naturally. When I was sick when we were young, she stayed with me. One of the secrets of long-term marriage," he says, "is to do something to make the other person happy all the time. After we were married one year, I came home with one rose for her. The next year on that day I brought her two roses. And I still come home with roses sixty-four years later. Fortunately, my daughter's friend owns a florist shop. It's not a great deal, but I get pleasure out of it. I don't do it so that she's better to me in bed or anything. I do it because I love her."

Bruhs Mero and Gean Harwood had been together for sixty-four years before Bruhs passed away in August of 1995. Bruhs, eighty-three, was a dancer for many years; Gean, eighty-six, worked at Paramount Studios and is also a composer. In 1991, Gean was forced to put Bruhs into a nursing home because he had Alzheimer's disease, and Gean could no longer take care of him. This interview was done both before and shortly after Bruhs went into the home. Gean is writing a book called The Oldest Gay Men in America, *a love story which chronicles their lives together. Though Bruhs was present for much of the interview, Gean does all of the talking.*

Bruhs Mero and Gean Harwood

"I met Bruhs in 1929," says Gean. "I remember that I was a little intimidated because he had a regular girlfriend, and it was just assumed that ultimately they were going to get married. But he and I spent a lot of time together, and eventually, whatever chemistry was at work, Bruhs realized that I meant more to him than the girl did.

"I'm sure it was basically a physical attraction at the beginning, but there was a strange feeling of recognition that passed between us, a sense that we were not really strangers. And we both had the same ideal, which was that we didn't want to ever leave each other.

"Being a gay couple in New York in the 1930s was difficult. All our lives, we were secretive. That was the way we felt we could survive. In order to not make waves we had to blend in with the scenery, and we were very particular about selecting the friends and people with whom we associated. Even with Bruhs in the theater, he still felt reluctant to pal around with other chorus boys who might have been very effeminate. We both felt that we must not do anything to disclose that we were gay. We had to try and remain as straight as possible; this was partly an economic thing, because we could've lost our jobs. I'm sure there were other gay people whom I worked with at Paramount, though they remained in the closet. Bruhs had a little more latitude in the theater world—I mean, there it wasn't looked upon as something akin to leprosy. I think that we've had mixed feelings about keeping our relationship to ourselves. At times we probably resented the idea that a relationship as valid as ours—sixty-four years together—could not be recognized publicly.

"But we built a life together which supported who we were and what we cared about. I think our most fulfilling times were the dance and music work we did together. At that time, in 1930, I was working in the transportation department for Paramount, and Bruhs was a dancer. I worked a nine-to-five day, but on my off-hours, Bruhs and I created this little theater where we

Gean Harwood and Bruhs Mero, 1942.

performed together. Bruhs developed his own, solo dance performances, and I composed and developed most of the music. We had quite a following.

"Bruhs was a perfectionist, and when we worked together we divorced ourselves from our emotional partnership. I was his accompanist, and I was supposed to deliver with the same degree of perfection that the occasion demanded. If I didn't, he told me off in no uncertain terms. There were periods when I felt very chafed with this kind of discipline and thought maybe he was a bit unfair, but in most cases I realized what he was driving at and had to agree with him and what he was asking me to do. We worked on his terms.

"I think that creating together strengthened our relationship. Ours might have gone the way of so many others without that creative cement to tie it together, because in gay relationships it's so easy to say good-bye to someone. There are no legal formalities to pursue,

and it's really very simple. And when you're young, you always feel that there are plenty of other fish in the sea. You don't hesitate to call it a day.

"At one point I drifted into a semi-relationship with someone else, and I felt an enormous amount of guilt. I told Bruhs what had happened, that I was attracted to this other person. I said that if I could go this much astray from our path together, then I really didn't deserve him, and I felt we should more or less go it alone. Bruhs was very understanding and said that if I wanted to explore this other relationship that he would still be there if I wanted to come back.

"So that is exactly what happened; the other thing lasted a very short time, and I realized the relationship between Bruhs and me was even stronger because of that rift.

"Now, looking back, I think if I could have done anything different in our relationship, it would have been to be more mindful of the importance of being together. That is one thing I do regret. Even though Bruhs assured me that our temporary rift actually brought us closer, I'm still sorry if it caused him any pain. And I think it did, because it takes a person of great stature to yield to the circumstances at the time. I think a lesser person would have given up and said, 'OK we're finished.' Bruhs showed great wisdom in sticking it out with me, to let me go my own way when I needed to and stand by. I feel that I have had the benefit of a very great expression of fidelity from him.

"A big turn for us was back in 1940, when Bruhs and I were taking one of our performances to Broadway, which was a big deal for us. That's when he suffered the heart attack, which ended his dance career. Along with the heart attack, he had a virus that infected his nervous system and caused him to lose all his reflexes. He was in the hospital for about ten weeks in a semi-comatose state. When he finally came to, he'd lost all his memory of the dance years.

"It was a terrible blow to me because I had to close the studio up, and it was Bruhs's baby. How was I going to explain it to him? But that worry was all for naught, because he didn't even remember his dancing. None of it ever came back, even when he heard familiar music that he had moved to.

"I felt that this was a very cruel twist of fate. Bruhs had lost the dance, which was the way he had been able to express himself better than any other method in his entire life. I'm sure that a lot of that rubbed off on me, because I felt so keenly about what he had lost. We no longer created together. We did some songwriting, but it never filled the real hunger for expression that dance had provided for him.

"Now Bruhs is suffering from Alzheimer's disease. It was first noticeable when he had some difficulty locating articles in the house, and certain tasks were hard for him to handle, like balancing his checkbook.

"Most of our friends have left the city or died, and I have to say that I've been disappointed in the way some friends reacted to the Alzheimer's. For the most part, they were too uncomfortable to see us, they backed off. So when SAGE (Senior Action in a Gay Environment) discovered us, we were two very isolated individuals. SAGE is a service for elderly gay people, and they work to provide a place where older gays can come together and socialize, and to assist those who are homebound in any way possible. They add perspective to people's lives and give them something to latch onto when they have been so totally left out of society after a certain age.

"SAGE turned our lives around, because it was through them that we finally went public. They provided an opportunity for us, and we have been spokespeople for them ever since. They are virtually the only friends, the only family, that we have at this point.

"SAGE honored us with a luncheon to celebrate our fiftieth anniversary; they assembled three hundred people, most of whom we didn't even know, who welcomed us with open arms. They had made arrangements for Arthur Bell, a columnist for the *Village Voice*, to interview us for his column, and from that point on, we were catapulted out of the closet.

"After that, we were on a television program called *Midday with Bill Boggs,* and when we had gotten home from the taping, the telephone rang and it was Bruhs's ninety-year-old sister. The first words out of her mouth were, 'I am so proud of both of you.' I've never forgotten that wonderful affirmation of our relationship. We had received so much publicity that we were invited to be the grand marshals of the gay pride parade in 1985. You have to understand that up until this point we were incredibly isolated, so this kind of attention was overwhelming and wonderful, especially given Bruhs's changing health and our need for support.

"I remember when the parade approached the lower part of Fifth Avenue at Washington Square, I

Gean Harwood and Bruhs Mero as grand marshals, 1985.

looked out at a sea of faces that seemed like over ten thousand people. As our car rode through, with one voice they let out the biggest roar of approval you have ever heard in your life. I can't describe how much love we felt coming from the sidelines. People were blowing kisses to us; it was just unbelievable.

"Since then, Bruhs's physical and mental condition have become much worse. There has been such a personality change in him that he finally viewed me as the enemy. One day he came at me with a knife and said, 'I guess I'm going to have to kill you because you side with all these people who push me around.' So, much against my wishes, I had to put him in a nursing home. We had lived together for sixty-one years at that point.

"I have to say in all honesty that life is not the same for me because we are missing many things which we had enjoyed together. We had such similar taste in things—the theater, things on television, the arts, music, painting.

"Now I've limited my visits to the nursing home. I used to go weekly in the beginning. We'd try to do an hour of songs every day, because the music seemed to connect us. It allowed us to go back in time to when things were quite different and for that moment, we could almost forget these other disturbing elements that have crept into our lives. Then I'd go every other week, then once a month, and now it's been three or four months. Bruhs doesn't recognize me at all. Before, he seemed to relish when I took his arm or took him outdoors; now he doesn't want to be touched, he pulls away. Before, when I would appear, he would cry, and I always felt this was a frustrated means of expression, that he realized I was somebody whom he should know but didn't remember my name. There are no more tears now. It's as if I were a total stranger.

"So, to preserve my sanity, I limit the visits. My therapist finally convinced me that visits were damaging to me and didn't do anything for Bruhs, and that I shouldn't return until I could handle it. The last time I saw him, he made this moaning sound over and over. The nurse said that he did it all the time.

"Our lives have been enormously changed by what has happened. It can best be described as a total role reversal. Bruhs was an active, intellectual, creative man. He was a meticulous perfectionist who worked with wood and made many of the tables and things we have around the house. He was a great homemaker and a real mister fix-it. I grew to rely on this type of thing; I didn't take it for granted, but I accepted it as being something that would never change.

"I try not to feel negative about it, but my emotional stability is very near the surface. I'm moved to tears very easily by the least thing—a fragment of a song or some seemingly inconsequential sequence in a commercial will get to me and break me up. Many times when I'm doing certain of our songs, I'm fighting back tears, because of the memories or the associations that I make with what we did in our lives together.

"I feel angry in some respects, but it's the anger of deprivation. I feel deprived of things that should be normally ours. At this stage of our lives it seems so very unfair that we have been cheated.

"Writing my book has been most difficult because I've had to relive the struggle, but I do think that it's helped me to put the past behind me. The two people I'm writing about actually no longer exist. Bruhs isn't the same, and I've changed, too; and we must learn to accept this.

"I feel that we are on this planet for a purpose, and that we must view our experience here as part of a gigantic classroom where we must learn our lessons in order to progress. Bruhs and I always had the feeling that our life paths came together not by accident, but for a purpose, and that we will be reunited at a future time in another setting."

*D*an and Sophie Trupin have been married for sixty-five years. Dan, ninety-two, was a lawyer for many years; and Sophie, ninety-two, wrote a book about growing up in the West. They recently moved to a retirement home because Dan was mugged twice last year and fell and broke his hip. They're committed to politics and social causes, and have two children, three grandchildren, and one great-grandchild.

Dan and Sophie Trupin

"The night we first met," explains Sophie, "was at his brother's home, where his brother and his wife and Danny and I played bridge. He and I were partners, and he was the lousiest bridge player I'd ever known. But he had an open face, he was handsome, and he had prospects. He was a law clerk and was going to be opening his own office soon. Of course, I'd had my heart broken a couple of times by then, like most girls my age. You know, life isn't a bowl of cherries for anybody. I guess I was too headstrong and obstinate—I still am. But I thought Danny was a nice guy."

"Well, that night I had a date with another dame," Dan continues. "And for the first and only time in my life, I—what's the term? I stood her up. I was a cad and I didn't keep the appointment. I remained with Sophie the whole evening at my brother's home. I must have been fascinated with her. Her countenance was pristine, sweet and pure. She was flat chested like an iron board."

"Yeah, I used to think of myself as pretty," says Sophie. "Anybody can be pretty, but I'm much more than pretty—I'm bright, I'm witty. But I must have been pretty because that's the first thing they say, 'She's pretty.' If she's not pretty then forget it."

"What the hell else do you notice the first time?" asks Dan.

"We started going out," Sophie continues, unperturbed. "We went to the movies and out for ice cream, that sort of thing. When I realized that I really cared for him, he told me that he couldn't marry me because he didn't have enough money to set up a house and open up a law office. So I says to him, 'I'm not going to play house; either I'm married or I'm not.' So I went back home to Chicago. I corresponded with Danny and tried to date other fellas, but I couldn't stop thinking about him. I guess I really cared about the bum. A year later I returned to New York and we married.

"I don't know that I really knew him too well at that time, or that he knew me. I had been raised in a

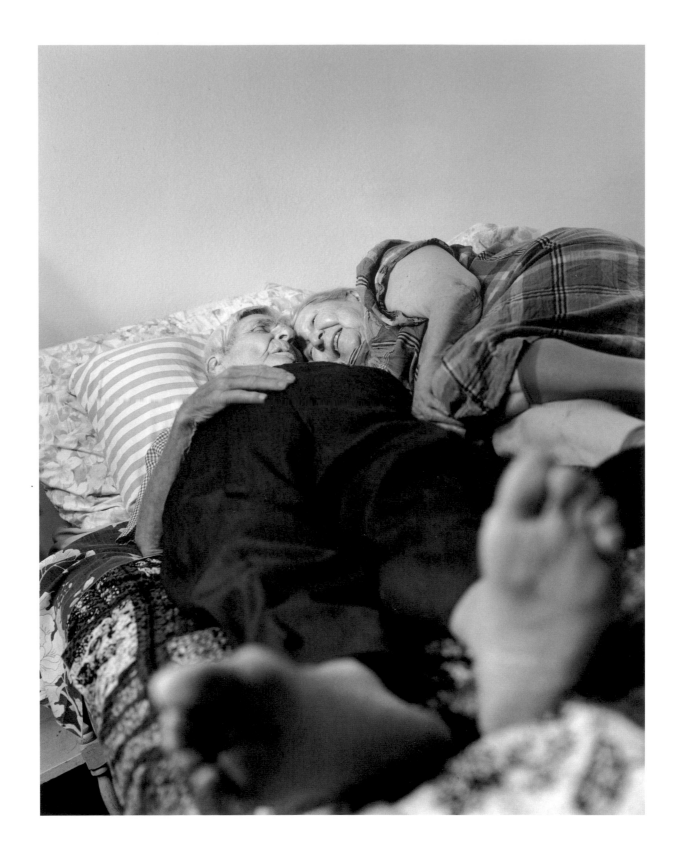

generation where all the girls read romantic novels, and you always projected yourself onto the heroine. You never thought of your future husband as being anything other than perfect. Despite the fact that our fathers and brothers were not perfect, we still expected our husbands to be.

"I think I was disappointed with Danny in the beginning. I think most women of my generation expected the man to take over. It was thought that the woman would have an influence, but it would be in a iron-fist-in-the-velvet-glove way. We'd never come out directly. We'd try to make the man believe our ideas were his, not ours. As women, I think we are born with a sense that we need to make the man feel that he knows more than we do. So the woman pretends that she doesn't know things and takes a back seat, because she needs to fulfill her need for a home and family.

"Danny made most of the decisions in our marriage. I would present all my arguments and my logic about something, but eventually I'd go his way. Some of his decisions were disasters, as a matter of fact—not that mine wouldn't have been, too. Danny had a very strong way of pushing, and I'd just give in, and this was hard for me because I'm a definite person, and I have strong feelings about things. Our different ways of seeing the world did cause some friction."

"Let me tell you a story," Dan interrupts. "Shortly after we were married—it must have been a matter of weeks, or days—we had gone to visit my brother, who lived in Brooklyn. I pressed the buzzer on his door once, and I was a little impatient so I pressed it a second time. Well, Sophie resented my impatience and thought I was disturbing people unnecessarily. We had not been married long then, and she slapped my face! This caused me, momentarily at least, to reassess my status vis-a-vis, you know, the relationship. Symbolically, it was a devastating blow to me. This was the beginning of something. As a matter of fact, it turned out that this kind of

intolerance and impatience has permeated and prevailed through our whole relationship. But it does not go to the essence of what we mean to each other."

"Just because we liked each other," Sophie adds, "didn't mean that we agreed on everything and that we didn't fight."

"On everything!" he says. "Oh boy!"

"But," she continues, "I think that if people are from the same cookie cutter, it must be awfully dull."

"We have the wildest eruptions over the the most trivial incidents," explains Dan. "The spelling of a word, ugh! The definition of *chicken bone* versus *drumstick*. This almost tore us apart once. We had to go to a consultant to get back on an even keel."

"Well," says Sophie, "because I am volatile and opinionated and have to express myself, we have fights. The neighbors say that we are the noisiest people in the world. But we're the only couple here; the other people are all single. If you live alone, who are you going to shout at? The walls? Of course we're noisy, we have one another to shout at. I am what I am, and if I can't express myself and make some noise….It makes for fighting, it makes for crying, it makes for yelling and screaming and being very frustrated and saying I'm going to leave. But basically that's why we've stayed together, because we allow ourselves to be ourselves, which isn't very civilized perhaps, but this is who we are."

"Now the question of the chicken legs," Dan continues, "we still haven't resolved that. I know I'm right. She got mad because she interpreted it as a lack of confidence in her ability, and she had had all this experience with the forstinking chickens growing up on the farm. You know, it's just nonsense, this kind of disagreement, and how the hell do you resolve that kind of thing? What difference does it make?"

"Why should it be important to me," Sophie interjects, "that he has to see that I know the anatomy of a

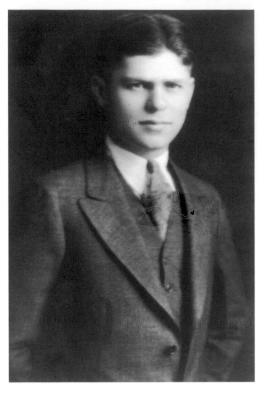

Dan Trupin, early 1930s.　　　　　*Sophie Trupin, early 1930s.*

chicken? To me it seems so unreasonable, and then I realize that I'm unreasonable, too. If he can't see it, he can't see it. Why is it so important to me that he see it from my viewpoint? I don't know.

"You know, it's hard to find a suitable mate," she continues. "People used to say you made your bed, now lie in it. Well, people today, they don't like to lie in lumpy beds, so they get out and try another bed. Why not? I mean marriage is hit or miss. It's very difficult to mesh your life with someone else's, because we have our own personalities and needs.

"Danny and I got very political in the sixties; and because I was the homemaker, raising our two children, Danny got to be the one who was away a lot. I'd resent it sometimes, even though he was trying to make the

world a better place; but he had to do what he had to do. We've always been very passionate people. Anger, love, hate, disappointment, agreement—everything's passion to us. It's only people who you care about that you wish were different or more understanding."

"Well, it's been sixty years," says Dan, "and a very difficult endurance contest. I finally made it, and it wasn't easy. When you're living with the same woman for sixty years, the definitions of monotony and monogamy blur."

"Well," adds Sophie, "I believe that men make laws that go against our nature. Men are not monogamous. Women are, by nature. A realistic woman accepts the fact that men are not monogamous. And the bright woman will hang onto her husband, and she'll turn

away and pretend she doesn't see that he stays late at the office for different reasons than he says."

"That's the bright woman, Sophie?" asks Dan incredulously.

"And," says Sophie, "she continues to be a Mrs. and has status, a position among her peers, and her husband does what comes naturally."

"Oh, Sophie…," he says, shaking his head.

"So, anyway," she says confidently, "this has been my observation."

"I must confess," says Dan, "she's the only woman I've ever known in my whole life, and that's why I can kid her and say, 'I have more trouble with you than any woman I've ever slept with.' It's literally true. The only woman I've had a total immersion experience with is Sophie."

"Do you want to know if sex continues?" asks Sophie matter of factly. "Yes, sex continues, don't worry about that. As a matter of fact, when a woman no longer has to worry about being pregnant, she's released from a tremendous responsibility."

"Look," Dan admits confidentially, "sexually, at ninety-two you don't even get an erection, let me tell you. When you get to be ninety-two, be prepared. I don't have to tell you about the decline. There's a decline in your need for food, and there's a decline in your need for sex. So whatever it was, X number of times a week,

then there's X number of times a month, then it's an annual celebration, and then after a while it's a centennial celebration. Okay?"

"I think our culture puts too much emphasis on age, anyway," adds Sophie. "There are three things that we should avoid as we get older: the mirror, the scale, and the calendar. I find them awfully depressing. It's our culture that makes us think negatively about growing older. It's inevitable, so why don't we learn to enjoy it and say, 'Well, we have less years to suffer, less time to make mistakes.'"

"If Sophie goes first," says Dan, "I will be the loneliest man on earth. This I can tell you. When Sophie goes away, and she doesn't do it anymore, but she used to for two or three days, I never went out in the evening. I didn't participate in any activity. I stayed home. I read and went to bed early. I was just a lonely man, and if Sophie ever leaves me that would be my fate, my destiny."

"Yes," she agrees, "as we get older we begin to find that time is running out. So instead of saying that we're bored with one another and our marriage is stale, it's just the reverse. We worry about trying to extend our period together."

"We don't have to resolve anything," he says. "We love each other. We're devoted to each other. That's it; we don't fight about nothing. There's nothing to fight about."

Irene and John Goyena met in the Philippines thirty-eight years ago and have been married for thirty-four years. They moved to the United States in 1971 and have five children and two grandchildren. Irene, fifty-four, works at an Orchard Hardware store; and John, fifty-nine, is retired and plays a lot of golf.

Irene and John Goyena

"Whenever I get mad at my husband," explains Irene, "I cook him food that he doesn't like. I will cook something different for the kids, but when John comes home I will cook the bitter fish, and this is how he knows I am mad."

"And I eat it," says John, shaking his head, "because I'm hungry. But she's been cooking the bitter fish for the whole marriage. When we were first married in the Philippines, I found that my wife didn't know how to cook. In fact, she didn't know how to clean the house, either. But I knew how to cook so I taught her. One time she tried to please me so she cooked this fish. When she brought it home it was alive, but she didn't know how to clean it and accidentally cut the bladder, which made the stew very bitter."

"But he ate a lot of it," she laughs.

"I was perspiring," he continues. "I kept eating because I didn't want to discourage her. The next day the fish was gone. I think she threw it away."

"Well, I never learned these things," explains Irene. "When I was eleven years old my sister and mother told me to learn the household chores, but I refused because I told them that one day I would marry a manager. That was my dream, to marry a man who would get me a maid so I wouldn't have to do any of the cooking or cleaning. I didn't even know how to cook rice!

"In the beginning of our marriage I would spend the day reading comics while John was at work. I'd visit my parents and sometimes help in their grocery store; and when it was time to go home I'd ask my sister to cook something, and I'd bring it home to John. One time my father came and saw me reading comics while John was doing the ironing, and he scolded me and said that I must learn to do these things."

"It was a little hard for us," says John, smiling. "I tried my best to understand that she didn't know much about housekeeping, which a Filipino wife was expected to know. The Philippines is a very chauvinistic country.

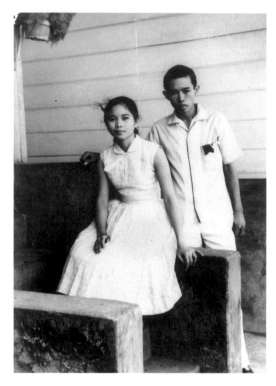

Irene and John Goyena, 1960.

I didn't want to push her, so I accepted everything she did, right or wrong. Even when we had four children, she was such a sound sleeper that I was the one who woke up to feed them. I taught Irene to do everything in the house."

"My sister told me that I was spoiled," Irene laughs, "but after the first baby he became a manager, he got me a maid, and my dream came true."

"We had already come a long way at that point," John says. "In the Philippines there are two groups of people, the rich and the poor. And in the poor, there were three groups, the upper-poor, the middle-poor, and the lower-poor. I belonged to the lower-poor. My father, a merchant marine, had divorced my mother and abandoned her with four children, and I was the youngest. I grew up on the streets selling newspapers and shining shoes. I was self-supporting at nine and the breadwinner of my family at thirteen. Before I met Irene, I had scratched the word marriage from my dictionary because I didn't want to be like my father; I didn't want my family growing up on the streets, the way I had. So I wanted Irene to know all these things about me, that even though I was striving, and working hard, and making my way through college, I didn't have anything to give her right away."

"I wasn't discouraged," says Irene. "I knew he was right for me because I had heard the song 'Johnny,' and

I told my sister that I was going to marry someone with that name. But she said John was the American name for Juan. We had a farmer neighbor named Juan, and he always wore shorts and was very lazy. She said all Juans were like that, but I didn't believe her."

"We made agreements before we married," says John. "Irene said that she wanted to own a store, and I said that I wanted five children. We agreed to live very simply, and things were good. I was working as an accountant and doing very well, and we had a store that was like a 7-11 variety store. Then I decided to come to the United States, because the situation in the Philippines was becoming pretty hard economically; I had gotten involved in politics and realized that there was going to be a dictatorship. So I left and came to Alameda in 1971; the family followed in 1972. We were living at Acorn housing in Oakland at first, which was subsidized by the state; and although I had a job with an import-export company here, we were poor again."

"But I think it brought us closer," admits Irene. "Everyone was so happy to be back with John again."

"I don't think our children enjoyed it so much at first," laughs John. "Back in the Philippines they had a color TV, and here we only had a small black-and-white. I only had eight hundred dollars so we went to a sale and bought two bunk-beds, a dining table, and a couch. We didn't even have a car; we took the bus everywhere. But I told them that when we did get a car, we'd go far away. Finally I got a Pinto station wagon, and I'd only had my driver's license for one week before we drove from here to New York. We went to Los Angeles, Las Vegas, the Grand Canyon, and crossed thirty-seven states. I was holding the wheel as straight and tight as I could, and when we changed lanes I'd ask my children, 'Can I go to the right lane? Are there any cars coming?'"

"And we'd say, 'Dad, look, it's so nice out here,'" Irene remembers, "and he'd say, 'Don't talk to me, I'm driving.'"

"We've had some heated arguments in the last thirty-four years," says John, "what is important is understanding. In my case, I have no intention of changing her. She's a little bit stubborn, but she's been like this since the beginning. I remember once, before we were married, she wanted me to come down to say goodbye to her brother-in-law, who was leaving on a ship; and I told her that I didn't want to. She said that if I didn't go, she'd throw herself off the ship. So the next day I got to her house very early so I could go with her to the boat."

"When we got there," laughs Irene, "every few minutes I would go closer to the edge of the boat pretending that I was going to jump, and that's why he's so close to me in all of our pictures—because he's afraid that I will really jump."

"She hasn't changed at all since the beginning," John says, shaking his head. "I have accepted all these things. Besides, she spoils me now; I can't complain. Since my eyes have gotten so bad from the cataracts and the glaucoma, I can't work anymore; and now she is the one going to work. For me, I try and get outside every day. If I stayed home I would get too lonely, so after everyone leaves for work, I go to the golf course. It's not that I'm such a good golfer, it's just that it helps me prove to myself that I can still do it."

"We came into a very difficult time in the late 1980s," Irene says. "Everything changed for us."

"I was the manager of a mall that included some theaters, three toy stores, three ice cream stores, and a laundromat," says John. "And in 1990 we lost the stores because of the economy. At the same time, Irene had to go through chemotherapy for colon cancer, and my eyes had gotten so bad I couldn't work anymore. We were pretty hard up, but we met with the children and we all talked about it. We pulled together and the children were very nice in helping out. They went out to find jobs, even though they were going to school. We needed everyone's help because we had just lost a very good income. Even so, we tried to have some humor about it. Like when she had the cancer, she cried and told me that she didn't want to die; and I told her kiddingly, 'Well, Ma, hurry up so I can have more women!' And when they told her she would lose her hair, she was crying again, and I said, 'Don't cry, Ma, look on the good side. When people see us, they'll think we're twins!'"

"John was great," admits Irene. "He was always there for me, especially when I told him about our sex life, how it would change with the chemo."

"I just learned to accept it," he says.

"He's very understanding," she says, "no pressure."

"Well, I love Irene," he says. "It wasn't her fault she got the cancer. I didn't want to lose her, and that was more important than sex to me. We both had our hard times. When my eyes went so bad, it was very depressing because I'm wondering what I'm going to do. It's difficult, but I can't drive much and I can't take her on a vacation anymore; I feel so bad. But I try to tell myself that I've been lucky from the time I was born until this time. I can still see— some people are born blind."

"And besides," says Irene, "we went to the top. We enjoyed life and the kids enjoy life. These difficult things, like John's eyes and my cancer, are hard to accept; but we accept them. We're not like other people who take simple problems very seriously."

John and Irene Goyena at their store, 1967.

olores and Martin Fusich have been married for forty years. She's sixty-nine and he's seventy-three. Retired now from the Department of Energy, Marty likes a good game of cards; and Dolores, who is retired from a senior center she started and directed, does a lot of reading. They have two grown daughters and one granddaughter.

Dolores and Martin Fusich

"Marty and I met during the war," explains Dolores. "My mother and my aunts were in a cocktail lounge in August of 1944, and they saw these two young sailors come in and get stopped at the door. My aunt wanted to know why and went up to ask them. I guess the club was under restriction because they had been caught selling to minors.

"Well, the sailors sent drinks over, and the ladies invited them back to our home for dinner the following weekend, which was something that you did during the war. And that's how we met. I was eighteen and he was twenty-one."

"But the deal was," Marty adds, "Dolores was my friend Jim's date and I was the date of her friend. But when I saw Dolores I thought, 'What a lovely young lady.' Later I asked Jim about her, and he said that she was nice, but that he had a girl back home. So I said, 'Let me have her phone number.' Then I went overseas and we wrote, but nothing really happened. We kind of

drifted. I got discharged and went back to Pittsburgh, and she finished college; but we did write. After I got out of school, I went back into the navy; and on a thirty-day leave I found myself back in California during the Korean War."

"Marty, what do you mean 'found yourself?'" Dolores says. "First of all, you forgot that we got together in New York. We *had* seen each other. And I said, 'How about coming to California?'"

"Yeah," says Marty, "and the next thing you know we're married—within a week."

"Marty!" she screams. "It was two weeks!"

"Two weeks," he shakes his head. "Bingo! Like a lamb led to the slaughter! I remember my mother-in-law gave me phenobarbital to calm my nerves going down the aisle."

"She wanted to drug him," Dolores laughs. "I actually think we decided to get married over a game of Scrabble."

Dolores and Martin Fusich, 1944.

"That was it," says Marty. "I could never beat her, and she claims I married her because I was determined to beat her."

"Well, that's one of the reasons, I hope," laughs Dolores. "Anyway, Marty was thirty-two and I was twenty-nine, and I think we were pretty comfortable with each other. We were both Catholic, which helped. But Marty was intelligent and had a wry sense of humor, and I felt that he would be a loyal strength in my life. He was like an oak. If he went out at night, I never worried what he was up to. I don't think I had any doubts about him at all, except that I found out he gets nervous when we travel. When we were going back to California after our first year in Washington, D.C., he really barked at me in the airport, which he had never done. And, fortunately or unfortunately, there was another couple with us, or I would have really given it to him."

"You remember those things, Dolores?" he asks. "They drip off me like water off a duck's back."

"But we didn't have many arguments in the beginning," she says. "I remember that time fondly. We were on our own, and we just lived for each other."

"We didn't have a lot of money," he says. "But we would treat ourselves. We'd go to Willard for dinner."

"Or see a summer opera in the park," she says.

"Right, or we'd read in bed together," says Marty. "I was reading *No Time For Sergeants*. I'd read it out loud to her, and we'd both burst out laughing. Dolores likes opera and stuff like that. And we like musical comedies, like *The Student Prince*."

"It was a musical made in Heidelberg," Dolores explains. "In fact, they made a movie out of it with Mario Lanza singing. Wonderful, hokey, but very good."

"I think they call that stuff schmaltzy now," Marty adds.

"Yeah, well then *Phantom of the Opera* would be called schmaltzy," says Dolores. "I mean really."

"We've had some hard times," Marty explains. "When we were living in Washington, Dolores was pregnant with twins; but they were preemies and they both died."

"I think that was the first instance where we felt like the romance was over," she says. "I mean, this was reality. Marty was very good to me because we just had each other and it made us close."

"Yeah," he adds. "It was more or less like a crucible, it made us stronger."

"You took care of me," she says.

"And I think the economics were hard on us," Marty remembers. "We moved back to California, and we had no work and had to stay with her mother for a while. I finally got a job as an accountant for a construction firm."

"And I got a dream job," adds Dolores. "I was the office manager for a key company. We were mostly thinking about logistics, getting jobs and a place to live. It wasn't as romantic as our first year together, when we just had each other. And then, in 1957, our daughter Monica was born, and while children are wonderful in many ways, I think they add another stress. I think it came as a shock to Marty that I was so involved with Monica."

"Well, I loved Monica so much, too," Marty adds. "Dolores would have her all dolled up after a bath and put her in nice clothes, and we had a big, old buggy, not like the kind they have now. But things did change fast.

When you get married, that's nitty-gritty time, when you have to earn a living. Then there's children, and you have to take care of their future. There's going to be a time when the kids get sick, or you're sick. I had cancer in the left lung in 1966. This was devastating to both of us. I had felt that I was…"

"Invincible," Dolores interrupts, "that we were invincible. The doctors said Marty's chance of successful recovery was very limited—like maybe five years to live. We were both extremely emotional, but we didn't verbalize it much; just sort of grinned and bore it."

"I was a smoker," Marty explains, "smoked a couple of packs a day, at least. I still remember the hospital. Priests would come in every day and see me."

"Remember the Lutheran minister Marty?" Dolores grins.

"Start making your pact with God," Marty laughs. "And Dolores was heroic. She was working, and our second daughter, Cecelia, was born by then, and Dolores was taking care of the children as well as me. But that was twenty-seven years ago, and I'm still here."

"Oh, God, and then right after the cancer I got that staph infection, which wreaked havoc for us," she says.

"Right," he remembers, "she was the stalwart when I had to have the operation; but then when she got sick, we had to lean on each other's shoulders."

"But God was good to us," she adds.

"Sometimes we'd have hot arguments," he remembers.

"But we never contemplated divorce," she says.

"Well, we could have," he maintains. "You know, those arguments. We'd have a few cocktails each night, those martinis…"

"Which were killers," she interjects.

"And if we had too many," he explains, "well, I could be kind of controlling, and this would make her mad. I always tried to control her drinking, like I didn't think she could handle it was well as I could. Maybe I was being presumptuous."

Dolores and Martin Fusich at their wedding, 1955.

"When the liquor leaks in, the truth leaks out," Dolores chants. "The truth was, I felt that Marty did have an inclination to be controlling. I was working at the time as director of the Emeryville Senior Center, managing and directing people, and Marty's still attempting to make all these decisions. I found that hard to accept."

"I didn't give her the credence that I should've," he confesses. "I thought the male was the dominant one. Just macho I guess. Now we don't drink. We felt it was a destroyer; I think it could have destroyed us."

"No, I don't think it would have destroyed us, Marty," Dolores adds. "It was a stress that we didn't need. But I think, in general, most of our arguments have been over the stresses of everyday life."

"Right," says Marty, "like when I watch the ball game with those earphones on."

"That drives me mad!" Dolores shrieks. "I'm trying to talk to him, and it's like he's off in another place."

"Well, we've been through thick and thin," laughs Marty. "I retired from the Department of Energy in 1982, and I started spending time over at the Elks Lodge, playing cards. I was doing pretty good, nothing that the IRS would worry about. Dolores was still working; and I'd play poker, then come home, put on the apron, and make a nice pork chop or meat loaf, baked potato, salad. She retired in 1988, so now we're both at home, and I can't go to the Elks too much."

"That's not true, Martin Fusich!" she screams. "That's baloney! You may not play cards, but you still manage to get over there every day!"

"Anyway," he goes on, "the next thing that happened was when she had her car accident."

"Right," she nods. "I was in a cast for five months, and it changed my life because I was totally dependent on Marty. He was everything. He wanted me to have a bell to call him if I needed to go to the bathroom. He had to buy personal items for me. He really proved himself."

"Well, that's part of the pact when you get married," he says. "As they say, for better or for worse. We'd had the good, now this was the worse part. You have to tighten your belt."

"Then after I got over that," she continues, "I got this PMR (polymyalgia rheumatica) disease, which is an old-age disease. Then, in August of 1992, I broke both my arms."

"We hate to bore you with this stuff," he laughs, "but it's part of the saga. I felt like getting the suitcase packed and moving many times."

"Oh, Marty!" laughs Dolores.

"That's right," he says, "get on up to Reno under another name."

"Well, it makes you realize," says Dolores, "that you do have somebody who's true blue. One day I said, 'Why do you do all of this?' and he said, 'Because I love you.'"

"Well what else could I do?" he scoffs. "Kick her when she's down? Sign powers of attorney?"

"Oh, we've had our laughs," she says. "We have."

"With Dolores and me," he explains. "it's been companionship. It's not like in the movies when they're going into the sunset, bright and cheery and all that. There are great times, but then there are the crises."

"I don't know if it's like the love we had when we were in our twenties," she explains. "That was idealistic, but the marriage becomes a partnership. There's still romance in our lives, we hold hands, kiss, look at each other. One night when he was falling asleep, I saw his eyelashes fluttering, and I thought, 'that's what he looked like when he was a little boy.' This touches me. It's a different kind of passion."

eggy and John Law live in a home they built overlooking the mountains of Northern California. John, sixty-two, is an iron man marathon runner and a retired architect. Peggy, fifty-nine, is the executive director for the National Radio Project, a current-affairs analysis program on public radio. Both she and John are devoted to the issues of social, global, and economic justice, and they have traveled to Nicaragua many times to work with peasants and community groups. They have six children and twelve grandchildren and have been married for thirty-nine years.

Peggy and John Law

"I am untrainably messy," says Peggy, "and John is outrageously, sickly neat. I mean, he is compulsively neat, and from the start I think this was a surprise to me. John says the only thing he cares about is his desk, his office, and that he has a two-foot-wide-by-six-foot-long strip on his side of the bed to get into."

"See, Peggy uses her side of the bed as a desk," explains John. "Every surface, including the floor—the whole house—is her desk."

"Well," Peggy retorts, "I have my soft desk and my hard desk, I like to move around. We're teasing each other, and some people are uncomfortable when we do this, but the teasing comes from a place of, 'Yeah, you're different from me and it's a little crazy, but it's all right.' We have a lot of fun together, as much fun as we had before we were married."

"Peggy and I met on a blind date during my senior year at Harvard," explains John. "The guy at the drafting table next to me was being rather pushy that I

should meet Peggy, and finally I agreed to go out with her as long as she didn't mind that I would have too much to drink."

"I don't know why I kept going out with him," insists Peggy, "because he had too much to drink the first three dates, but this was the era when everybody drank too much. In fact, one of the things that I liked about our first date was that we had some terribly significant conversation. On the second date, we had the same exact conversation, and I realized that he didn't remember the first one. But what made John different from a lot of people was that he was willing to talk about real things, about his feelings. He wasn't protective like most men, which was unique in 1955."

"Being an architect," says John, "I had this concept that I liked things that were beautiful, so I have to admit that one of the reasons I was attracted to Peggy was her beauty. But she also became a good friend and approved of my unique style of dating, which was to not make a

big deal out of it. I was very practical about not giving corsages and making artificial overtures, and I think this appealed to her."

"A typical date," remembers Peggy, "was that I would take the bus from Wellesley to Harvard. I'd bring my homework, and I'd study at the end of his drafting table. We'd chat a bit, and then we'd go out for dinner in the graduate school cafeteria, where we could get these great hamburgers. So when everybody else was worrying about going to a fancy-enough restaurant or getting a corsage, we were eating hamburgers or snuggled up on the couch of his parents' rec room reading *Winnie the Pooh* to each other. To me, it made a whole lot more sense and was a lot more fun."

"Plus, it was cheaper," John adds.

"Much cheaper," Peggy insists. "My father used to say that I was the cheapest person he knew until he met John. We have fond memories of those early days. In fact, that's why we've never used 'Honey' or 'Dear' with each other. We've always been 'Piglet' and 'Pooh.'"

"She's Piglet," says John, "and I'm Pooh. I like to embarrass her now that she's become a more public figure, and sometimes in a crowd I'll yell, 'Piglet!' across the room. Everyone turns, obviously thinking, 'What the hell is going on here?'"

"And people get really upset when he does that," Peggy laughs, "because they consider it derogatory, but they have no understanding of *Winnie the Pooh.*"

"We were married after her sophomore year," says John, "and then I went directly into the air force for three years. We lived in a house at Mission Air Force Base in Texas, and the whole house was probably the size of our living room."

"It was called Rainbow Village," remembers Peggy; "some houses were pink, some were green. Ours was lemon yellow, which was a lot better than watermelon pink."

"Anyway," John continues, "the floorboards of the house were open. This was great because, if you spilled something, it would just go down under the house. But you could also see the rattlesnakes underneath, so we'd call base maintenance every now and then, and they'd jack up one corner of the house, hit it with a sledge-hammer a few times, and the floorboards got pushed together again."

"I didn't mind it at all," says Peggy. "I thought it was wonderful because it was ours. I never thought, 'God, I can't wait to move into a nicer place.'

"I don't remember a lot of conflict with John from the early days, but we women were brought up that if there were difficulties, we were supposed to figure out how to fix them or put up with them. I grew up not very different from other women my age—we just didn't deal with feelings. Making an issue about things was seen as tacky. So I stuffed it. I learned early on that there's something wrong with you if other people don't feel the way you do, so I learned not to ask questions about my own feelings."

"And like most men," adds John, "I learned not to talk about my feelings; I didn't know if I had any feelings. I didn't get angry, and I believed that I was incapable of it; but what it really amounted to was that I was suppressing it."

"The turning point," says Peggy, "was when we were having problems with one of our teenagers, who was doing all the things that every parent hopes their teenager never does. It was really devastating for me, because a lot of it was directed at me. It really shook my sense of self, because a lot of my self-esteem came from being a parent; and John didn't know what to do or how to respond to the situation. We decided to see a counselor who, at one point, labeled him, 'Slippery John,' because when John was uncomfortable or didn't know what to say, he just slid to the edges of the issue, and that left me feeling really bad. I was angry, lonely, and confused, and we hit a real crisis at one point when I

Peggy and John Law at their wedding, 1956.

what happened yesterday, but I'm feeling really bad,' and we'll talk about it. It's really important because otherwise my feelings build up to the blind, irrational explosions that kind of clear the air but don't go anywhere. So I learned through these early experiences that if I'm feeling things, I need to tell him and not wait until it's gotten to the point where I'm so hurting and so self-protecting that my anger frightens him."

"And I don't have to be Slippery John anymore," John explains, "because I understand earlier what's going on with her and I don't have to react so dramatically. These talks take care of the communication process before a problem gets to the stage where I used to slip to the side and disappear. We also give each other weekly massages, which I think is great. Giving a massage is almost as neat as getting one.

"These days I do essentially all of the dishes and more than half of the cooking. The first twenty-eight years we were together, Peggy did so much more work than I did raising the kids and taking care of the house. The fact that I bring her coffee or do more around the house is not really a payback. It makes me feel good. We're finding ways to enable and support one another."

"One thing I can say about John and me," says Peggy, "is that we're not afraid of change. We don't look at life as something where you accomplish a certain relationship or living style, and then you're supposed to protect it. Both of us look at life as a process, and process means change. Some of the changes will be scary and hard, but change in itself is not a bad thing. We both grew up in a privileged world of East Coast money and opportunity, with a privileged way of looking at the world. The changes that have taken place for us are partly generated by historical circumstances and by our children living in a vastly different world from the one we grew up in. When we started having grandchildren and saw the world that they were growing up in, we wondered what gift we could possibly give to them. We

told him I needed a hug and he said he didn't want to give me one because he was feeling too protective of himself. And I exploded. I said, 'I'm not going to do this anymore. Either we're going to deal with what's going on or I'm splitting, because I can't live with this kind of thing.'

"Now we have a routine that handles a situation like that. John gets up early in the mornings and makes the coffee, and when I wake up I say, 'Coffffeeeee,' and he brings it to me. I'm very spoiled. Then he sits on the edge of the bed, and we talk about what we're doing and what we're thinking or feeling. These morning conversations work because I can say to him, 'I don't know

decided that the gift of paying attention to the world's problems was the best one. What occupies my mind now is, 'Have I walked on the earth in a fairly quiet way and left a mark toward sanity and health in the larger sense?'

"Now we spend our time with people of very different backgrounds, people who are very poor, or who are threatened physically because of the views they hold, and John and I have learned an incredible amount from this. We look at the world entirely differently from the way we used to, and we ask different questions about policy and what that means to human beings—questions that I was taught not to ask growing up. Freed from our privileged pasts, we now can engage in social and political activities and use our money in ways that enhance our values, rather than do what we were taught one should do—which is to invest in the fastest-growing stock. Instead, we invest in socially responsible things. It's amazing to do these things together, to go to Nicaragua and be four miles from a war zone. We grow, we discover things, and we talk about them. There's an enormous sense of freedom and privilege in being able to move in a much more real world."

"One of the primary reasons I think I drank so much from ages seventeen to forty," John explains, "was to numb myself from a value system that I didn't really understand. Now I'm doing what I've wanted to do all my life. Peggy and I live in a world that makes sense to us."

"A few years ago," adds Peggy, "a friend of ours from college was sitting here with us, and he said, 'I think you guys are crazy, and I think you're going to get yourselves killed; but in a way I envy you, because of all the people we grew up with, you're the only ones who have passion for life at this stage.' I know we're not the only ones, but we do have an enormous sense of awe and thankfulness about our lives and the fact that we're growing and changing together."

David and Marnie Wood have been married for thirty-seven years. They met in New York, dancing with Martha Graham. They spend half the year in New York City, where Marnie, fifty-nine, teaches at the Martha Graham Studio and David, seventy, choreographs dance performances. The rest of the year they live in Berkeley, California, where Marnie runs the dance department at the University of California. David has written a book about dance entitled On Angels and Devils and Stages Between. *They have three daughters and four grandchildren.*

David and Marnie Wood

"You know, when I first met David I was really impressed," Marnie begins. "He was the big star in the Martha Graham Dance Company, a soloist and one of the major charismatic teachers in the dance world. And here I was a student, twelve years his junior. David was at a place that I was hoping to achieve someday, and that's how I saw him. I was in no frame of mind to be serious about men. I was on an important mission: I was going to be a dancer, I was never going to get married."

"Joan of Arc," David remembers. "I think our first encounter was when Marnie came up to my desk at the American Dance Festival and signed up for my class."

"I asked to be moved from the beginning to the intermediate level," says Marnie.

"She was always asking for something," David laughs. "And still is."

"That's right," Marnie smiles, "something a little bit more, a little extra, some recognition. I remember David as being extraordinarily strict, standoffish, and even conceited because he was so unwilling to be conned into anything."

"We became friends," David continues, "when I was invited to teach at Sarah Lawrence College as a guest teacher and she'd bring me coffee and doughnuts between my Friday morning classes."

"That was my job," explains Marnie, "as head of the dance club."

"She did it very well," David grins, "and I thought, 'This is nice.'"

"So I graduated to doing it domestically," Marnie laughs. "You know, I had had other boyfriends, but none took my dancing seriously. In David, I realized that I had found someone who was interested in me and my dancing, and who understood what that meant in terms of a commitment. I never knew that I could have a relationship and dance as well; I thought I'd have to be alone to keep my commitment to dance.

"Ours became a very physical and loving relationship,

David Wood and Marnie Thomas, dancers, 1968.

right time. She was so cute, so bright and light, and she made me feel cute and bright and light.

"The first six months after we married," says David, "were spent in Mexico, where I was dancing and choreographing and Marnie was demonstrating for my classes—even though she was ill with dysentery and ready to pass out the whole time."

"I remember our first fight was over a flat tire," says Marnie.

"Well, you know, in Mexico we had one flat tire after another," explains David. "The roads are so bad, and you run over all these dead cows, which are bloated and lying all over the road. So we got this flat tire, and I got out of the car in my newly married, manly way to change it. Just as I was getting the tire off, I look up and see Marnie coming around the corner, struggling with the spare, and I said, 'Put that down; you're going to hurt yourself.' She said that she wanted to help, and I said, 'No!' And she got very offended and started crying."

"I thought this husband-wife thing was going to be equal," Marnie explains. "So when he starts ordering me back to the car in this macho way I was furious. I soon found out that there was going to be the *man* thing to do and the *woman* thing to do, and this pattern would repeat itself through the marriage."

"Well," explains David, "we had made an agreement that we would never tour and travel separately. We realized that if one had an offer to go to Russia to dance, and the other to Italy, it would pull us, as partners, further and further apart. So when it came time to decide where we would go professionally, it was basically my say, because I was more experienced and therefore could draw more money.

"We both made sacrifices," David continues. "But we had to keep coming back to what we really wanted. Did we want to maintain the relationship, or did we want to go off separately to dance?"

"It was frustrating," Marnie adds. "I was just start-

because dance is so physical; and the whole physical side of love brought a great deal of satisfaction. David's dancing was very sensual. He was always a powerful personality, and his movements and vocabulary were as inviting as his whole being."

"You married me for my movements?" asks David.

"Along with other things," Marnie grins.

"Well, I have to say that marriage had never occurred to me, either," explains David. "I really wanted to dance. I *wanted* a career that would tie me down— but it all came at the right time, Marnie came at the

ing my career, and sometimes I was resentful of this. When we started having children, my career as a dancer had to be divided between family needs and my needs; and during those first years in New York there were times that the balancing act was difficult."

"Marnie sacrificed a lot to have children," says David. "But she was never out of the loop in the dance world."

"Well, after every child I'd go back into dancing," she explains. "I think I might have eaten the children alive if I hadn't had my own thing. I always said that I'd lay down my life for my husband and my children, but I'd never lay down my leotard. And that was true. When I am dancing, it makes a difference to who I am."

"We tried to do it all," says David. "I was dancing and teaching during the day, and at night I'd take the children, and Marnie would go teach."

"It was a really stressful time in our lives," admits Marnie, "because with teaching, rehearsing, and being parents, we were making love, war, and dance in whatever tangled priority we could. I didn't mind that juggling," she insists. "What I did mind was that there were problems in the way I could be recognized for what I was doing. I was always the one who had to give way because we had an agreement to put our relationship and our family first, and it was something that I wanted to honor. I always believed that I would be able to get back to my career. I think maybe my frustration came to a head when David made the decision to retire from dance in 1968 and take a job in California."

"Well, because of our age difference, I was ready to retire," David explains. "It was time to stop dancing because I didn't go up anymore. I stayed down on the ground. And we had three daughters who were growing and needed to be provided for. There was no way I could earn enough money dancing or teaching with Martha Graham to fulfill that. Luckily, the job came up to head the dance department at the University of

The Wood family, 1960s.

California, Berkeley. That was really good for me, but Marnie still had a lot of dance life left."

"I'd been with Martha Graham for ten years," says Marnie, "and in that time I had given birth to three children, had one miscarriage, and one stillbirth. There was a lot of time that I wasn't dancing, and that many pregnancies had knocked my dancing back to where I was still part of the chorus. I was just beginning to get solos and was starting to build my own career because the last child was three years old by then. So leaving New York and coming out to California was literally the end of my career in the sense that I didn't have a chance to build, and I was just thirty-two years old."

"I don't think our personal relationship was sacrificed," David says, "although I think that Marnie resented a lot of what was happening."

"Well, it became apparent," Marnie cuts in, "that

my whole energy toward dancing could no longer have the integrity of the Martha Graham Company. That was the major national image I'd been working on."

"She danced in pieces of mine," says David, "but that wasn't the same thing."

"I'm sure I resented David," she says, "and I was probably passive-aggressive to a degree, because I knew that I had made the choice to focus on our relationship and the family. In fact, when we were getting ready to leave New York, Martha called me to ask what I had decided to do. She told me that she would like to see me continue to grow as a dancer, and she made a very direct plea for me to stay. I felt very undone by the fact that suddenly someone was saying to me, 'I have a vision for you that you need to stick with and fulfill.' No one had ever said that to me. The focus of our leaving had been on David because he had been the company soloist, the rehearsal director, and the star. This had a terrible effect; it added to my own distress because I felt things closing in on me. I could see myself at the supermarket and I could see myself in a smaller local dance scene, but it didn't measure up.

"Today what I've discovered—and it took many years to come to this—is that I've been able to have a really productive career in dance and a deeply satisfying personal life. I don't know of many people in the arts who can say that. I have become the ultimate juggler, and that juggling ability has been my real skill. I thought I would be a deeply involved dancer-artist, but what I really became was a dancer, a teacher, a mother, and a wife, and all of those things turned out successfully. I have three really loving children, I have a loving husband, and I have a career in dance and teaching that

continues; so instead of celebrating the totality of one thing, I've learned to celebrate myself as someone who can keep things in constant balance."

"We've both had to make changes," says David. "In 1982 I was diagnosed with muscular dystrophy, and this year the doctors found that I have Parkinson's disease, as well. I was still able to teach for some time, but in 1990 I lost full access to my body; and in 1994 I started using a wheelchair. Interestingly, I don't feel totally restricted. I know that I can't physically do as many things, but that's mixed up with getting older too. You face this when you take up dance, because you know that you can only dance for so long until you go on to something else. In fact, I feel freer now because before, when I was using my own body to create and move, I was limited to what I could and couldn't do. Now when I choreograph, I feel movements kinesthetically and it's limitless. I feel I can still dance; I can leap better and jump better kinesthetically. Sometimes I feel badly that I can't go wherever I want to go and do whatever I want to do, but there's a reality about one's life that one deals with. I've started writing, too; and all these things keep me feeling creative. That's the most important thing."

"I think of us as a team," adds Marnie. "We began as teacher and student, and then became professionally involved with each other as dancers, and then domestically involved with our marriage. We've always related to dancing, teaching, and parenting in terms of the total involvement of both of us. The same goes for his illness. I'm glad that I'm here with him and that there are two of us to deal with it. We're two different sides of something that becomes a unit, and that's family."

rank and Margaret Cruz have been married for forty-five years. Frank, seventy-eight, worked as the shop foreman for an automobile dealership for thirty years. Now retired, he works in the nutrition department for a senior citizen center that delivers food to the elderly. Margaret, seventy-five, is a longtime community activist who became a lawyer at age sixty-two and practiced immigration law for twelve years. She continues to serve the community as founder of the Margaret Cruz Latina Breast Cancer Foundation. They have one daughter.

Frank and Margaret Cruz

"You know what I tell young women today?" Margaret crooks a finger. "I say, 'I don't care what you tell me, dear, the man who goes to bed with you before you get married will always end up saying, "My mother never went to bed with my father before marriage, and my father had tremendous respect for my mother." The fact is, men who take women to bed before marriage never end up marrying them. Maybe today's different, but I go by the old book. You want something to last? Then hold back and don't give yourself away so easily. People say, 'Well, what's a piece of paper?' I'll tell you what it is; it's respect for you as an individual."

"You make the paper worth what you want to make it worth," adds Frank with a nod.

"When people tell me that they need to have sexual chemistry before they make a commitment," Margaret continues, "I tell them that sexual compatibility is something they have to learn. Besides, it's not even a third of your married life! Too much emphasis is put on it anyway. I see these aggressive young women on television knocking the guys down and going to bed with them before they even know their names. There must be a void in their lives if they make themselves so available just to be loved and accepted."

"Before we were married, we didn't even think about sex," says Frank. "Sure, we had hormones, but I didn't feel I had to express them; I knew there would be a time and a place for that. You see, my parents were very strict Catholics, and I was taught to take care of the lady. To me, the woman was something very beautiful, like a flower that you had to cultivate in order to have the love and understanding grow."

"God gave Frank many virtues," says Margaret. "And patience was one of them. His father was the governor of the state of Sinaloa, in Mexico, and he was groomed to be a gentleman. He has more tolerance and understanding than anyone I know. He's my anchor, really, because where I am energetic and very visible,

he's more passive and supportive. I tend to be aggressive, impatient, and very gung ho, and to do exactly what I want to do all the time."

"I think I'm softer," smiles Frank, "and maybe more forgiving than Margaret is. I'm certainly more emotional; I cry when I watch the drama programs on TV. And I cook and clean the house. In fact, Margaret doesn't even know how to run the washing machine."

"It's true," she laughs. "Frank mops the kitchen; he does the vacuuming, the washing; he does everything. You know, his mother never let him pick up a dish from the table. This was the traditional Hispanic way; the men were never expected to do housework, and the mother idolized the oldest son and put him on a pedestal. When she saw him helping me in the kitchen, she was livid. When she saw him wash the dishes, she couldn't believe it. I traveled all over the country as a political activist speaking on Mexican issues, and he'd stay home, run the house, and take care of our daughter, Debra Lee. And many times his mother would say, 'Why do you let her go? She's going to meet other men.'"

"And I'd tell her," says Frank, "'I know she'll meet other men, Mother, but Margaret knows what she's doing. I don't have to worry about her.' My mother didn't understand that Margaret had her own life and that I was proud of her."

"This is exactly what I love about Frank," she says, "though I don't have any idea why God assigned him the job of being my husband, because I'm very difficult to get along with. Lucky for me, he knows how to handle me; he just lets me think that I'm doing what I'm supposed to be doing. Now, I could never have handled a macho, Hispanic husband; we would've destroyed each other. But believe me, there are no bosses in this house. Frank and I are individuals; we're peers. I would never say we have a role reversal going on here. When I'm out in the world, I'm a different person; I want everybody to know how wonderful I am and I'll use my muscle to get what I want. But here at home, nobody gives a damn. Frank has never been threatened by my bravado or my so-called knowledge and scholastic ability, though I know that other people have given him a hard time and called him henpecked because of it."

"Well, I don't know if they ever said anything to my face," Frank says quietly. "I could tell that they didn't believe Margaret should be so aggressive, and that hurt me; but I kept it to myself because I believed in her and I was proud that she was my wife. It was an ego boost for me. I started calling her 'Little Giant,' because one day I saw her standing in a circle of men, all six feet tall, who were listening to her—this little lady—and I said, 'Little Giant, you're doing OK.'"

"I couldn't do half the things I do if it weren't for Frank," Margaret goes on. "He's never said I shouldn't try for something, even though other people have given me a harder time. I'm involved in many community projects, and not everybody likes me. Most of the groups I work with are made up of men, and most of these men—especially the Mexican men—don't like aggressive women. When I became the first woman vice president of the Mexican American Political Association, in my acceptance speech I said, 'You are now looking at the person who will become the first woman president of this organization.' And a man came up to me later and said, 'Over my dead body.' So when I did become the president, I called him and said, 'What size casket should I order you?'"

"It's hard for me when people don't like Margaret," admits Frank. "I've seen her feelings hurt a number of times, and I think it's that some people don't see what she's trying to do. Like the time the Mexican community didn't support her nomination for San Francisco supervisor."

"I was grooming myself to run for public office," says Margaret. "But when I confronted the Hispanic

Margaret and Frank Cruz on their first date, 1947.

had to be done, because we had a house and a child, and Margaret couldn't move. At first I was a little overwhelmed; our big house seemed like a mountain to me, and the shopping and the cooking made me feel terribly lost. But I did these things for Margaret because she needed me."

"When you live with someone," adds Margaret, "you have to be able to understand the other and anticipate their needs to make sure that they have all of their comforts. That's what marriage is about. You have to take care of each other, because nobody else will. When I was sick, Frank was totally there for me. Now, I do what I can to take care of him. So when he comes home at two o'clock, I have his lunch ready with a nice glass of wine or chilled beer. And I make sure that he always looks nicely groomed and that he has new jeans and feels attractive. And I never get anything just for myself. If I run down to the Mexican store and get enchiladas, I get four, two for him and two for me. I never minimize him. Every day before he leaves the house, I give him a blessing with holy water. I've done it since we got married. I mean, he may not come back."

"These things mean something to me," smiles Frank. "They are Margaret's way of showing her love, and I'm very grateful."

"I'm the grateful one!" Margaret laughs. "At the age of fifty-eight I was given a four-year scholarship to law school in San Francisco, and I couldn't have done it without Frank's encouragement. After I found out about the scholarship, Frank said, 'Well, Little Giant, this is what you've always wanted, you better take it.' I ended up being the valedictorian at my graduation, and I said, 'I got a college degree and Frank got a cooking degree, because he learned how to use the microwave!' But Frank was never jealous of these accomplishments. He's the most secure man in the world!"

"In fact, I began going to City College and taking music," he brightens.

community for their backing, they said no. They didn't like me because I was arrogant and domineering, and because I was a woman. And the truth was, I was not as nice a person as I should have been.

"Anyway," she continues. "I didn't get a chance to run for office at all because I found out that I had polio. I think that was God's answer to my running for a political office, because I'm basically an honest person and I couldn't live with myself as a political prostitute. So I spent the next year bedridden, immobilized from the neck down. Our daughter was two years old, and Frank took care of her, the house, and the cooking. That was his domestic education."

"Well, I had to," Frank smiles shyly. "These things

"I'd said to him, 'Nobody stays at home while I'm at school!'" beams Margaret.

"I wanted to learn how to read music," he says, "because I was singing in the choir at St. Finn Barr's Church."

"After I had the breast surgery in 1994," Margaret continues, "Frank took care of me. He'd pick me up and take me to the bathroom. See what I'm saying? This man is a saint."

"I think that cemented our relationship," he says.

"My family really loved me though that cancer," says Margaret. "They knew I was a mean bitch, but they took care of me, warts and all."

"Well, she wasn't so bad," smiles Frank. "In general, I may feel a little hurt by things Margaret says in the moment, and I may yell a little myself, but it's only temporary. It goes away and is forgotten."

"I've learned patience from this man," says Margaret, "and the futility of arguing, because he doesn't argue. That's why everybody likes Frank. Nobody ever says anything bad about him. And you rest assured that, if they did, they'd have me to contend with because I wouldn't tolerate it!"

"My wife is a great talker," laughs Frank. "If you want a friend, you'll have one. But don't make an enemy out of her, because you'll really have an enemy. Of course, it's not as severe at home. I make mistakes, but we can talk about it."

"When I give thanks," says Margaret, "I always thank God, and my daughter Debra Lee, and then I thank Frank, who is my friend and husband, and who forty-five years ago asked my father for my hand. The lucky dog got the whole body. I have made arrangements for the little person upstairs to take Frank before me so I can start canonization proceedings, because the man is a saint!"

Tandy Beal and Jonathan Scoville had been together for twenty-seven years before they married five years ago. Tandy, forty-seven, is a dancer/choreographer and head of Tandy Beal and Company, a well-known dance troupe. She has taught for many years and is currently artistic director for the New Pickle Family Circus. She makes her home in the Santa Cruz Mountains of California. Jon, fifty-two, is a composer, musician, and dance accompanist who teaches music in the University of Utah's dance department six months out of the year. The other half of the year he lives in California with Tandy. This interview took place over the phone, which seemed appropriate since so much of their relationship takes place over the wires. They met on a blind date when she was fourteen years old and he was nineteen.

Tandy Beal and Jonathan Scoville

"When Jon suggested that we get married, I was concerned," says Tandy.

"She was horrified," laughs Jon.

"I was!" she screams. "We'd been together for twenty-seven years at that point, and I questioned whether we should rock the boat and change something that had been working well for so many years. I guess I was superstitious and felt that our relationship would change for the worse. And as soon as we announced our marriage, everybody had horror stories of people who'd lived together for years, gotten married, and then gotten divorced. I thought, 'What strange folklore and perverse human nature is going on that people want to give this kind of bad-luck story? It fed directly into my fears.

"But Jon pointed out that marrying would be the most meaningful gift that we could give our parents, who were in their eighties at that time."

"Actually, our parents never came right out and said, 'We'd be happier if you were married,'" adds Jon.

"In fact, my parents used to say that we had a marriage made in heaven. Not that we had a better relationship than anyone else, but that ours was obviously very special. Of course, my father, who was a Presbyterian minister, would jokingly offer to marry us for free from time to time. There was never any real pressure from them, except in knowing that their lives were coming to an end, and I sensed our marrying would tie up loose ends for them."

"So even though I'd never thought to marry," Tandy continues, "I heard what Jon was saying and realized that all an aging parent hopes for is that their children find love in life and are taken care of. I felt that our marriage would bring them this completion. I also realized that we had proven our point, that our relationship didn't need the sanctity of the government or the church for the love to sustain it. That was part of the mystique and atmosphere of the sixties and seventies. And once I pushed past my superstitious thoughts, I really didn't

Jonathan Scoville and Tandy Beal, 1960s.

riage, we were right up against mortality issues and there was clearly a sense of appreciation of the mystery of life that was braided into the wedding. I'm grateful that we didn't get married when we were in our twenties for that very reason. In your twenties you feel so thoroughly immortal, but when you take vows in your mid-forties, as we did, at a point when you realize that life is short, the mystery is richer and therefore the impact is greater."

"When the part about richer or poorer, sickness and health came up," says Jon, "I lost it because we'd lived through those things. When you marry at twenty you really don't know what those words are going to mean. But suddenly saying them and knowing what they have meant over the last thirty years, and what they will mean for the next thirty years, just really broke me up."

"I remember when Jon and I were in our early twenties in the 1960s," says Tandy. "One day we were standing in the ocean and we called out to the universe, 'Give us an intense life filled with adventure!' I feel that our relationship has been the boat which has taken us out into that sea of intensity. It buoys us up and allows us to float into the world of activity and adventure with safe passage."

"And the difficulties in our relationship have been terribly valuable in terms of deepening our experience of the world," says Jon. "For example, I grew up in a really orderly house, and Tandy grew up in a house that was, well, spontaneous."

"That's a nice adjective, Jon," she laughs.

"Now, Tandy has all the sense of order of a cloud," he smiles. "And like a cloud, there are boundaries, but they're constantly shifting and reframing. Our house in California, for instance, tends to have pockets of chaos and pockets of order. My own aesthetic is to have an environment around me that reflects order so that, if there's chaos in my mind, I don't have to actually see it."

"We used to fight about this a lot," says Tandy.

believe that marriage would be a radical change for us after being together for twenty-seven years.

"But believe it or not," she continues, "marriage has altered our relationship. Since then, there's been this magical pixie dust that's settled in around us. I think it had something to do with the circumstances at the time of the wedding. Three weeks before the ceremony, I'd had a hysterectomy that I was very nervous about because I was convinced that the anesthesia would do me in; and then a month later Jon's father lost his vision and started his final decline. So at the time of our mar-

"Then one day Jon said, 'I realize you just don't see the mess.' And it was true, I didn't see it. So now Jon might say, 'Let's clean the kitchen.' And I'll say, 'Oh, really, why? Oh, I get it; it must be dirty.'"

"It can be annoying at times," Jon admits, "but Tandy's priorities are about spontaneity and creativity; so if I'm worried about whether the bed is made or the dishes are washed, maybe I'm making too much of it. I've seen how she moves through her life, and she's very fluid. And as you become older, life becomes more rigid and fixed, and if you can keep your mind fluid you can deal with your own mortality and the world getting screwier. I'm grateful to get a chance to share my life with such a protean personality, one who has taught me to accept change in the world."

"One thing that I'm grateful for," says Tandy, "is that Jon and I both realize the fragility of our lives. This is a strong undercurrent between us, and it allows us to have the astonishing realization that we're just sitting on a rock in the middle of the galaxy, moving at great speed with no comprehensible purpose. We come back to a subtle variation of this awareness a lot in our day-to-day life. It's a deep river that connects us and inspires us to treat the other with respect."

"I think it's a form of prayer," says Jon, "that was inspired by our parents. My parents got up every morning at 6:00 A.M. to pray. That was my map each morning, seeing them sitting side by side with their Bibles. And while I didn't share their form of faith, I'm grateful that their lives were engaged in asking about the mystery of the spirit. Tandy's parents had coffee in bed each morning and laughed and shared in a different way, but that was their form of prayer."

"That's beautiful, Jon," she says.

"I think what we've gotten from our parents," he continues, "is a way of entering each day with something other than, 'Oh, I have to get the laundry done, you need to get your tires fixed, and who's going to pay the bills?' Instead, we might start the morning with a walk, because we value getting out into the natural world before the human world imposes its schedule—and that's a form of prayer too. Last summer we set up a bed in our California garden, which was filled with iris, poppies, lilies, and lavender, and slept under the stars night after night. It's astonishing how quickly the cares and concerns that are deep and real during the day drift away."

"That was really something," Tandy says. "It was one of the most intimate things we could imagine doing."

"Just being out there was a form of making love," Jon says. "It was a union with the cosmos, with eternity. I love the image; two tiny little heads sticking out of a tiny little bed in a slightly larger garden in an immense universe. It's the perspective lesson—the realization that our lives are small and that we need to find something larger than ourselves to give our lives meaning, rather than just walking around with these fragile egos that constantly need backing up."

"This is critical," adds Tandy. "All humans yearn for passion and meaning in their lives, so whether it's religion, art, or childbearing, we need that larger connection. When people focus on their individual needs and believe that one person should meet all their needs, they're headed for trouble. Getting one's needs met is such a short way of looking at life. Who the hell cares about your needs? It's the whiner's way of looking at life. I don't know, maybe I'm being outrageous."

"Well, I think you need to know about your needs," says Jon, "and figure out who they really serve, you or something larger?"

"What I'm saying," Tandy continues, "is that the whole concept of needs is so boring to me. Having a rich life should be more about the intensity of your interests and passions than about, 'Am I getting what I want?'"

"One person can meet your interests," says Jon, "though if they continually don't, you'll have an attention-

deficit problem in the relationship. A relationship is more than domesticity; you need to share ideas and understandings. Maybe personal needs take over when the deeper spirit of a relationship isn't strong. I'm grateful that we share a similar inquisitiveness and openness in the way that art, spirit, and nature show up around us and constantly teach us. This keeps the universe unfolding and our relationship growing."

"We've been lucky that our work is about making art," adds Tandy, "and about working with large groups of people, which quite literally makes us feel part of something larger."

"And because our careers are so aligned," Jon says, "we've created a union in our relationship that is magnified by music and dance—the oldest allies in the arts. I know that my music is most fully realized when Tandy is dancing to it."

"I've had a number of people come up to me after Jon and I have done a class together," Tandy says, "and say, 'I feel like you guys are making love when you teach this class.' They feel the resonance between us, because Jon and I have become each other's muse. I wouldn't have done half of my major projects if it hadn't been for Jon's muse quality. Whether he's handing me a big cup of coffee, or a title for a dance, or a great piece of new music that he's written, he's always letting me know that I have the strength and the imagination to create from. And then he's delighted by what I do, which makes me want to do more of it."

"Tandy gives me my best inspiration and is certainly my greatest critic," adds Jon. "I always play new pieces of music for her. Interestingly, the very area in which we have disagreements is where we differ in our artistic esthetic. We generally have the same point of view, but if we're making a piece together and we have different ideas about the music, the lighting, or costumes, it can get very tense because we each have strong opinions about what works."

"We'll be short with one another," says Tandy, "and people can see that we're having a disagreement."

"And it gets very quiet around us," smiles Jon.

"So we'll storm about for a while," Tandy laughs, "and then it gets resolved. One of us will ultimately go with the other's decision or we'll find a compromise. But the nature of the creative act is change, and relationships, when they're creative, are about change too."

Mel and Lenore Lefer have been together for thirty-five years, although they have been divorced for seventeen of those years. Lenore, fifty-seven, is a psychotherapist currently working with women around midlife and menopausal issues, and also with cancer patients. Mel, sixty-three, was in the garment business and has driven cabs, owned restaurants, and played the horses. He currently teaches workshops in stress management and yoga. The couple has two sons.

Mel and Lenore Lefer

"When we got married in 1960," Lenore begins, "I had no idea what I was committing to. Mel and I didn't know who we were, and we didn't even know that we didn't know."

"We were like babes in the woods," says Mel.

"I knew we had something special," Lenore continues, "but I was following the collective experience: Jewish girls married Jewish men; you bought a house and had 2.7 children. We lived an upper-middle-class lifestyle in suburban Connecticut, where we dressed for dinner, were the appropriate weight, and had long, straight blond hair, even if that meant going to Harlem to have it ironed and colored."

"We had three little boys," Mel continues, "a dream home, an English nanny, three cars, and a prize-winning Hungarian Puli. I was in the family garment business. Lenore was a great wife, constantly serving me. I'd come home from work, and she'd have the table set with candles and a beautiful French meal. Wine...."

"Julia Child's, from cover to cover!" she laughs.

"I'm telling you, she was a great homemaker," he says, "my picture-perfect wife."

"Always available to you," she laughs, shaking her head, "morning, noon and night—even though I was gritting my teeth some of the time. We had the traditional marriage, he went to work and I had the dinner parties."

"I was thinking about making my fortune," says Mel, "but I was also depressed most of the time and couldn't get out of bed some mornings."

"We got bored," says Lenore. "It had never occurred to me not to do what was expected of me. I didn't start living a life without a script until I was in my late thirties."

"The first turning point for us was in 1971, when we went to the Pocono Mountains in Pennsylvania to take a workshop with a woman named Betty Fuller," says Mel. "We took our clothes off—we got naked—smoked some dope...."

"Ah, the early days of the human potential movement," smiles Lenore. "Exploring and expressing our feelings."

"Our minds were blown," Mel says. "This was like another world."

"We'd done some experimenting on our own," Lenore says. "The guy who did my hair used to sell me joints for a dollar, but this world was 360 degrees to the left of our mannered little life in Connecticut. For one thing, it was the first time I ever had acknowledged feelings, and I came home very high. Mel had the same experience, so we came to California for a three-month residence program at Esalen, in Big Sur."

"I left the business," says Mel. "We rented the house and went west with the kids."

"We'd been together eleven years at that point," says Lenore. "And we'd been going through the motions of living with no sense of purpose or self-awareness. We were asleep. I had these three kids, but I had no idea how I'd gotten pregnant. No idea how I'd given birth. Things just seemed to happen to me. All of a sudden we were in Big Sur, and these fully tanned women were walking around without their clothes on, and it was like, 'Where are we?' I'd never seen this lifestyle before, and yet it was very appealing to me; but as a young woman with three children and a handsome husband, I was threatened. I had no idea who I was. Up until then, I thought I could change my entire life by combing my hair a different way. I was always in search of myself, but because I had been reading from the good girl script, my solutions to life's questions were not deeply considered."

"A lot of people told us we'd last six months or a year together because there were so many temptations at Esalen," says Mel.

"Like open marriage," Lenore adds.

"One time we tried to talk this beautiful blond woman into sleeping with us," Mel laughs.

"A ménage à trois," Lenore lights up. "We all got stoned, went out to dinner, and were going to go back to her house; but when we picked up her little boy, he'd thrown up. So the evening was canceled and we were all very relieved."

"We were trying to be adventurous," explains Mel. "It wasn't that our marriage was so bad—certainly the sex was always very hot between us—it was that we wanted to be more alive as people."

"And what we found," adds Lenore, "was that while we had a very good physical relationship, we had no ability to communicate deeply. We were friends and were doing our gender roles appropriately, but now neither of us was working; we didn't have our English nanny or our big fancy house, and things were shifting very quickly. We were waking up to how we felt about each other. We loved one another, but we didn't know who we were."

"We stayed in Big Sur for four months," Mel continues. "Then we moved to San Francisco, where I got a job running a garment factory."

"I wouldn't call myself a homemaker at that point," Lenore grins. "I was stoned every day. We were still on the swing from having been responsible, Jewish people and having a child-centered family to doing exactly what we wanted to do. And the kids, oh, the poor kids," she laughs. "I didn't know what to do. They were sort of disheveled and displaced. We'd taken away the structure of their lives. They'd lived in this nice community where their aunt lived across the street, their cousins around the corner, they had bikes, and I drove them to every conceivable lesson; and now I was stoned practically every day."

"I was working," he says. "I got to work at seven every morning."

"You were lucky," she says. "You had that structure. I wasn't sure what was going on; I'd lost all my props."

"And our oldest son started acting out," says Mel.

"One New Year's Eve, he ran out in the street saying he'd call the cops unless we stopped smoking pot."

"But it was also a very liberating time," Lenore remembers. "The women's movement was happening, and here I'd been serving Mel for years, totally locked in tradition. It became clear that I needed to take hold of my life, so I got interested in something called psychosynthesis, a spiritual psychology which focused on spiritual and transpersonal values. I went back to school and became more committed to my work and career than I was to my husband. I was hardly ever home and preferred being with colleagues. When Mel and I were together, it was very strained because we had created so much distance. I had really turned my back on him, so he initiated divorce proceedings."

"Lenore had became somebody I didn't know," Mel explains. "She was totally involved with this psychosynthesis group, to the point that you could call it a cult. The kids didn't matter, I didn't matter; she was going to save the world. I kept trying to talk to her; I even went to work for the outfit because they were having financial trouble. I figured maybe I could get in, but she wasn't part of the family anymore. We stopped making love, stopped spending time together."

"It was the first time in my married life that I was being supported intellectually," explains Lenore, "and being seen as a smart and gifted teacher and therapist. The marriage seemed boring in comparison. I didn't want to leave Mel, but it appeared that I couldn't have both; I felt I was doing the right thing. It was an issue that many women experienced then, and the psychosynthesis group encouraged me to leave the marriage so I could devote myself to my work. It was a horrible period."

"A bitter, bitter, horrible time," remembers Mel.

"Hard for the children and hard for our friends, who had seen us as the most stable couple in our circle," adds Lenore. "Nobody had been married for twenty years, so it was disruptive to everybody. We were incred-

ibly cold to each other. I avoided him and he avoided me; cutting off completely felt like the only way to end things. I don't think we spoke to or saw one another for about a year. I know it had a lot to do with this group I was in, which I realized much later was a cult, but I can't say that it caused the divorce; it's not that simple. Here I'd come from my family home to live with Mel and have these children, and I felt like I didn't have a breath to have a life of my own. Here was that opportunity; it was part of an individuation that I had to do. It was also very important for me professionally and became the foundation for my career. If we had been more conscious, maybe we could have done it differently, but this is how it came down."

"It was a really hard time for me," says Mel. "I always thought we might come back together if she would be Lenore again, but she wasn't Lenore. She was this strange creature that came out of the swamp.

"Then, in December of 1980, after we'd been divorced for a couple of years, our fifteen-year-old son drowned in the Pacific Ocean. It happened in Big Sur, where Lenore and the kids had gone for the holidays. Jason was climbing with a friend on a steep cliff near the ocean, and they were swept into the sea by a very large wave. After that, Lenore and I started talking again."

"I couldn't bear to be with Mel in the beginning," says Lenore. "Mel's grief was so intense and mirrored mine too deeply. It was a horrible, horrible time, as you can imagine. It was months until I felt like I could even talk to him. I ended up going to London for a year and teaching at the Psychosynthesis Institute. It was the first time in my life I'd ever lived alone, and it was very healing."

"We started writing to each other," says Mel. "Gradually the letters became love letters, and then I visited her in London for the Christmas holidays."

"We celebrated the anniversary of Jason's death together," Lenore says. "It was so cold and dark in

London, and we spent the day talking about Jason and walking in the snow; and then at some point I became enraged thinking about my feelings toward Mel and Jason. I remember how he just let me rage at him without engaging with me. He was like a mirror for my rage at having lost this child, and I remember feeling spent and falling into his arms and just being held. He understood my rage and didn't take it away from me. We cried and talked, and we made love that night for the first time in years. I felt all those old feelings of feeling loved and beautiful and connected to Mel. When I came home four months later, Mel moved back into our house and we became a family again, though we've never remarried. I think on some level we'd never disconnected with each other. He went out, I went out, we had affairs, but he was still there for me."

"I think it took Jason's death to bring us back together," says Mel. "His death impacted all of us. We wanted to be a family again, and suddenly we all valued each other more than we ever had. But as sobering as that event was, five years later we had another turning point. I had a bad heart attack that almost killed me and certainly changed our lives. I'm still on drugs to lower my blood pressure, and it's been a gradual battle to try and keep an erection, which has discouraged me from wanting to have sex with my wife."

"Interestingly," adds Lenore, "we had this very passionate connection for so many years and it went away around an illness. We've tried a lot of things: Tantra workshops, urologists, cock rings, you name it. We spent so many years trying to wake up, and it took the death of our son and the death of Mel's sexual ability to create a real intimacy, with tenderness, between us.

"So even though there's less physical intimacy, we're growing closer because we're talking about our fears around aging. We know that this is it, that we'll be together until one of us is dead. We've gone from *hormonic* to *harmonic*."

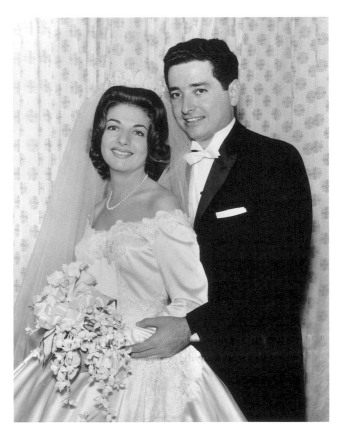

Lenore and Mel Lefer, 1960.

"We're totally different people today," Mel says. "I'm probably happier than I've ever been. The only thing that really bothers me is the damage that's happened to my body, because it limits me."

"I know how betrayed by his body he's felt," says Lenore, "and how scared he is from time to time, but that change has also yielded something quite wonderful. He's more tender and we're much more loving toward each other. More open. After Jason died and we came back together, and after we saw all the pain around Mel's illness and the losses we'd shared, we decided that we should just be kind to each other. 'For better or for worse' has a whole different meaning to me now. I

didn't know what worse was when I was twenty-one years old. Worse was if you got fat."

"You can never get the same kind of deep and meaningful feeling as you do when you stick something out for thirty-five years like we have," says Mel.

"We've learned to be patient with each other," Lenore says. "We've learned how to communicate, when to yield, how to compromise, how to take turns, be generous, and be tender. They seem like simple things, and so cliché, but they're not. It's taken us years. We've connected in the deepest ways emotionally and physically. We've loved each other and hated each other; we've been mean; we had a horribly bitter divorce. I've expressed more of myself in the marriage with Mel than in any other place in my life. I don't regret anything that we've done; the hardest events have been the greatest teachers for me. I believe there's a rightness to how things happen. It wasn't right that Jason died, but how we've created our family harmony out of it has made us all examine life a lot more and certainly brought us the aliveness and love that we sought all those years."

*A*lice and Ancil Johnson have been married for fifty-one years. After Ancil, seventy-nine, worked for the post office for thirty years, he told his work buddies that he was retiring to take care of Alice, who's had an assortment of illnesses. Alice worked at a hospital, and also as a domestic for many years, cleaning and sewing for other people as she raised their four children. At last count, they had thirty grandchildren and great-grandchildren.

Alice and Ancil Johnson

"Let me tell you something," Alice says. "A wife needs to do her homework if she wants to keep things interesting with her husband. She needs to keep herself presentable and clean, make sure the house is nice, and keep everything just right up in the bedroom. You know that TV commercial? How does it go? 'If you smell it, you don't want it.' That's the secret. If nothing else, you got to keep that right. So I take a bath and put on some nice lingerie—not that old, faded, raggedy stuff. And then maybe I'll put on some Estée Lauder, because Ancil loves Estée Lauder.

"Every night before Ancil comes to bed, he shaves and gets himself ready. He used to use aftershave until recently, but since he don't use it now, I guess that's my key to back off. Right, honey?"

"Oh, I don't know," Ancil laughs.

"You have to spice up the marriage and keep each other happy if you want things to last," says Alice. "Otherwise you'll be finding yourself in the arms of other people and that's no good. See, we believe in monogamy. When you make a commitment, you don't break it, but you also got to work for it."

"You got to be strong," adds Ancil, "because there's a lot of women out there. I don't mean to put nobody down, but women *will* come after men. But I'm a one-woman man."

"That's right," says Alice, nodding her head.

"So the strong one has to stand up," he continues. "I just tell them, 'I got a pretty wife at home, and that's all I need.'"

"And I do take care of all of my husband's needs," Alice smiles. "And if I'm tired, well then, let me rest a moment. Now with sex, it's not as frequent as it used to be. God knows, it used to be every night and we miss it, honey. I long for it! But believe it or not, there is more to life than sex—though you couldn't have told us that when we was young.

"I met Ancil the day I first came to San Francisco

from Chicago. I'd run away from my first husband because we were totally incompatible. The only thing we could do was make babies, and we made three of them, but we had nothing else in common. So one day my first husband went to work, and I called a taxi and took the Illinois Central to Oakland, then the ferry to San Francisco. I met Ancil that night at church. He was the church clerk, and at the end of the service, after he'd gotten my name and address, he said, 'Oh, I forgot to get your phone number.' And he's been calling me ever since. It took us four years until we actually got married, but we were together all the time."

"Since we'd both been married before," Ancil explains, "we weren't in a rush to trust just anybody."

"But we sure messed around a lot," she giggles. "And he forgot to go home sometimes. But, honey, a girl has to do what she has to do. I was twenty-three, I had three babies, and I had to work and take care of myself, and we had to try sex to see whether it was what we wanted. We was young and hot, honey! And Ancil was very hot."

"Well, I don't know," he laughs.

"You know you was hot!" she slaps his hand.

"Well…," says Ancil shyly.

"That's what brought you to me," she laughs, "seeing me. I'm telling you, this man is sexy; he's a demon in the bedroom! Tell them, Ancil!"

"Everything is all right," he laughs.

"But you know," she continues, "we had morals. We don't believe in shacking up and committing fornication. So during this fooling-around time we didn't feel as free to participate as much in our church, because we were feeling guilty. But I'm telling you, we couldn't help ourselves. Every time we got behind closed doors, wow!"

"I think physical love is very important," adds Ancil. "You need to find a person who you're compatible with in order to stay together. But it was more than

that with Alice; she is a devoted Christian and a very loving person, and I realized this. When we were dating, I had tuberculosis and spent ten months in the hospital. I don't think a day went by that she didn't visit me there. Sometimes she came twice a day, just to say goodnight. While I was sleeping I would think of her, and we would have joyful times in my sleep. Some people would call it a dream, but I felt that it was the spirit talking to me and showing me that she was the one for me, so we got married."

"Sure we had some problems," Alice adds, "but marriage is hard work."

"It's a give-and-take deal," her husband continues. "I may have a lot of things that I want to do, like stay out too late and come home when I'm ready, but she don't like that, so I don't do it."

"I guess the only thing I like to do that Ancil don't like to do," explains Alice, "is pull the slot machines every now and then. I don't know whether he thinks it's a moral sin or what, but what *is* a sin is that he don't ever want to go with me. Now, if I *really get mad* he will take me, but he ends up being a wet blanket most of the time. He'll stay up in the room reading his Bible, and I can't enjoy myself and relax because I know he's up there having a miserable time. But gambling is against his religion, and I can understand that."

"I don't see any point to gambling," Ancil says.

"Well I do!" Alice shouts. "Oh, Ancil wouldn't pull a machine for nothing. Not a penny! Won't give me anything to put in them either, so I always bring my own money. The last time he took me gambling, he was vexed because it took me so long and I didn't want to leave. But, honey, when I gamble, all my problems fade away. When I see the lights flashing and hear the bells ringing, I forget everything except what I'm doing, and that's a wonderful feeling when you can put your problems on hold like that. I don't know why Ancil can't be considerate enough to realize that, if my blood pressure's

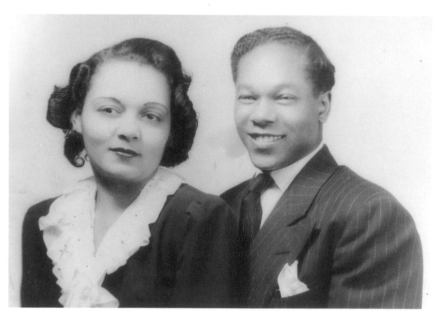

Alice and Ancil Johnson, 1945.

if we're good, he gives us ten more. So now God's given me ten plus four more, and he's given Ancil ten plus nine. This is tomorrow! What are we saving for? Now I admit that I do raise up a little when I get upset, but then Ancil knows that I mean business, and of course, if he wants peace, then he has to give it up. Right, honey?"

"I'm just listening," Ancil smiles.

"We're opposites," explains Alice. "I talk and he listens. He never talks except when he wants a car, or if he wants to take a vacation, or if a friend comes by and they get to talking about the Bible. How many times you read that book?" she asks Ancil.

"Once or twice," he says.

"And he reads it everyday," she says. "He goes into his bathroom—which he calls his throne—and he reads the Bible every morning. They don't make men like my husband anymore. He's like Job in the Bible: he's strong and can take on a lot. And he's sweet and loving and kind. He was never the type to go to bars, or smoke, or drink. No, he likes the finer things in life. And he's very meticulous and clean. Plus, he buys me my Estée Lauder and all my lingerie; and he brings me cantaloupes and strawberries, which are my favorite fruit. He's everything that a woman would want, though he does have a few habits that drive me crazy. Like every morning when he goes to the bathroom, he clears his throat. I could just die! I told him how I felt about it, but it just don't seem to matter. But now, I'm not perfect, am I, Ancil? Tell them what you're always telling me not to do."

"Well," he smiles, "I don't know…"

"Come on," she chides him, "you know what you're always saying to me, 'I wouldn't say that if I was you, better not say that, Alice.' Ancil thinks I talk too much."

"Well," he continues, "Alice is a lovely lady, but if she's mad at you, she's liable to say anything. And I tell her, 'You need to think twice before you speak once.' I guess maybe she's too free sometimes. But she does try

up and I need to relax, he should take me gambling. Now, is that too much of a sacrifice?"

"Now, Alice," he smiles, "it really hasn't gotten that bad. I've never had to pray that you stop gambling."

"No! You got to pray for me to win, baby!" she screams.

"Well, you know how I feel about gambling," he smiles. "I just don't like to electrocute my money."

"Oh, Lord!" laughs Alice. "He don't like to lose a dime! In fact, the biggest fights we ever have are about money. My husband just don't give it up, do you, honey? See, I'm not the type who wants everything I see. It's just that I want *what I want when I want it.* I never ask for anything unreasonable, do I, honey? It's just that he's a little tight with the money."

"Well, it's just that I try to save…," Ancil starts to say.

"He's frugal," she continues. "He wants to save what we have for tomorrow. But at our age tomorrow may never come. God only promises us sixty years, and

to have some regard for my feelings, and I appreciate that because she knows what I don't like."

"Well, I never *try* and go against Ancil," Alice grins. "But I do think for myself. I hear what he tells me, but he's not my father so I don't always do what he say, unless I promise him something."

"Let's just say that Alice pays attention to what I say until I leave the house," smiles Ancil. "And after that, we don't know what she do."

"Well, it's just because I had that stroke that he gets a little worried about me," she says. "But Lord, I've had so many illnesses. I had diabetes, asthma, and high blood pressure; and sometimes I get depressed because I can't go out and I can't do as much around the house, and this hurts my self-esteem. I like to walk; I like the malls, but since I also have this little problem with my eye, I need Ancil to hold onto me as we walk."

"That's why I scold her," says Ancil. "It bothers me if she cooks when I'm not here, because her eyesight is not the best and I never know when she might get on a stove and burn herself. It's all right if the house goes up, but I wouldn't want her to be in the house when it does. But you know, I've been married to this woman for fifty-one years; she's always been like this and I expect she always will be."

"At least for as long as I'm here," Alice smiles. "And then in the afterlife…"

"I'm going to be an angel in the afterlife," says Ancil.

"Oh, me too!" says Alice. "I plan to be an angel, too."

"Although we won't know each other," he adds. "That's what my Bible says."

"That's why I'm trying to enjoy him as much as I can while we're here together," says Alice. "And if I could just get him to do a little more with me, like taking me to Reno, then I think my life would be complete."